In the Moment

JAPANESE ART FROM THE LARRY ELLISON COLLECTION

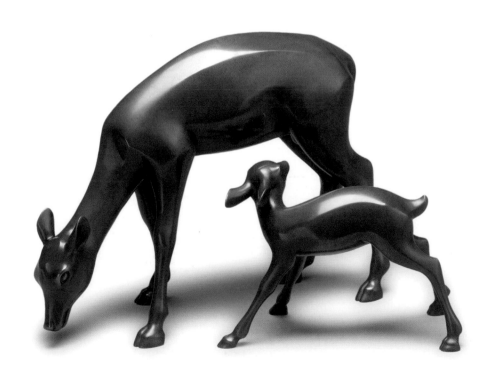

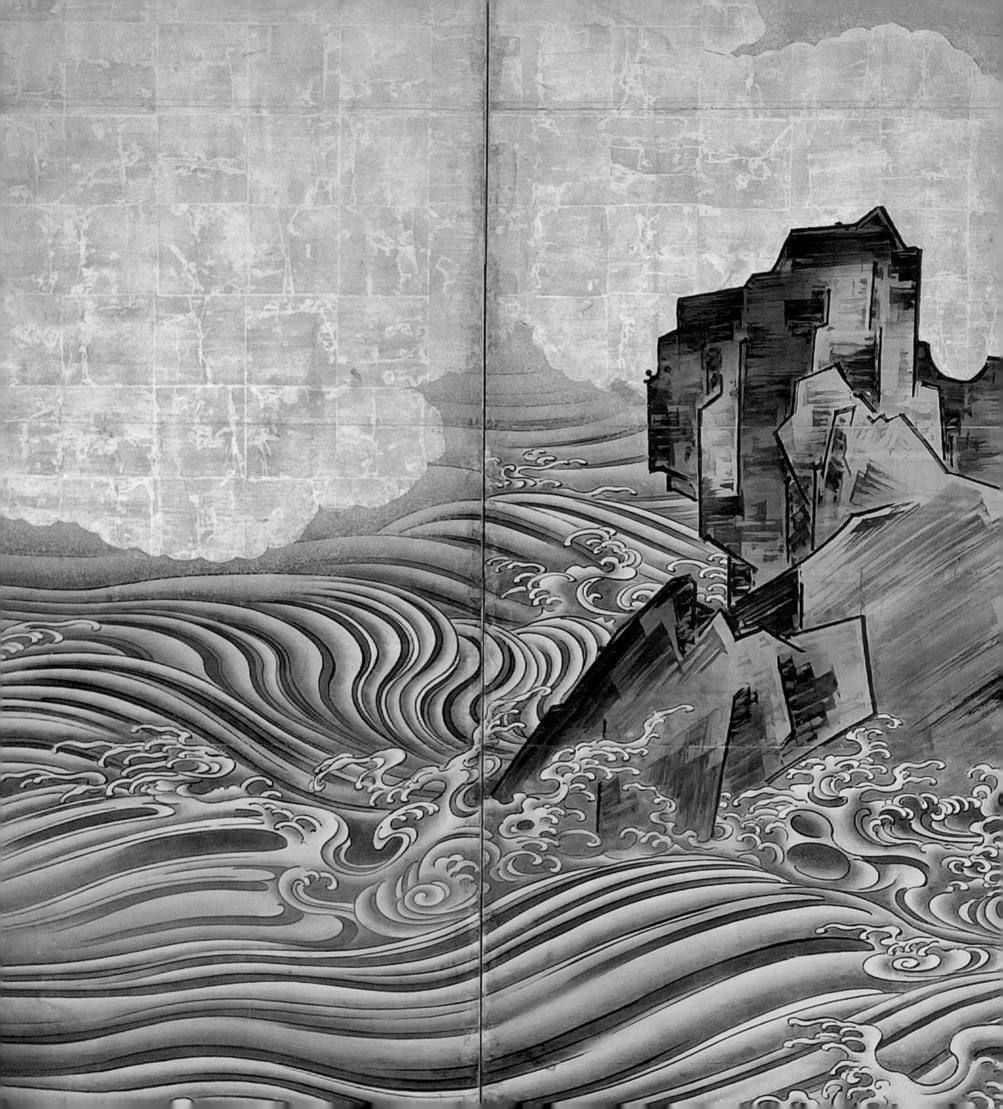

In the Moment

JAPANESE ART FROM THE LARRY ELLISON COLLECTION

Laura W. Allen, Melissa M. Rinne, and Emily J. Sano

Essays by Emily J. Sano, Matthew P. McKelway, and Joe Earle

Asian

ASIAN ART MUSEUM | SAN FRANCISCO

PLATE II (DETAIL)

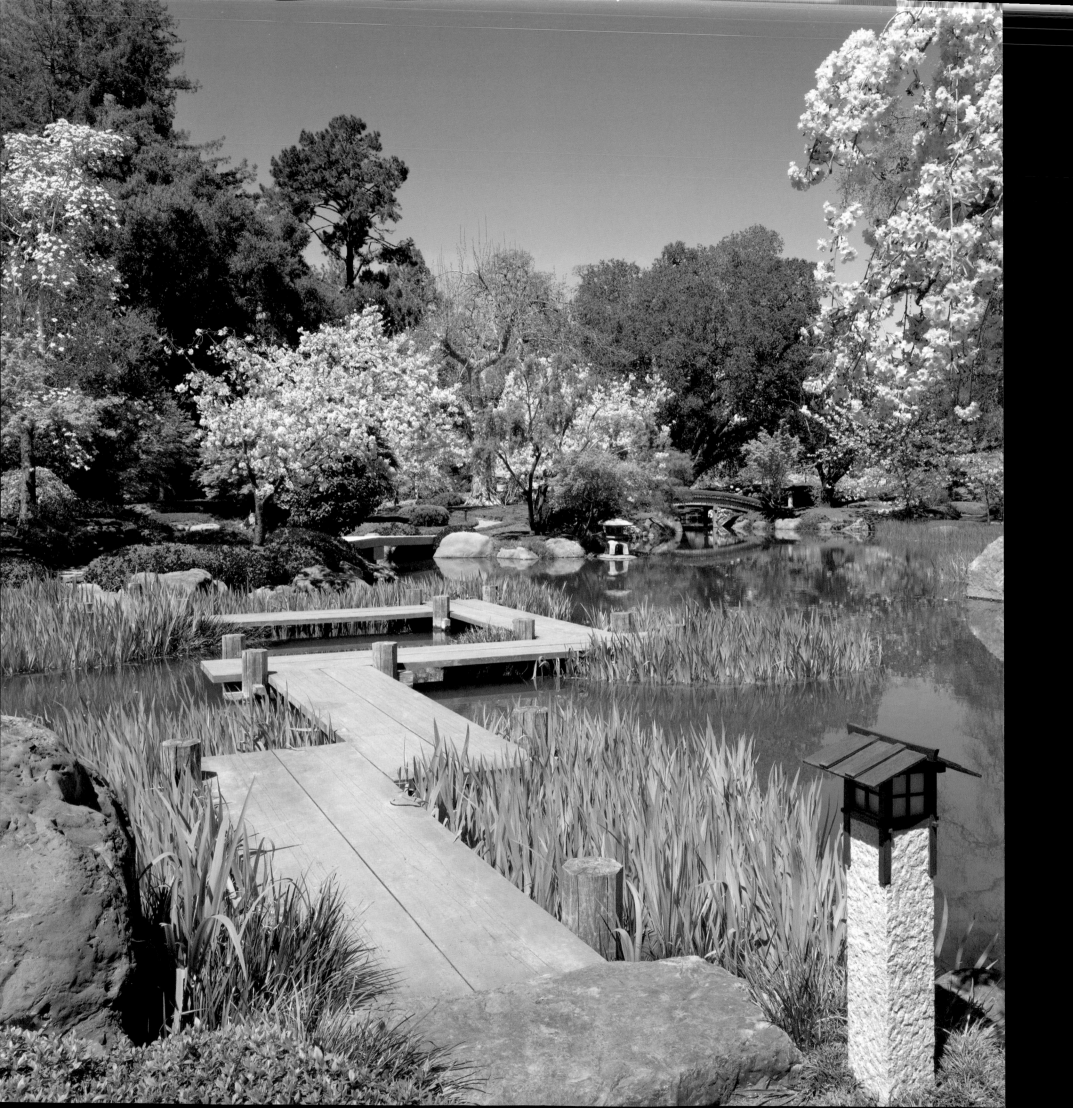

Contents

Director's Preface

JAY XU

The Asian Art Museum has always celebrated great art collectors. The generosity of private collectors enables exceptional artworks that could not otherwise be seen to be presented to the public. We are deeply grateful to Larry Ellison for making these outstanding works, spanning centuries of Japanese artistic achievement, available to our visitors, and to a worldwide audience through this catalogue.

From *A Chorus of Colors: Chinese Glass from Three American Collections* (1994); through *Between the Thunder and the Rain: Chinese Painting from the Opium War through the Cultural Revolution, 1840–1979* (2000), featuring works from the collection of Richard Fabian; through *Bamboo Masterworks: Japanese Baskets from the Lloyd Cotsen Collection* (2000); through *Collector's Choice, Collector's Voice* (2010), featuring works from the museum's affiliated collector's group, Nexus; through this year's highly praised *Out of Character: Decoding Chinese Calligraphy*, drawn from the collection of Jerry Yang—to name but a few—many of the museum's must significant and successful exhibitions have presented works from private collectors. We are proud to add these extraordinary artworks from the Larry Ellison Collection to this list.

Profound thanks also go to Mr. Ellison's curator, Emily J. Sano, director emerita of the Asian Art Museum, who was instrumental in bringing this exhibition to fruition, as well as to Laura W. Allen, the museum's curator of Japanese art, and Melissa M. Rinne, associate curator of Japanese art, who have devoted long hours to the project. We are also deeply grateful to Professor Matthew P. McKelway of Columbia University for consultations on the content of the exhibition from its inception and for his essay on Kano screens, as well as to Joe Earle, for the expertise he so generously shared, and for his valuable contributions to this catalogue.

Thanks for photography in this catalogue go to T-land Studio, Octopus Holdings, and Mark Schwartz; for project management to Tom Christensen; for design and typesetting to Ron Shore of Shore Design; and for printing to Elcograf S.p.A., Verona, Italy.

Any exhibition of great art is a large undertaking involving many persons and museum departments: curators, registrars, conservators and preparators organize and present the works while the educators and development and marketing specialists ensure that the show reaches its intended audience. We are grateful to each and every person who has helped to make this magnificent exhibition a reality.

PLATE 20 (DETAIL)　　　　　　　　　　　7

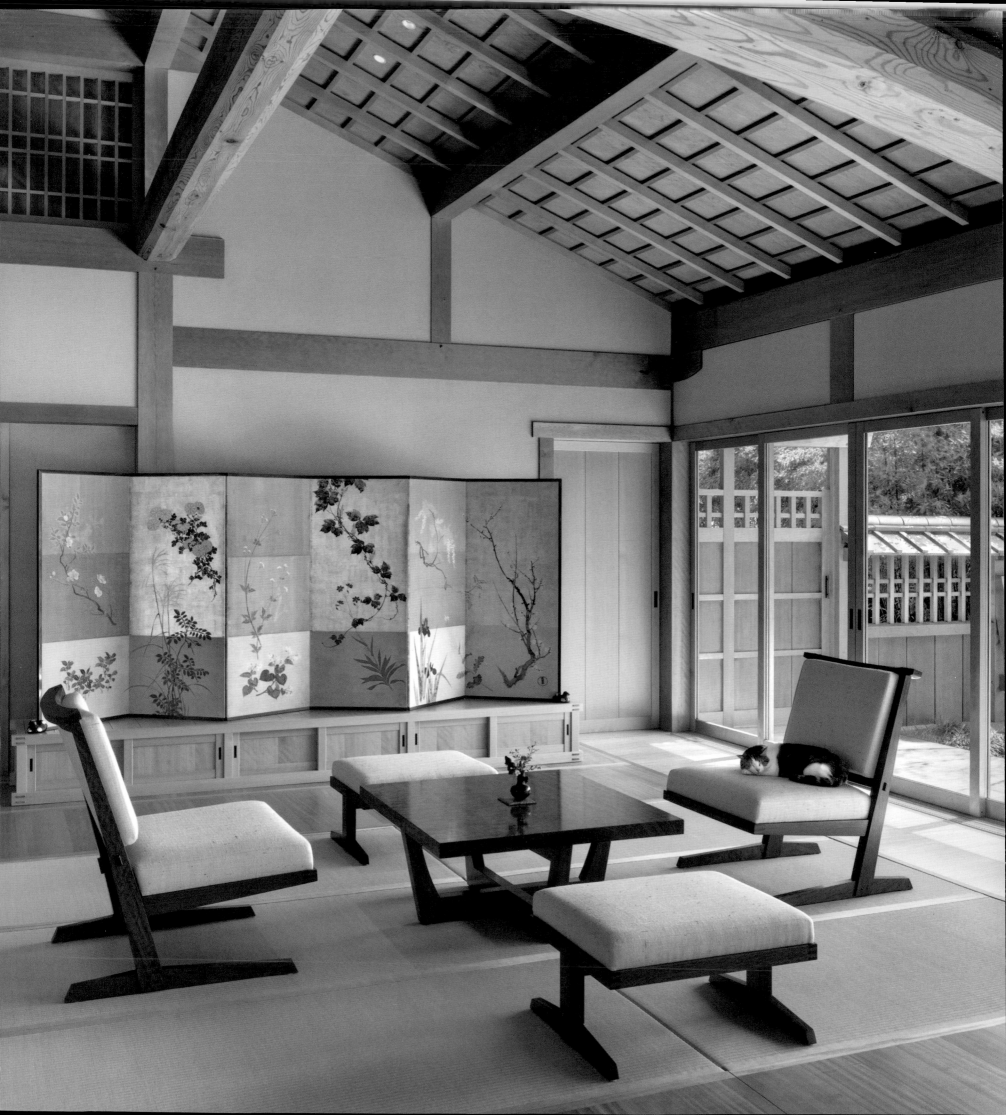

In Pursuit of Perfection:
The Larry Ellison Collection of Japanese Art

EMILY J. SANO

A lot is known about Larry Ellison. Since his emergence in the late 1970s as the co-founder and CEO of what would become Oracle Corporation, he has been the subject of several biographies that focus on the development of Oracle, as well as intense media scrutiny that has produced an abundance of lurid stories of his competitiveness, and his love of cars, airplanes, sailing, tennis, and real estate. What is not so well known about Larry Ellison, however, is his love of art.

When asked when and how he got interested in art, Ellison recalls his days as a college student in Chicago, when he started going to the library of the Art Institute of Chicago to do his homework. In order to be able to go as frequently as he liked, he purchased a student membership. When taking a break from the books, he wandered the galleries, familiarizing himself with the Art Institute's excellent collections.

Like many other visitors, Ellison was most taken by the Art Institute's superb collection of Impressionist and other nineteenth- and early twentieth-century painting. He mentions such masterpieces as Jules Breton's *The Song of the Lark*, the Renoir painting of *Two Sisters* (*On the Terrace*), and Picasso's *The Old Guitarist* as among his favorites. This early interest has stayed with him throughout his life. Today he can compare the Chicago collections with others he has seen around the world. And he confesses that he was, and still is, totally smitten by the picture by Edouard Manet, *A Bar at the Folies-Bergère*, at the Courtauld Institute of Art in London. "I fell in love with that picture," Ellison has said, "as well as with the girl behind the bar."

"… As well as with the girl behind the bar." Herein lies the key to Larry Ellison's response to art. Lacking formal training in any form of art, he, nonetheless, is open to acknowledging the feelings that emerge when he looks at art. His is a physical and emotional reaction. And it is completely natural to him.

This openness helps to explain how Ellison was touched by Japanese art and aesthetics. As young employee of Amdahl, a division of the Fujitsu Corporation formed in 1970, he was sent to work in Japan. He recounts that on his first free weekend he went to Kyoto on the Shinkansen—the new high-speed "bullet train" that cut the traveling time from Tokyo to Kyoto from eight hours to three.

> I had been told that Kyoto was the most beautiful city in the world, even more beautiful than Paris. So when I arrived at Kyoto Station I was a bit shocked. That meager pre-war

building did not look at all competitive with Paris! But I walked out of the station and into town. As I walked, I came across this huge torii gate. I had stumbled on to the Heian Shrine, and walked right into its precincts. I ended up spending the entire afternoon there—well, until sunset. And I was entranced. I have since learned that the gardens at the Heian Shrine are not among the very best Japanese gardens, but it was the first authentic Japanese garden I had been in, and it was a revelation to me. I was stunned by the fact that I felt more at home there—more comfortable and more at home—than any place I had been in my life.

It was such a surprise to me. I was surprised by how the garden made me feel, and it was then that I decided that someday I wanted to live in a Japanese garden. I have also spent a lot of time thinking about why [Japanese gardens affect me so deeply], but that is a separate question.

In the course of many trips to Japan, Ellison's knowledge of gardens and Japanese culture grew. Today he speaks with familiar ease about his two favorite Kyoto gardens, the famous Moss Temple, called Saihōji, established as a Zen temple in 1339, and the Katsura Detached Palace, or Katsura Rikyū, dating to the early 1600s, now controlled by the Imperial Household Agency. Temple gardens and imperial estates therefore set standards for him regarding the kinds of buildings, as well as their art and objects, that should be placed in gardens.

Japan has this interesting combination of minimalistic structures with glorious naturalistic gardens. I have never seen art as beautiful as this perfect collaboration between man and nature. But in time, I also fell in love with other arts—the screen paintings, hanging scrolls, and even Japanese music. Japanese music is very different from Western music. I think the greatest Western art is music, and Bach and Mozart are the greatest Western artists. But their music clearly consists of man-made sounds; Mozart's *The Magic Flute* and Bach's *Brandenberg Concertos* are

artifacts of human creation. But Japanese music to me very much complements gardens, because the sounds are like the natural sounds a garden would make. The *shakuhachi* sometimes sounds like wind blowing. It makes very natural sounds on a very different scale, and it blends perfectly with other forms of Japanese art, especially the art of the garden. So I have found that everything I experience in Japan can be taken to a high level. Even the food of Japan is exquisite; their cuisine is art."

Given this level of interest, it should not be surprising to learn that Larry Ellison is engaged with his art collections on a daily basis. He sets the parameters of the collections himself, always for personal reasons, and not because of someone else's notions of "good taste." This is not a man who hands an advisor a chunk of money with the instructions "go out and buy me a great collection." Instead, he chooses everything he purchases himself. Since his primary residence is a Japanese-style house in a garden, the art on view there is Japanese. And, having learned that Japanese art, particularly hanging scrolls and screens, are fragile and susceptible to damage from an excess of natural light, he takes care to rotate the paintings and lacquer ware every two weeks. He selects the items for these rotations himself in concert with the seasons, special occasions, and his personal taste.

With Japanese art in particular, the range of his taste is impressive. While he was long-rumored to own screen paintings and some Japanese armor and swords, when I first encountered his collection I was surprised by his interest in metalwork, particularly the exquisite craftsmanship of bronze vases and objects from the Meiji (1868–1912) and Taishō periods (1912–1926); lacquer ware; and, most importantly, Buddhist sculpture, with examples from early history all the way to the Edo period (1615–1868).

Across all these fields, Ellison's purchases reflect his awareness of a particular quality that captures his interest. When queried about his favorite piece in the collection, he points to a stunning pair of tiger and dragon screen paintings in ink by one of the greatest artists of the Edo period, Maruyama Ōkyo (1733–1795; cat. no. 21).

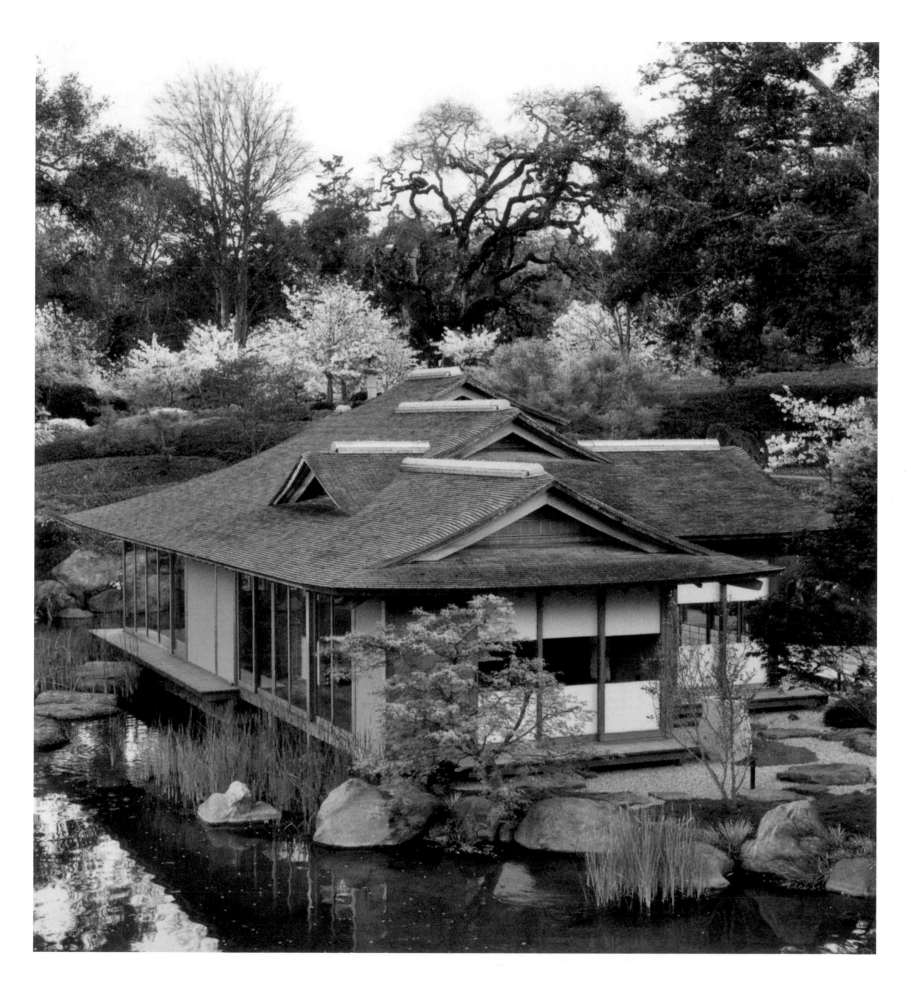

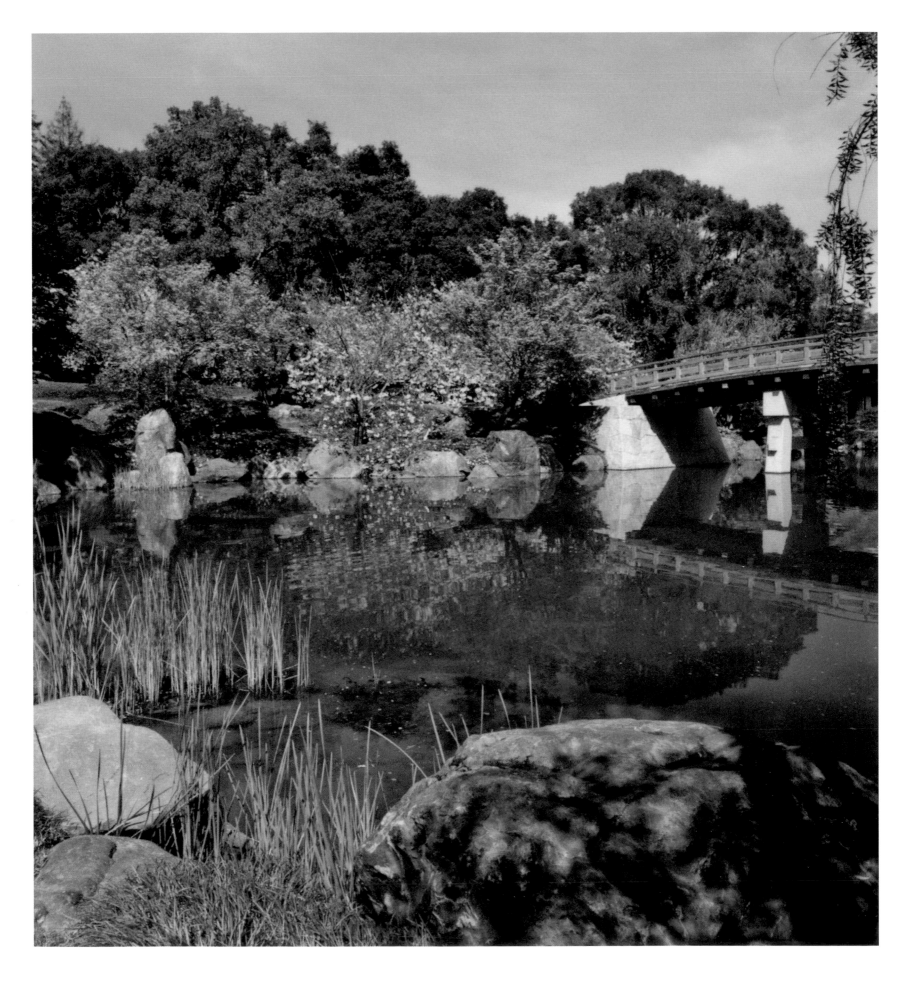

I love Ōkyo. I love his ability to imbue his drawings of animals with personality and a whole range of expressions, even better than other artists in the collections. It is just remarkable, as if Ōkyo knew these animals when they were young, or when they are wistful, as if remembering their youth. I have a number of paintings by William Bougureau (1825–1905) who used to paint pictures of very young girls. One particular favorite is this girl, nine years old, who has mischievous eyes that prompt me to think, "I know she is up to something …! I bet she is going to get caught …!" Ōkyo does that with his animal paintings better than any Western artist I have ever seen. Other artists can capture beauty and movement, but rarely do they catch the personality and the moment something is happening in the mind the way Ōkyo does.

When asked what he hoped a public display of his Japanese art collection would accomplish, Ellison reflected on separate goals for the two different types of audiences. First, for the Asian's regular audience—those who are already familiar with Japanese art—he hopes they will appreciate the masterpieces that have been assembled. Second, for the uninitiated, particularly school children on an outing, he would like to think as they march through, seeing art in the context of a garden, they will encounter something wonderful, and for a few, possibly kindle a lifelong interest in Japanese art.

Looking to the future, Larry Ellison envisions consistent public access to his art collections:

My idea is to create a building that is like a residence converted into a museum. I would like to see art in context with architecture of the period, along with furniture and gardens correct to the period. So the visitor is transported back in time, to a different place, and sees art as it was intended to be viewed. In Japan I have a property called Kaiusō on the grounds of the Nanzenji Temple in Kyoto. That will have a guest house with a garden that will be

open for people to tour. The house will be like a small museum combining art, architecture, gardens, and music, all together. I think that is going to be wonderful.

The traditional Japan that Larry Ellison loves seems far removed from the slick, high-rise, high-tech Japan we see today. Yet, he seems to think that Japan has not changed so much in ways fundamental to its culture. In spite of a crazy real estate bubble in the 1990s, followed by two decades of recession, the Japanese people, he believes, remain the same.

They are still hardworking, smart, and take on the pursuit of perfection unlike any other culture I've ever seen. And it is a joy just to be there and see them make melons better than anyone else's melons. Selling for $140 per melon, theirs is not a pursuit of a market, but a pursuit of perfection… gee, I am going to make this one perfect melon. That pursuit, and the constant awareness of a melancholy sense of the impermanence of all things, are characteristic of this brilliant, unique culture.

If the pursuit of perfection seems a bit obsessive, Larry Ellison readily acknowledges that personality type as characteristic of Japanese people. Moreover, he admires it. "My friend of twenty-five years, Steve Jobs, was certainly obsessive, and compulsive, and I share some of those traits. I have found it is always useful to try to do something perfectly. And Japan is absolutely inspirational in that way. Just look at the way taxis are run, how clean and beautiful, and how precise the trains are, arriving exactly on time, all over the country. I think that pursuit of perfection—that standard for precision—is useful to anyone who is running a business."

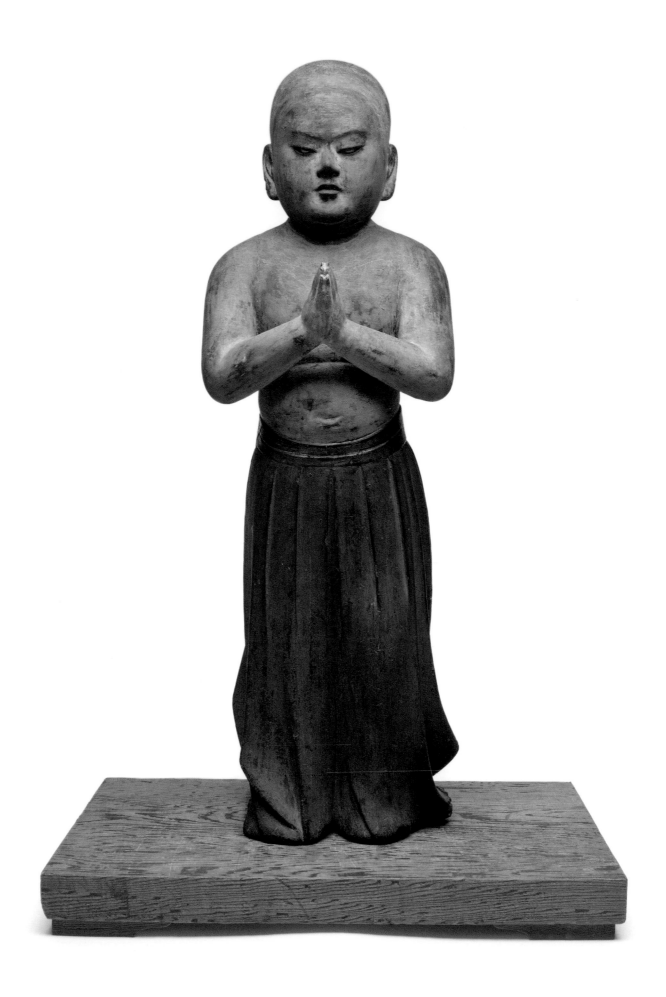

The Larry Ellison Shōtoku Taishi

EMILY J. SANO

The most outstanding work of Buddhist sculpture in the Ellison collection is the standing figure of Shōtoku Taishi as a two-year-old child. It presents him as a pleasingly plump, half-nude boy wearing vermillion *hakama* trousers that billow slightly around his feet, his hands pressed together in the prayerful mode called *gasshō*. The sculpture depicts the moment recorded in the early-tenth-century *Shōtoku Taishi denryaku*[1] when the child took two steps and, facing east, called out praise to the Buddha. Sculptural images in this form—called the "Prince Praising the Buddha," or Namubutsu Taishi—appear for the first time in Japan during the Kamakura period (1185–1333). From the late twelfth century forward to the Edo period, many, many statues of the Namubutsu Taishi were made, and more than two hundred are known today in Japan.

The Ellison Namubutsu Taishi (cat. no. 5) is 27½ inches tall, with inset glass or crystal eyes. His round face has small features and down-cast eyes that give him a gentle, meditative expression. Five Shōtoku Taishi sculptures are known to exist in American public collections, including: the Seattle Art Museum; Princeton University Art Museum;

Indiana University Art Museum; the University of Pennsylvania Museum of Archaeology and Anthropology; and the Fogg Art Museum at Harvard. Among these, for scholars of Japanese art, the most celebrated is the so-called Sedgwick Shōtoku Taishi at the Fogg Museum (figure 1), published by John Rosenfield in *Archives of Asian Art* (1969), both for its quality as a piece of sculpture and because dedicatory documents found inside the statue bear the date of 1292.[2] Experts believe the sculpture dates from approximately that same time.

An X-ray examination of the Ellison statue failed to detect any objects inside, but we look forward to a light-probe examination that will search for inscriptions that could have been made on the interior walls of the hollow sculpture. Yet, even without that documentary material, the Ellison sculpture's superb condition, the flesh-toned paint of the face and body, its delicately carved facial features, and its beautifully proportioned body make this Namubutsu Taishi one of the finest sculptures of this type. The Ellison Namubutsu Taishi closely resembles the Sedgwick piece in many respects, especially in the carving of facial features, strongly suggesting that it, too, dates from roughly the same period, the late thirteenth or early fourteenth century.

PLATE 5

15

Who is this child, how did this image develop, and why did it become so popular during the Kamakura period (1195–1333), five hundred years after the historical Prince Shōtoku (574–622) lived?[3] Over time, Prince Shōtoku acquired many identities that increased his stature as a divine being and led to his personification in many different forms of art and in different stages of his life.

Prince Shōtoku, also known as Shōtoku Taishi, was a semi-legendary regent, who ruled Japan on behalf of his aunt, the Empress Suiko, from 593

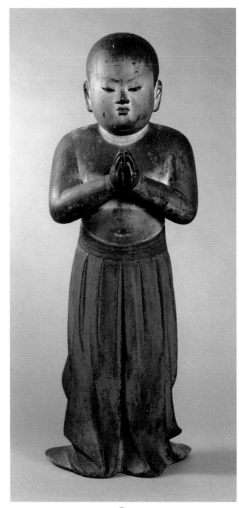

FIG. 1. THE SEDGWICH SHŌTOKU TAISHI

until his death in 622. The major accounts of his life, written years later, describe him as a devout Buddhist and an extraordinary and gifted political figure. Among the few highly educated Japanese men during the seventh century, he learned to read and write Chinese. During this time, he also developed a deep understanding of the tenets of Buddhism and Confucianism, which in turn contributed to his unique approaches to government and social policy.

An ardent devotee who composed commentaries on Buddhist texts, he is credited by modern scholars with founding at least two important temples that exist to this day, Shitennōji in Osaka and Hōryūji in Ikaruga, near Nara. For those reasons, the Japanese remember him as the founder of Japanese Buddhism.

In the secular realm, Shōkoku Taishi receives credit for establishing a "Twelve-Level Cap and Rank System" (603), which allowed a system of government advancement based on merit, and the so-called "Seventeen-Article Constitution" (604), a set of Confucian ethical concepts and principles that applied to the social behavior of the nation as a whole. He also sent some of the first official missions abroad to Korea and to China, and is said to be the first person to refer to Japan as *Nihon*, which means "land of the rising sun."

Shōtoku Taishi died suddenly, when he was but forty-nine years old. Legends about him soon arose, and his reputation as a Buddhist saint spread. Current scholarship on early Japanese history has moved away from the strictly legendary and hagiographic nature of the Shōtoku biography and now focuses on the complex social, political, and religious milieu that encouraged his rapid, posthumous deification. One study suggests that immediately upon his death, to protect their interests within court circles, native Korean "kinship groups" living in Japan promoted Shōtoku Taishi as a saint and the founder of Japanese Buddhism.[4]

That same study notes that images of Prince Shōtoku also started appearing soon after his death, with their number increasing as time went on and the hagiographic status of Shōtoku Taishi grew. For example, some believe that the long-hidden seventh-century Yumedono Kannon at Hōryūji was created in the prince's likeness in size to appease the gods, who may have been angered by Shōtoku's death.[5]

The earliest known Japanese painting of Shōtoku, dating to the eighth century, shows the prince flanked on one side by his younger brother, Prince Eguri, and on the other side by his first son, Prince Yamashiro. This image, said to portray Prince Shōtoku as a Confucian statesman, graced the Japanese ten thousand–yen note until 1986.

Confucian sources also contributed to the development of Kōyō Taishizō, or "Shōtoku Offering Filial Piety Images," which show the prince as a sixteen-year-old youth holding a censer. This image relates to the story that the prince stayed by the side of his father, Emperor Yōmei, when he fell ill, praying until the emperor recovered.

The earliest images of this type exist within sets of paintings of Tendai patriarchs, such as the eleventh-century set from Ichijōji Temple in Hyōgo Prefecture.[6] Tendai Buddhism originated in Japan in the seventh century, when the Japanese monk Saichō founded the sect based upon studying the Lotus Sutra with the Chinese priest Huisi at Mount Tiantai in China. Since Huisi died in 577, just a few years before Shōtoku Taishi's birth, Tendai monks came to promote Shōtoku Taishi as the

reincarnaton of Huisi. They then focused their beliefs on the historical incident of the prince's act of filial piety. Images of the sixteen-year-old Shōtoku Taishi, in both painted and sculpted form, were made in large numbers during the Kamakura and Muromachi periods.

Early Japanese Buddhism flourished in the hands of monks who rose from Japan's elite class. They resided in great monasteries and served as intermediaries with divine beings. Buddhism was also taken up by monks who lived among the people, not in large monasteries, and they began to preach Buddhist teachings to common people. As admiration of continental models of statesmanship led the court to build roads and bridges around the country, monks who identified with Shōtoku cults began to travel the country outside the capital to teach and to build temples.[7] Michael Como discusses the activities of one monk, Gyōki (668?–749), who traveled the country organizing lay believers to perform meritorious works. In so doing, he helped strengthen the awareness of Shōtoku worship among the populace at large.

But the primary reason Shōtoku Taishi became important in Japan was because of his association with belief in Pure Land Buddhism, which came to dominate religious practice throughout the country during the medieval period. Developments in the Pure Land sect that flourished on Mt. Hiei during the Heian period contributed to stronger association of Shōtoku Taishi with the beliefs of Pure Land Buddhism than had existed before. Especially through the unorthodox practices of the monk Shinran (1173–1263), who first studied with the venerable Pure Land priest Hōnen (1133–1212), Shōtoku Taishi came to be revered as an incarnation of the Compassionate Bodhisattva, Avalokiteshvara (Japanese: Kannon). Shinran explained this association by recounting how Shōtoku Taishi appeared to him in a dream as Kannon, and spoke of the need to teach all people they could achieve salvation by simply calling upon the name of Amitabha (Japanese: Amida), Buddha of the western Paradise. In addition, he received the message that Shōtoku Taishi was the first Japanese person to be reborn into the Pure Land paradise of Amida Buddha.[8] Shinran went on to found the Jōdo Shinshū sect of Pure Land Buddhism, which singled out Amida Buddha as the primary object of worship, and promoted belief in the *nenbutsu* practice as the path to salvation, and rebirth into Paradise.

Shinran was active as a preacher during the beginning of the Kamakura period, and the number of his converts increased, including many women.

Unlike other sects of Buddhism that did not consider the salvation of women significant, Pure Land sects supported the welcoming of women into Amida's paradise. For men, as well as for women, the appeal of easy salvation by simply reciting the *Nenbutsu*—"All praise be to Amida Buddha"—found many grateful followers of the Pure Land sects, and their devotion inspired the need for iconic images, including images of Shōtoku.

Although hundreds of statues portraying the Namubutsu Taishi exist, the origin of the image is unclear. Its appearance seems to go hand in hand with the development of sets of large painted scrolls, the *Shōtoku Taishi eden*, which began to appear in the Kamakura period as visual references for priests who recited events of the life of Shōtoku Taishi to teach salvation to the masses.

In two examples of the *Shōtoku Taishi eden* dating to the Kamakura period, the prince as a two-year-old child appears in an interior setting, with one or both or one of his parents, as he faces forward, toward the east (figs. 2 and 3).[9] Dressed in a pair of Japanese-style trousers called *hakama*, and nude from the waist up, the palms of his hands pressed

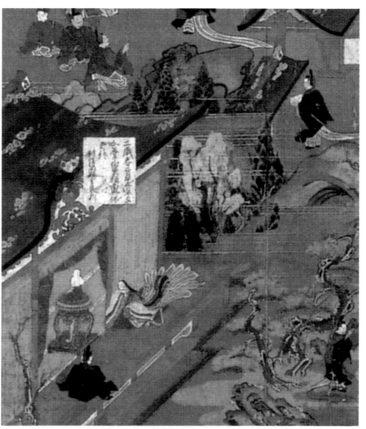

FIG. 2. *SHŌTOKU TAISHI EDEN*. SCROLL 1 (DETAIL). 16TH CENTURY. COLLECTION TACHIBANA-DERA, NARA PREFECTURE.

FIG. 3. *SHŌTOKU TAISHI EDEN*, SCROLL 1 (DETAIL), 14TH CENTURY. COLLECTION HONSHŌ-JI, AICHI PREFECTURE.

together in prayer, the prince calls out to praise the Buddha. It is said that at that moment, a relic, a bit of bone from the back of the historical Buddha Shakyamuni, fell from the little Prince Shōtoku's hands. Although this story is apocryphal, the relic is said to still exist today, enshrined at Hōryūji.

Such devotion to a legend is remarkable, but recent scholarship has clarified the reasoning behind the development of this image in the Kamakura period. Looking at the earliest example of a child divinity in Japan, the eighth-century gilt bronze image of the Buddha at birth at Tōdaji, it is apparent that it was the model for the two-year-old Prince Shōtoku, dressed in the same manner in hakama trousers, and similarly nude from the waist up. In the Birth of the Buddha legend, it is believed that at birth, emerging from his mother's side as she walked in a garden, the new-born Shakyamuni took seven steps and raised his hand to declare himself ruler over heaven and earth. In the late Heian and Kamakura periods, it seems that parallels were drawn between the two-year old prince and the infant Buddha in order to further burnish Shōtoku's credentials. The on-going effort to equate Shōtoku Taishi with the historical Buddha, Shakyamuni, was intended to raise his profile as a divine leader even above the Chinese Tiantai monk Huisi, or the compassionate Bodhisattva Kannon.

Although we cannot be sure, it seems likely that the painted image of the Namubutsu Taishi preceded the production of the first sculpted images. A record of a Namubutsu Taishi dating to 1210 exists[10] but the earliest extant dated sculpture of the Namubutsu Taishi type remains the Sedgwick Namubutsu Taishi at the Fogg Museum at Harvard, which, as noted above, can be dated to 1292 on the basis of internal documents. The Ellison Nambutsu Taishi belongs to the same early period, around the end of the thirteenth to the beginning of the fourteenth century.

Kevin Carr makes a strong case for the enduring Japanese love of Shōtoku Taishi as a divine being. Unlike other monks and deities, who came from the continent, Shōtoku Taishi was a native Japanese and a historical person, who acquired a continental lineage, but was still someone they could hold dear as one of their own native gods. The popularity of the image is understandable. Even today this appealing child with his round face and small features captures the sweet innocence one associates with very young children, and a level of faith that inspires our trust.

NOTES

1 *Shōtoku Taishi Denryaku* ("Biography of Prince Shōtoku"), compiled in the tenth century, is the primary source for the legendary Prince Shōtoku. The text is available in Dai-Nihon Bukkyō zensho, Vol 71, *Shindenbu* 10, 142c–143c. For a list of the legendary events ascribed to Shōtoku Taishi, based on the *Shōtoku Taishi Denryaku*, see Appendix B in Carr, Kevin Grey. Unpublished PhD dissertation (Princeton University), 544–548.
2 Rosenfield, John M., "The Sedgwick Statue of the Infant Shōtoku Taishi," *Archives of Asian Art* 22 (1968–1969), 56–79.
3 *Nihon Shoki* (Chronicles of Japan), compiled in 720, has details of the life of the historical Shōtoku Taishi. For a list of the events recorded in the *Nihon Shoki*, see Carr, Kevin Grey. Unpublished PhD dissertation (Princeton University), Appendix A, 541–543.
4 See "Inter-ethnic Conflict and the Shōtoku Cult" in Como, Michael, *Shōtoku: Ethnicity Ritual, and Violence in the Japanese Buddhist Tradition* (New York : Oxford University Press, 2008), 22–24.
5 Ibid., 35.
6 *Shōtoku Taishi ten*, entry no. 128, shows a detail of a scroll picturing the youthful Prince Shōtoku holding a censer. The scroll is part of a set of paintings on the Ten Tendai Patriarchs, indicating that in Tendai belief, Shōtoku Taishi was regarded as one of the patriarchs.
7 Como, Michael, *Shōtoku: Ethnicity Ritual, and Violence in the Japanese Buddhist Tradition.* (New York: Oxford University Press, 2008). See "Shōtoku and Gyōki," 111–132.
8 Lee, 12–13.
9 *Shōtoku Taishi ten*, entry no. 168, detail from Shōtoku Taishi eden, scrolls, Kamakura period, fourteenth century. Honshoji Temple, Aichi Prefecture. Also, entry No. 164, Shōtoku Taishi eden, Muromachi period, sixteenth century, Tachibana-dera, Nara.
10 See Carr, Kevin Grey. Unpublished PhD dissertation (Princeton University), 128–129.

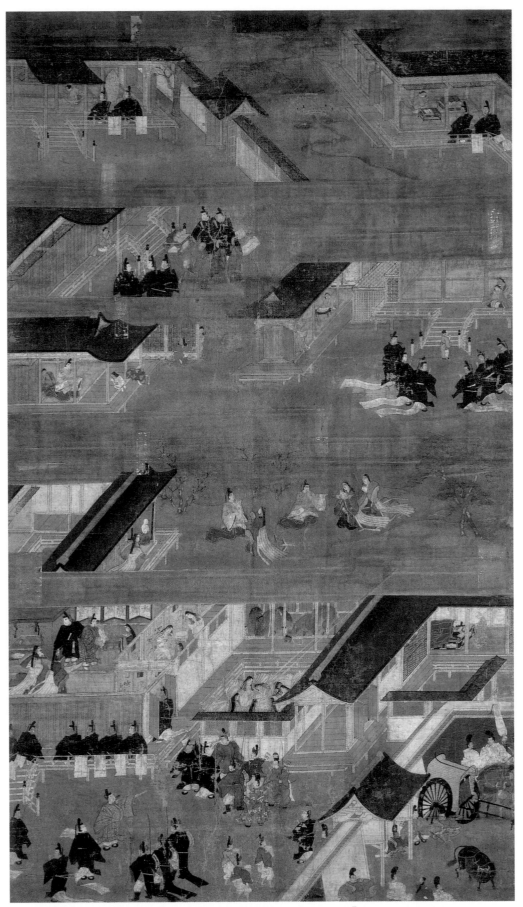

FIG. 4. *SHŌTOKU TAISHI EDEN*, SCROLL 1, 14TH CENTURY. COLLECTION HONSHŌ-JI, AICHI PREFECTURE.

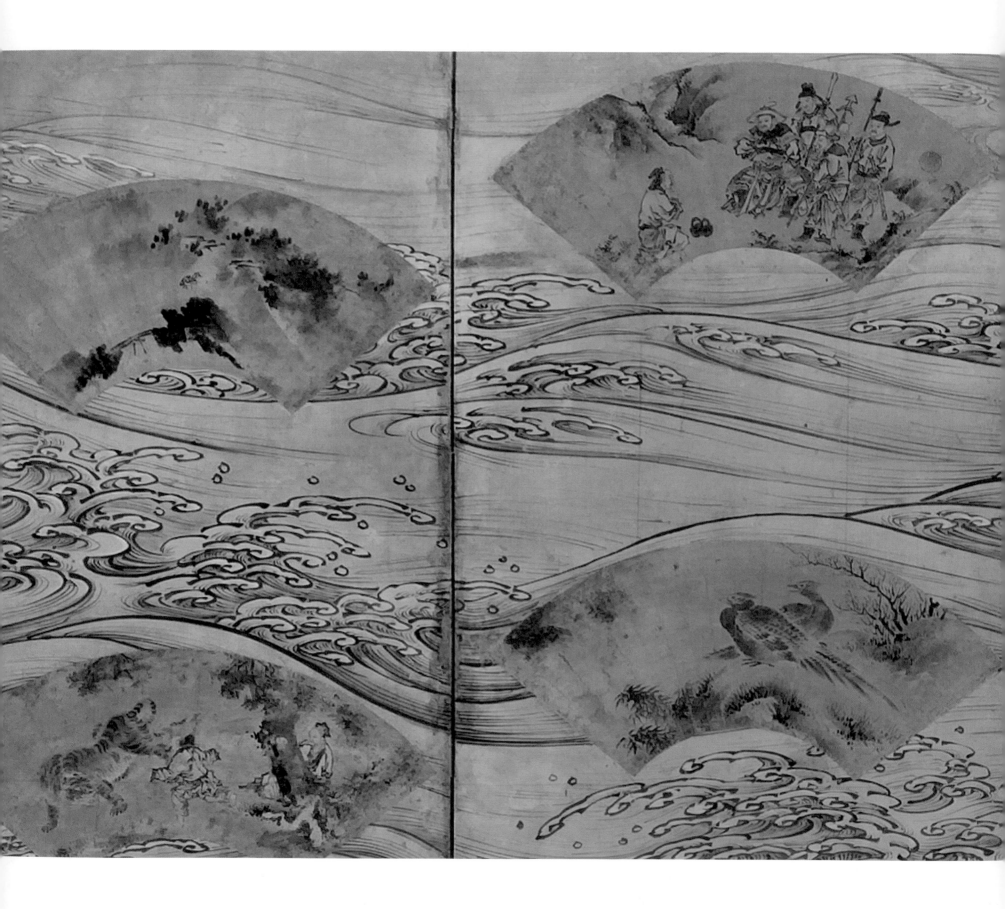

Masterworks of Kano Workshop Screen Paintings in the Larry Ellison Collection of Japanese Art

MATTHEW P. MCKELWAY

One of the keys to the overwhelming success of the Kano school, a network of workshops of blood-related painters active in late medieval and early modern Japan, was its ability to master virtually any subject matter or medium, from Buddhist icons, to room paintings in monochrome ink or in brilliant colors and gold, to narrative handscrolls and lacquer design. The first true history of Japanese art, *History of Painting in This Realm* (*Honchō gashi*), itself written by a Kano painter, Kano Einō, notes how the true founder of the Kano enterprise, Kano Motonobu (1476–1559), mastered a wide range of painting subjects by fusing Japanese and Chinese themes and methods of painting.[1] Armed with an enormous arsenal of subject matter, the execution of which was perfected through a highly organized and hierarchical studio system, painters of the Kano school dominated artistic production for the warriors, the imperial court, temples, and other major patrons of late medieval and early modern Japan.[2] The founder of the Kano school, Masanobu (c.1434–c.1530), produced Buddhist images, landscapes in monochrome ink, and images of native scenery, but in the generations of painters who succeeded him, such as Motonobu, Shōei (1519–1592), and Eitoku (1543–1590),

their workshops quickly expanded their repertoire to include depictions of everyday life, paintings of the natural world, and illustrations of tales and legends. By the end of the sixteenth century, Kano painters led the way in the adoption of such new subjects as depictions of European visitors to Japan and cityscapes. No other school of Japanese painting, and few others in the history of art worldwide, attempted images of such a broad thematic range. By the late seventeenth century, Kano painters dominated virtually all fields of image production in Japan, monopolizing commissions, the training of painters, and treatises on painting.

Among the works featured in the present exhibition of Japanese art are several distinguished works of painting on folding screens (*byōbu*) that painters of the Kano school produced between the late sixteenth and mid-seventeenth centuries. The subject matter of these works runs the gamut of themes and approaches to painting produced by the Kano workshops, offering an instructive glimpse into their art. They include works that refer directly to Chinese paintings and literature, to Japanese literary classics, to depictions of the natural world, and depictions of everyday life. The following essay will survey these paintings on folding screens.

PLATE 15 (DETAIL)

21

Paragons of Filial Piety, Birds and Flowers, and Landscapes

Thirty-six folding fans are arrayed across this pair of six-panel folding screens (cat. no. 15). The fans seem to float above a sea of waves that undulate evenly over the painting surfaces. Three patches of reeds arranged along the lower edges of the screens both pull the viewer into and act as a barrier to this dreamlike seascape. At once both a depiction of a body of water and a surface—or pictorial frame—for the display of smaller pictures on fans, the screens exhibit the height of Kano painters' creativity and imagination in the first century of their enterprise.[3]

As early as the fourteenth century, Japanese painters produced screen paintings to which fans were attached, according to references in a courtier's diary from the period.[4] The particular combination of wave-painted screens with attached fans emerged from the practice of pasting fans on screens, but appears as a named motif, *ōgi-nagashi* ("flowing fans"), in documentary references to textile design before painting.[5] Fans depicted in *maki-e* arranged fluidly across the surfaces of lacquer objects dating to the fifteenth century exemplify the cross-pollination of designs in different media in medieval Japan. The earliest examples of screen paintings of waves with attached fans (*ōgi-nagashi byōbu*) survive from the sixteenth century, sometimes combining older, used fans on screens newly prepared for their display. In some examples the fans lack telltale creases, which indicates that they were never used as actual fans. Screen paintings to which fan paintings, originally folded, from a single set were attached preserve the serial nature of some subject matter—the chapters of the *Tale of Genji*, for example. *Ōgi-nagashi* screens upon which fans from a cohesive group were affixed are exceedingly rare. The present pair is one example.

The thirty-six fan paintings are arranged evenly, three to a panel, and their positions are staggered so that their overall arrangement visually echoes the gentle rise and fall of the waves painted on the screens beneath. The fans' subject matter comprises twenty images of human figures, ten of birds, two of animals, and four landscapes. Fans with figural images generally alternate with those with other subjects, hinting at a deliberate effort to create an internal dynamism in their arrangement on the screens. All thirty-six images were executed on paper coated with a thin layer of powdered mica (J: *unmo*; *kira*) over which the images were painted in monochrome ink, and to which a

light layer of gold wash (*kindei*) was brushed primarily in the negative spaces. The combination of ink, gold, and mica lends the images a silvery sheen and material sumptuousness. The expertly drafted images, painted in crisply brushed, self-assured strokes, point to a seasoned, professional hand. The fan paintings also have a consistent number of creases. The only major difference among them other than their subject matter is that the figural images bear identical round seals reading "Kuninobu," while the others have no seal impressions. In spite of this discrepancy, the fans' commonly shared medium, size, condition, and style all suggest that they were originally conceived as a set produced by a studio led by Kano Eitoku, the late sixteenth-century Kano master who used the "Kuninobu" seal. The rolling and cresting waves, brushed in long, uninterrupted strokes, also display the dynamism and confidence of Eitoku's mature works, and at least to this writer's eye, it is possible that he painted them. The active, modulated lines of Eitoku's churning waters form a harmonious backdrop for the monochrome fan images that drift above. Compared to other examples of "fans on flowing water" screens, the present pair exhibits an unusual degree of visual cohesion in which monochrome ink fan paintings float on an expanse of expertly painted waves in monochrome ink.

Fan paintings from each of the main subject categories illustrate the ways in which the Kano workshops mastered diverse pictorial subjects and disseminated them among their patrons. They also point to a process of pictorial canonization that occurred in Japan in the waning years of Ashikaga rule. Specifically, the fan paintings demonstrate processes of copying and disseminating famed subjects and images derived from Chinese antiquity. Surveying the fan images more closely to see what kinds of subjects are depicted, we discover that the various subjects present a virtual catalogue of themes that the Kano workshops mastered in the sixteenth century. Kano painters produced them on other formats, such as sliding panels for temples and residences, as well. The bird and animal subjects include pheasants, mynahs, sparrows, chickens, a Daurian redstart, a heron, geese, a bulbul, swallows, golden pheasants, civets, and oxen. Four landscapes are executed from varied perspectives and in varied brush modes. The twenty figural images illustrate episodes from the *Twenty-four Paragons of Filial Piety*, a Yuan-dynasty text compiled by the scholar Guo Jujing based on the famous Confucian text *Classic of*

Filial Piety (C: Xiao Jing) of the late Zhou dynasty. Judging from the overall unity in style, material, and condition, it would appear that the fans come from at most two or three larger sets sharing a common subject or range of subject matter. The presence of seals on approximately half of the images (all depicting the *Paragons*) and not on the remainder might suggest that the fans were once paired with Paragons images on the front and images of birds, animals, or landscapes on the back.

What do the fans tell us about the relationship between the Kano school's ever-expanding painting repertoire, its fan-painting business, and the function of fans as a medium for developing visual images? To begin with, we should examine the largest set of fans on the screens, the depictions of Paragons of Filial Piety. These episodes include, in the order in which they appear on the screens, right to left, the following: (1) Filial Shun plowing with elephants, (2) Lao Laizi entertaining his parents, (3) Dong Yong and his mother leaving for the realm of immortals, (4) Min Ziqian pleading for leniency for his cruel stepmother, (5) Meng Zong searching for bamboo shoots, (6) Zeng Shen rushing home to aid his mother, (7) Jiang Shi and a bubbling spring of fresh water, (8) Wu Meng attracting mosquitoes to drink his blood, (9) the three Tianzhen brothers looking up at a tree, (10) Yu Qianlou praying to the Pole Star, (11) Zhu Shouchang resigning office to search for his mother, (12) Lu Ji explaining the dropped oranges to Chief Minister Yuan Shu, (13) Huang Shangu serving his mother, (14) Huang Xiang fanning the pillow, (15) Ding Lan serving wooden statues of his mother, (16) Lady Tang nursing her mother-in-law, (17) Jiang Ge confronting bandits, (18) Emperor Wen of Han personally checking his mother's medicine, (19) Yang Xiang wrestling a tiger to save his father, and (20) Wang Xiang lying on the ice to catch carp for his stepmother. Each of these narrative images focuses on no more than a few figures depicted in three-quarters frontal view, and framed by a building, trees, or other landscape elements. These stage set–like vignettes of the *Twenty-four Paragons* stories include only the most essential visual elements of each episode, a formula for portraying narrative moments that allowed painters to expand or compress the images into a variety of formats.

Unsurprisingly, given the Kano workshop's reliance on picture manuals and copybooks for image production, the Twenty-four Paragons images appear in other paintings by Eitoku and other masters of the Kano school, including Eitoku's father, Shōei. Although these images differ in format, medium, and size, and are painted on folding screens and sliding partitions in monochrome ink, and fan paintings painted with colors and gold, they share similar compositions that point to a shared source, either painting manuals that no longer survive, or lost Chinese paintings.[6] The Twenty-four Paragons fan paintings show that this subject matter was part of a standardized pictorial repertoire. Their production on folding fans also suggests that these images were valued for the visual and narrative pleasure they brought their owners, who could recount the stories of children caring for their parents—or perhaps learn them—from the images they possessed, and not solely for the didactic character of the Confucian texts upon which they were based.

The fan paintings of birds, animals, and landscapes illustrate equally compelling ideas about how Kano Eitoku and painters in his circle mastered subjects and drew upon visual connections to older images. An image that at first appears to be a generic Chinese landscape in the "splashed-ink" mode of coarse brushwork and broad ink gestures coheres to form a picture of a bridge and two figures climbing a path toward buildings in thickly forested hills (p. 20). Another image depicts a wave and cliff in similarly abbreviated brushwork. On another fan two sparrows perch on a barren limb. All three images are derived from Chinese paintings that formed part of the Ashikaga shoguns' personal collections that had been amassed since the fourteenth century, and are copied by late Muromachi period Japanese painters. The landscape reworks into the curved space of the folding fan "Mountain Market, Clearing Mist," one of the *Eight Views of Xiao and Xiang* by the Southern Song painter Yujian. The Chinese painting, originally part of a handscroll that was later subdivided and remounted as eight hanging scrolls, was a treasured work that had been passed down in the Ashikaga collection for generations until the shogunate's demise in the 1570s, after which it circulated among the collections of powerful warlords.[7] The fan painting of a cliff and wave (fifth panel, left screen) undoubtedly approximates Yujian's famed "Cliff and Wave," another famous work from the Ashikaga collection. The sparrows come from a vertical hanging scroll painting, *Sparrows in Bamboo* (Nezu Institute of Fine Arts), attributed to the Song monk-painter Muqi; this work bears the *zakkeshitsuin* seal that indicates that it was in the collection of the Ashikaga shoguns from

the early fifteenth century. Muqi's works were especially revered in the intersecting worlds of Zen Buddhism and Tea in late medieval Japan, and the existence of another nearly identical fan painting of the same Muqi-based sparrow picture shows the diligence with which Kano painters replicated such images and hints at the demand that existed for copies of Muqi's painting.[8]

It is the world of Tea, recorded in diaries of tea gatherings, that offers the most suggestive evidence for the desirability of Chinese images that might have encouraged painters to produce copies on folding fans. The tea master Yamanoue Sōji features the *Eight Views* by Yujian prominently in his diary, *Yamanoue Sōji ki*, highlighting its cultural importance among Japanese connoisseurs.[9] Following Tani Akira's research on the display of paintings in tea gatherings, it is clear that Yujian's "Mountain Market, Clearing Mist," was a prominent article of display at tea gatherings as early as 1567 (Eiroku 10), around which time it appears to have left the Ashikaga collection.[10] Its display at one event merited its inclusion in a quick sketch in Tennōjiya Sōkyū's account *Tennōjiya Sōkyū dōgu haiken ki*.[11] "Cliff and Wave," which had been divided into two hanging scrolls during the rule of Ashikaga Yoshimitsu (1358–1408), entered the collection of Imai Sōkyū (1520–1593), and it is mentioned repeatedly in tea diaries from the mid- to late sixteenth century.[12] The painting was reportedly among a group of tea utensils that was brought to the temple Honnōji for a gathering to be hosted by Oda Nobunaga in 1582, and was thus believed to have been lost in the fires that engulfed the temple when Nobunaga was assassinated there.[13] The fact that paintings by Yujian and Muqi, including "Mountain Market, Clearing Mist" and "Cliff and Wave," circulated among tea practitioners after they left the Ashikaga collection ensured for them a vaunted place among Chinese images, and narrates the emergence of a common visual experience, in which revered masterpieces could now be owned, recognized, and understood by more people. Fan paintings, wielded in the social lives of their possessors, occasioned a form of access to works that were once secret and exclusive, in a process to which we can discover parallels in the development of Tea, which itself generated a demand for images for display at tea gatherings. The reimagining on fans of Chinese masterpieces in the shogunal collection may have contributed to a nascent pictorial canon that propelled and legitimized the Kano atelier's monopoly on painting.

Kano Sōshū: *Scenes from* The Tale of Genji

Another way that the Kano sought to assert their dominance in the painting market of the late sixteenth century was to master pictorial subjects that had been the purview of other schools of painting. These subjects included portraiture, classical tales, and legends of the karmic origins of temples and shrines, all of which had been produced by painters of the Tosa school and several other hereditary workshops that specialized in indigenous paintings subjects and were active in Kyoto in the fifteenth and early sixteenth century.[14] Aside from their numerous portraits of priests and warlords, Kano Motonobu and his followers' narrative handscrolls in the *yamato-e* mode, combining bright colors and abundant use of gold, vividly illustrate the process by which they widened their repertoire. *History of Painting in this Realm* acknowledges this synthesis, stating in the section titled "Ga-un" (Ways of Painting) that the

> Kano merged *yamato-e* with *kanga*. In the Tosa's *yamato-e* style, emotiveness and lustrous glamour are found. When drawing faces— of adults and of children alike—this was completed with lines representing the nose and the mouth (the nose and the mouth are comprised of a singular brushstroke executed with a light touch. *Yamato-e* painters refer to this as *hikime-hikihana*).[15]

Although no known paintings on large formats of classical tales such as *The Tale of Genji* survive from the first two generations of Kano painters, it is clear from extant works and documents that members of Kano Eitoku's generation produced them. Eitoku is reported, for example, to have produced a pair of screens depicting scenes from *The Tale of Genji* that his patron, Oda Nobunaga, sent to his rival warlord Uesugi Kenshin in 1574.[16] The screen paintings depicting Genji scenes attributed to Eitoku now in the Imperial Collection were originally in the collection of the Hachijō princes (*Hachijō no miya*), and were mounted as sliding partitions for their residence. A recently discovered pair of screens by Eitoku's younger brother, Kano Sōshū (1551–1601), makes an important addition to the small corpus of early Kano workshop pictures of the *Tale of Genji* on large painting formats (cat. no. 16).

The screens present scenes from seven chapters of the novel. Framed by a tall pine tree at the right edge of the right screen, they proceed as follows: (right screen; clockwise, right to left) Chapter 23, "Warbler's

First Song"; Chapter 3, "Cicada Shell"; Chapter 8, "Under the Cherry Blossoms"; (left screen; clockwise, right to left) Chapter 39, "Evening Mist"; Chapter 28, "Typhoon"; Chapter 45, "Maiden of the Bridge"; and Chapter 51, "A Drifting Boat."[17] Although the scenes represent seven distinct moments in the novel, they occupy uneven amounts of space and do not follow the order of the chapters. The painter of the screens has nevertheless arranged them in a way that suggests scenes that are linked together by continuous clouds of gold, trees, and landforms, framed by buildings. Other than the pine tree, several other trees assist in articulating the screens' compositional structure: plum trees reach across a body of water in the upper center of the right screen; a willow bends in the wind in the left foreground; cherry trees bloom above the willow. In the left screen red-leafed maple trees, pines, and orange trees perform the same function. Each of the trees signals to the viewer a change of season, so that we advance from the plum blossoms of early spring to willows and cherry trees in the right screen, and from autumn maples to winter oranges in the left screen. Seasonal change, then, becomes the screens' driving narrative impulse, rather than the actual way the story unfolds in the novel. When examined closely the screens reveal the depth of their compositional complexity.

The first three panels of the right screen open with a New Year's scene from the "Warbler's First Song" chapter (p. 26). The open pavilion reveals Genji, seated at left, at the apartments of his daughter, the Akashi princess, who sits at right. Before them are an unrolled scroll of rose-colored paper with a poem, and a basket of New Year's delicacies sent by the princess's mother, the Akashi Lady, who resides in another wing of Genji's Rokujō Palace. Page girls and attendants occupy themselves with gathering pine seedlings in the garden below. Beyond some fences and the willow tree in the fourth panel, we move back in time to Genji's youth. Here, Genji spies the Lady of the Cicada Shell (Utsusemi) through the lowered blinds of her residence, where she is playing *go* with her sister. In the upper portion of the fifth and sixth panels we find Genji and Oborozukiyo, the "Lady of the Misty Moon," near a veranda looking out over blossoming cherry trees and a crescent moon in the night sky. The scenes with Utsusemi and Oborozukiyo function as flashbacks for the New Year's scene at the Rokujō Palace—Genji could be reckless in his youthful affairs, but becomes the respected head of a large household after his exile.

In the left screen the painter has depicted four scenes that center on the escapades of Genji's descendants: his son Yūgiri; Kaoru, who passes as Genji's son but whose birth was the result of an illicit affair between Genji's principal consort, the Third Princess, and a character named Kashiwagi; and Prince Niō, the Akashi Empress's son and thus Genji's grandson. Each scene is shaped around a specific seasonal reference. In the "Evening Mist" scene at upper right, Yūgiri gazes out at deer in a harvested field. In "Typhoon" immediately below it, Yūgiri peers through some blinds at his father's wife Murasaki, who watches as her ladies-in-waiting attend to a garden abloom with chrysanthemums. Winter takes over in the last two scenes, where we find Kaoru spying on the daughters of an imperial prince in "Maiden of the Bridge," and Niō with Ukifune on an icy river in "A Drifting Boat." Beyond the seasonal contrast with the scenes in the right screen, those in the left screen share the common theme of the frustrated or thwarted romances of Genji's descendants, implying that none of them can measure up to the exploits of the Shining Prince. What at first appears to be a disordered series of vignettes arranged according to season thus becomes a carefully selected and structured image that, in contrasting Genji's exploits to those of his descendants, echoes the general tenor of the Tale itself, which grows in melancholy as it searches for a conclusion.

The painter of the screens has been identified as Kano Sōshū partly on the basis of an urn-shaped seal impression in the lower left corner of both screens. The seal is inscribed with Chinese characters that read "Genshū" (or "Motohide"), which was Sōshū's original name.[18] Sōshū employs several visual conventions that had become common in *Genji* images by the Momoyama period. The figures' facial features are simplified, and they are depicted wearing sumptuous garments; rooftops are removed to reveal interior scenes that are depicted on planes formed by high-pitched diagonal ground lines; gold clouds divide the narrative spaces. At the same time, traces of Sōshū's Kano training surface throughout the screens. The large, framing pine and willows are executed in the same sinuous form as those in other Kano workshop paintings such as Eitoku's screens in the Imperial Collection, and the texturing of the rocks and the rendering of the brushwood fence and maple trees closely resemble those in Sōshū's screens of *Birds and Flowers of the Four Seasons*.[19] Aside from these stylistic features, certain anachronistic details also

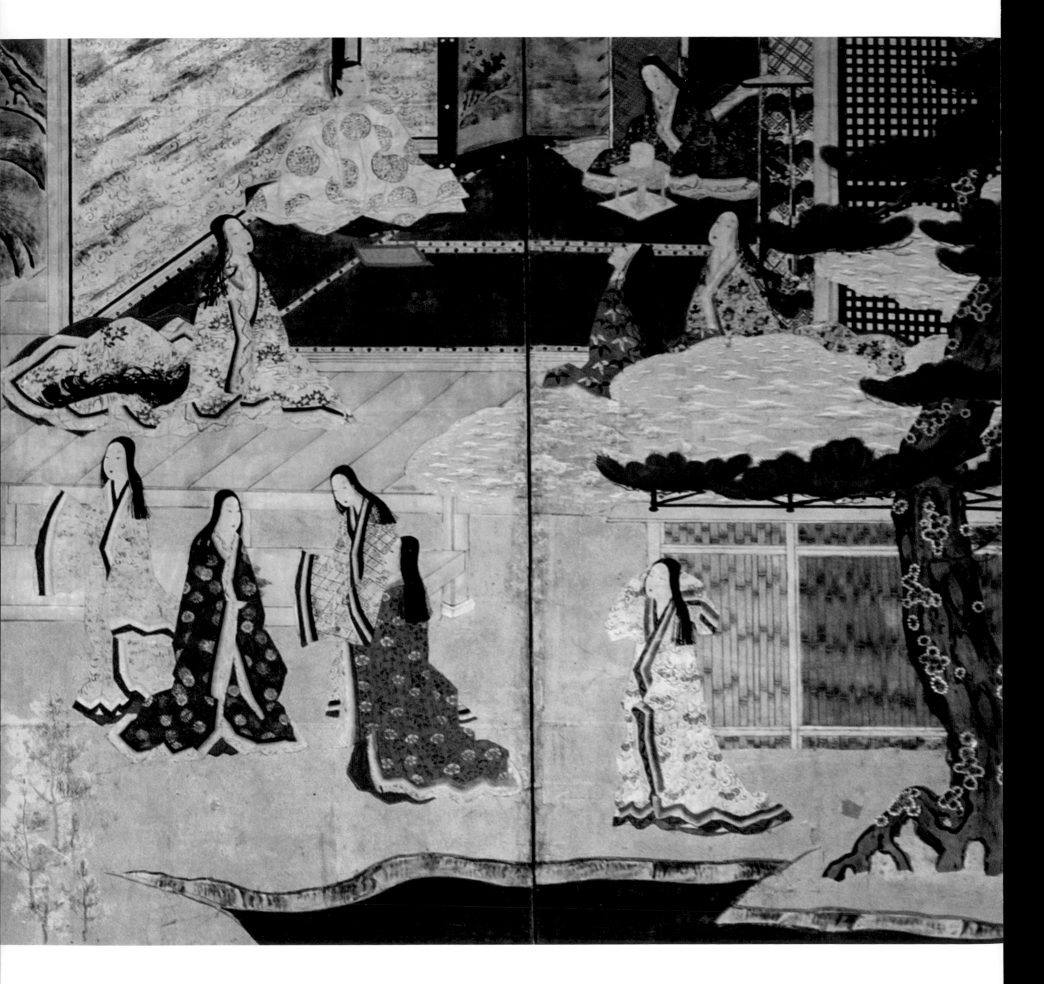

point to the relative newness of classical tales as part of the Kano painting repertoire. A folding screen with a Chinese-style landscape in splashed ink in the "Warbler's First Song" scene, for example, would seem out of place in an eleventh-century interior. The rooms themselves are completely covered with tatami mats, a furnishing that was used in the Heian period but that did not become a standard floor treatment until later in the Muromachi period. Although the women are all depicted wearing the classic twelve-layered robes of the Heian period, none of the ladies-in-waiting are shown with outer aprons (*mo*), a standard feature of their dress in earlier examples of *Genji* paintings. Such idiosyncrasies of Sōshū's screens do not detract from the sheer sensual appeal of their brilliant colors, gilded surfaces, and inventive composition.

Kano Jinnojō. *Battles of Ichinotani and Yashima,* from the *Tale of the Heike*

A major and not unexpected drawback of the Kano studio system, as mid-Edo period (1603–1868) critics and rival artists would eagerly point out, was a resultant lack of originality in expression, a side effect of generations of tirelessly copying other images. While this was the case by the mid-eighteenth century, in its nascent stages up to the late seventeenth century the Kano school produced vivid, clearly structured images that were immediately accessible to their patrons. The growth of cities and urban economies that attended Japan's political unification in the late sixteenth century, along with the Kano school's success, saw a proliferation of themes, or genres of painting, especially on folding screens. Along with new paintings that depicted the capital city of Kyoto (*rakuchū rakugai zu*) and older themes like the *Tale of Genji*, Kano painters led the way in depicting exotic European visitors in Nanban ("southern barbarian") screens, as well as other images of everyday life. Painters of the Kano school initiated most of the major genres of painting that developed in late sixteenth-century Japan.

Like any system that required years of apprenticeship to produce a work worthy of the studio, the Kano ateliers generally, but not always, subsumed individual artistic identity within the larger purpose of studio production. The nature of their patronage also appears to have discouraged the open assertion of something like artistic identity, since the superior social status of the patron would normally preclude the obvious or prominent placement of signatures or seals on finished works. While fan paintings from the Kano studios often feature seals bearing the names of painters who otherwise receive scant mention in the historical record of treatises and other accounts, large-scale works like folding screens were usually executed by a team of painters and more commonly bear the seals of the head of the studio, or of another hereditary member who held a similarly prominent position. Paintings on walls and sliding partitions, by contrast, almost never feature such marks of individual artistic identity before the eighteenth century. It may be assumed, therefore, that when a pair of screens does bear the seals of an artist, that artist must have been a painter of note.

The pair of screens *The Battles of Ichinotani and Yashima* illustrates the practices and habits of production outlined above. Like the screens of *The Tale of Genji* by Kano Sōshū, they depict episodes from a work of classical literature (cat. no. 17). Illustrated on them are two major battles between the rival Minamoto and Taira clans recounted in the early medieval *Tale of the Heike*. This anonymous, quasihistorical account of the rise and fall of the Taira clan in the twelfth century gained popularity in Japan through its recitation from memory by wandering blind minstrels called *biwa hōshi*. Although *Heike* battle scenes were the subject of paintings on screens and other formats before the present example was produced, the present pair, for reasons that will be discussed below, marks a key moment in the development of the theme.

The screens bear impressions of the same urn-shaped relief seal reading "Genshū" ("Motohide") that appears on the *Tale of Genji* screens, but here they are stamped on opposite ends of the composition, in the more common positions in the lower right corner of the right screen and lower left corner of the left screen. These seals appear on paintings by Kano Sōshū, including several fan paintings depicting scenes of Kyoto, but on the basis of stylistic analysis and comparison to other works, the *Heike* screens should be considered the work of Kano Jinnojō (dates unknown; active early seventeenth century), a son of Kano Sōshū who sometimes used his father's "Genshū" seal.[20] Although scholars of Japanese art have not yet attempted a systematic study of Kano school seal use, the evidence from extant works supports the idea that it was not unusual for painters who led the central, hereditary atelier to use their fathers' seals while in their youth.

PLATE 16 (DETAIL)

27

The screens capture the confusion of battle in their vivid depiction of a multitude of figures set against glimmering surfaces of gold leaf.[21] As a pair, they present a continuous narrative sweep from the right edge of the right screen moving to the left. The screens present two separate battles that took place in 1184, at Ichinotani (near the present-day city of Kobe) and at Yashima on the coast of Shikoku. These battles, beginning with the Minamoto surprise attack at Ichinotani, marked the turning of the Taira fortunes that would eventually lead to their final defeat and the Minamoto establishment of Japan's first military regime, or shogunate. In the upper right corner of the right screen we find the Minamoto forces, led by Minamoto Yoshitsune, about to charge down the steep Hiyodori Pass in a daring surprise attack from the mountains above the Taira stronghold. This large fortified mansion festooned with the Taira red banners is already under attack by Minamoto forces, identifiable by their white banners, in the left center of the right screen. The Taira, in retreat, attempt to escape in several boats in the left panels. Key episodes from the Battle of Ichinotani receive special attention in *The Tale of the Heike*, and Jinnojō includes nearly all of them. We witness, for example, the famous confrontation between Kumagai Naozane and Taira Atsumori in the upper quarter of the fifth panel of the right screen (p. 29). The young warrior Atsumori, riding a dappled gray horse caparisoned in scarlet, appears spotlighted against the deep blue azurite of the sea into which he has charged his steed. Naozane, arm outreached with an open fan, summons Atsumori back to shore for a proper fight that would become one of the *Tale's* most poignant and retold encounters. In the lower quarter of the sixth panel, Taira Shigehira appears at the shore, armor stripped off and preparing to commit ritual disembowelment. Perpetrator of the torching of the great temples of Nara, Shigehira's attempt at suicide will soon be thwarted, leading to his arrest and eventual delivery to the monks of the temples for justice.

The left screen depicts the battle at Yashima on the Inland Sea coast of Shikoku, where the Taira have fled, pursued by the Minamoto forces. *The Tale of the Heike* recounts many memorable episodes in the story of this battle, which involves a long standoff between the equestrian forces of the Minamoto, and the Taira, who goad them from their armada offshore. Kano Jinnojō focuses our attention on one key moment when

the Minamoto warrior Nasu no Yoichi shoots an arrow at a fan held by a Taira woman who stands at the bow of a boat in the third panel. An oracle had predicted a Minamoto victory if the arrow met its target: the fan is depicted borne aloft against the blue water, thus guaranteeing that the Minamoto will carry the day. Other key episodes that appear include an incident from the "Dropped Bow" chapter of *The Tale of the Heike* in the upper half of the first panel, where Minamoto Yoshitsune demonstrates his bravery by fishing his bow from the water amid the Taira boats. Like the Atsumori episode in the right screen, the "dropped bow" was also the focus of a Noh play, *Yashima*, which without doubt lent its painted depiction an added degree of familiarity.

Other than the masterful depiction of large clusters of figures engaged in battle, the screens exhibit the artist's skillful manipulation of the narrative within the physical space of the screens. We are offered sweeping, airborne perspectives on the action set across a landscape of cliffs and mountains, the shore of the Inland Sea, and the island of Shikoku. The considerable distance from Hiyodori Pass to Yashima, and the time between these decisive battles, are both traversed in the space of the screens' twelve panels. A low green hill in the lower right corner of the right screen and a stand of pines in the lower left corner of the left screen physically anchor the stories of the battles at opposite ends. Extensive applications of gold in thick clouds of gold leaf with raised patterns, as well as in shimmering passages of mist in gold dust, contribute to the artist's modulation of the pictorial space and create dynamic, sumptuous surfaces. In addition to the abundant gold, silver, now tarnished, was applied extensively to the screens. The warriors' swords and halberd blades still retain a trace of their original metallic shine, and beachheads are rendered with a combination of silver and gold powder in a technique similar to their application on lacquer.

The painter of these screens, Kano Jinnojō, now occupies an obscure position in the history of the Kano workshops, falling between such giants as his uncle Kano Eitoku (1543–1590) and his cousin, Kano Tan'yū (1602–1674), who established the Kano house in Edo. In his time, Jinnojō was a painter who held a respected position in the Kano enterprise, but he suffered the misfortune of losing his father, Sōshū, at a young age. A will written by Sōshū to his nephew Mitsunobu

PLATE 17 (DETAIL)

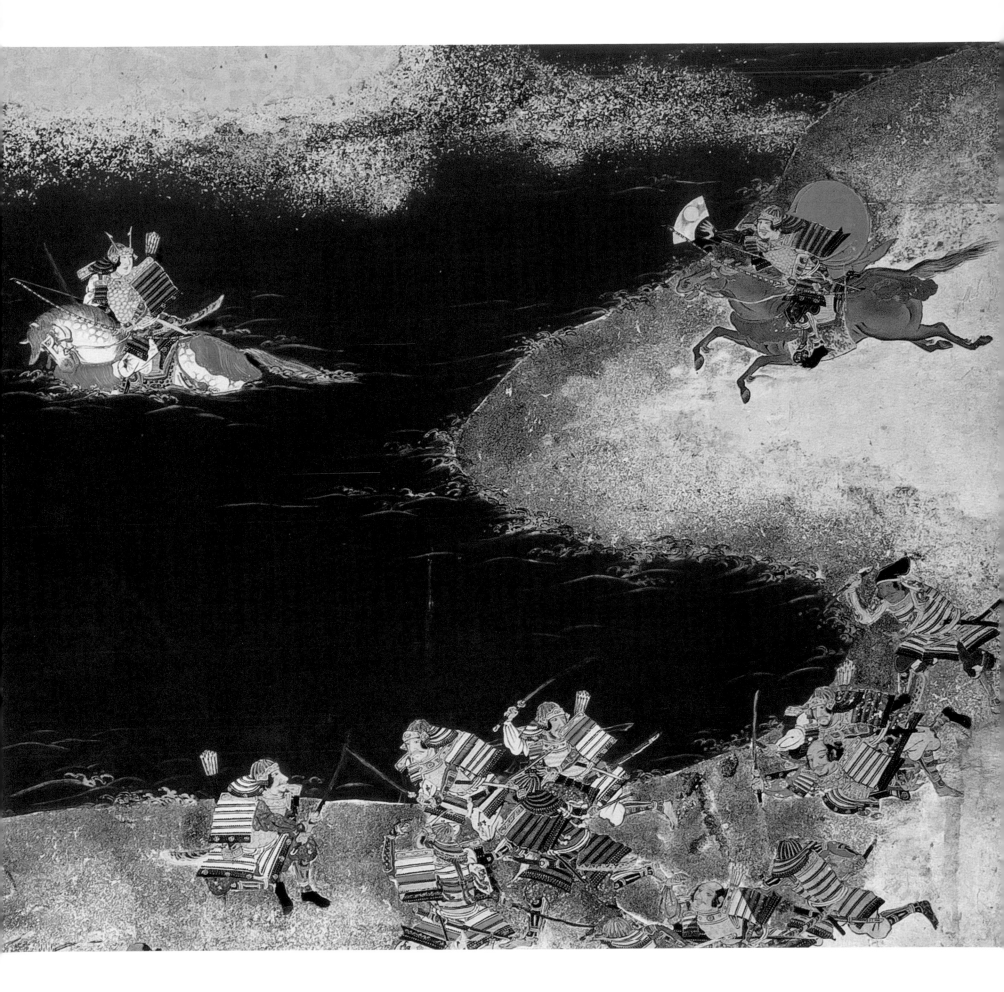

(1561/1565–1608) dated 1601 requests that the latter look into the welfare of the young "Jinkichi" (Jinnojō's childhood name), which Mitsunobu evidently did, arguing in his own letter to Kano elders that the young boy's talent as a painter and descent from Kano Motonobu justified special consideration.[22] Under the guidance of Mitsunobu and later Mitsunobu's son Sadanobu (1597–1623), Jinnojō would flourish as a painter, participating in major commissions into the late 1620s.

Jinnojō's style reflects the delicacy of the work of his cousin, Kano Mitsunobu, whose paintings often feature slender pine trees like those in the present work. The most noted works by Jinnojō are a series of sliding partitions painted in Nagoya Castle in the late 1610s, but documents also show that he produced sliding partition paintings for the Imperial Palace in Kyoto in 1619, screen paintings for the Tokugawa in Edo, and room partition paintings at Nijō Castle in 1626.[23] His work at Nagoya and the Imperial Palace indicate that he was part of a workshop led by Mitsunobu's son and successor Sadanobu, to whom he may have been close in age. Extant works by Jinnojō include the following: a pair of screens, *Exemplary Emperors of China* (private collection), that bear the "Shinsetsu" seal that Jinnojō also used; *Genre Scenes in Famous Places around Kyoto*, a series of sliding panel paintings from the *taimenjo* (reception hall) of Nagoya Castle; and *Tartars Playing Polo and Hunting* (Freer Gallery of Art). Stylistic similarities to *Tartars Playing Polo and Hunting* and similarities to the application of raised designs on the gold clouds in *Exemplary Emperors* link the *Ichinotani and Yashima* screens to Jinnojō. Other stylistic elements, such as color gradation, ratio of negative space, treatment of the horses' legs, and texturing of rocks, also resemble those features of Jinnojō's works. Considered together with the present screens of battles from the *Tale of the Heike*, these works demonstrate that Jinnojō was a master at depicting large groups of figures set in landscapes on the large surfaces of folding screens and sliding panels. Given his close associations with a studio that served the Tokugawa, it is not unlikely that the present work was produced for a member of the Tokugawa clan—who considered themselves descended from the Minamoto victorious in the screens—or one of their allies.

Kano Sansetsu: Auspicious Pines, Bamboo, Plum, Cranes, and Turtles

Kano Jinnojō is reputed to have died in Edo at the age of forty-six, probably sometime in the late 1620s or early 1630s.[24] With the Tokugawa clan's transfer of their seat of power to Edo in the early seventeenth century, the Kano school workshops divided themselves between painters such as Kano Mitsunobu, who produced commissions for the Tokugawa in Edo and would eventually establish permanent studios there, and painters who remained active in Kyoto, serving the imperial court and the Toyotomi family until its fall in 1615. The Edo Kano branches were established after the shogunate granted Kano Tan'yū (1602–1674) an official residence at Kajibashi in Edo in 1621, while the branch in Kyoto (J: Kyō-ganō), first led by Kano Sanraku (1559–1635), would continue to pursue its own sources of patronage outside the official sanction of the Tokugawa regime. Sanraku's successors maintained their branch family's activities through the early nineteenth century, producing works for temples, members of the court aristocracy, and members of Kyoto's intellectual elite. In comparison to the consistently conservative style of many painters of the Edo Kano, works by the Kyoto Kano frequently exhibit a bold, idiosyncratic, and even eccentric quality.

This magnificent pair of screens, a masterwork by the Kyoto Kano painter Kano Sansetsu (1589–1651), is replete with felicitous imagery (cat. no. 19). Cranes and turtles, both associated with longevity, are the protagonists in this work. These creatures inhabit a setting with old pine trees, groves of bamboo, and a blossoming plum tree, plants that are known as the "three friends of winter" for their ability to flourish during the coldest season of the year. Painted against a background of shimmering gold leaf and anchored at the right and left extremes with geometric, angled rocks, the screens exhibit the strong tension between naturalistic representation and abstraction that distinguishes Kano Sansetsu's best works.

By the time of Sansetsu's career, flower-and-bird paintings executed on gilded screens had a long history in the Kano school. With roots in Chinese professional painting, these *kinbyōbu* (gold screens) were an important part of the pictorial repertoire of early Kano painters such as Motonobu and Shōei. *Kinbyōbu* were shipped to Ming China as part

of a diplomatic mission from the daimyo Ōuchi Yoshitaka in 1541; their paradisiacal associations appear also to have made them appropriate for use in funerary rituals.[25] The excellent condition of the numerous surviving examples by Kano Motonobu, Shōei, Mitsunobu, and Sanraku indicates the degree to which their owners treasured these works. The present pair of screens is the only known example of this type of work by Kano Sansetsu.

Sansetsu was the adopted son of Kano Sanraku, who was himself adopted by Kano Eitoku by the order of the military warlord Toyotomi Hideyoshi.[26] A century before Sansetsu produced the present screens, Eitoku perfected an atelier style that featured shallow compositions in which bold motifs were set against gleaming gilded surfaces. *Auspicious Pines, Bamboo, Plum, Cranes, and Turtles* generally follows these basic compositional principles but exhibits Sansetsu's own penchant for abstracted, even distorted forms. As a painter of the Kyoto Kano workshop, Sansetsu did not benefit from the lucrative patronage of the shogunate, but he was free to develop his own individualistic style, unencumbered by officially determined aesthetic preferences.

These screens are noteworthy within Sansetsu's oeuvre in several ways. First, they are signed, "Kano Nuidonosuke hitsu," employing a name that the artist used on few other works, among them a large votive painting (*ema*) in the temple Kiyomizudera. Second, Sansetsu executed the screens in a rich palette of pigments and gold leaf, a polychrome painting mode used in his *fusuma* panel paintings for the Myōshinji subtemples Tenkyūin and Tenshōin, but in few of his paintings on folding screens. The pair of screens by Sansetsu that is closest in theme and style to the present work, *Gulls and Plovers on a Snowy Shore* (private collection, Japan), is considered a masterpiece of early Edo-period painting. Third, *Auspicious Pines, Bamboo, Plum, Cranes, and Turtles* has survived in superb condition, with minimal evidence of abrasions, pigment loss, or other damage.

Like Sansetsu's other folding screen paintings, *Auspicious Pines* manifests both contrasting and complementary motifs. The painter balances the single pine in the right screen with a pair of smaller trees in the left screen. The old pine in the right screen bends and twists to fill much of the space around it, while the trees in the left screen stand erect, with one branch reaching across three panels in an exaggerated gesture typical of Sansetsu's painting (p. 32). In the right screen Sansetsu depicts three red-crowned cranes (*Grus japonensis*), one of which is tending to chicks in a nest, and in the left screen he depicts a different species, white-naped cranes (*Grus vipio*), with their own fledglings. Turtles appear by the shore of an azure marsh in both screens. Other motifs, particularly the rocks that balance the right and left corners, differ from one screen to the other and contribute to the overall dynamic interplay that enlivens the screens' separate halves.

An exhaustive, untiring attention to detail pervades *Auspicious Pines, Bamboo, Plum, Cranes, and Turtles*. Sansetsu's consummate technical abilities emerge in the self-assured brushwork we find in the contour lines, and in the brushwork that defines and textures the rocks' jagged surfaces and the pines' scale-like bark. Dark ink wash and highlights in gold paint (*kindei*) give volume to the trees and rocks, heightening their contrast against the flat gold background. The pleasingly even rhythms of the ranks of pine needles and clumps of bamboo leaves suggest that Sansetsu sought patterns in such natural motifs. The cranes' poses were probably derived from pictorial sources rather than actual observation, and yet the details of their feathers and their arrangement come across as surprisingly spontaneous and naturalistic.

As is the case with other East Asian paintings of birds and flowers, avian subjects in Japanese painting often appear to have served as metaphors for aspects of human affairs. Raptors, for example, were prized possessions of the warrior aristocracy and feature prominently in early Kano school paintings created for the martial elite. The present screens of families of cranes and turtles possess an inescapable mood of familial affection—beyond their association with longevity, cranes mate for life and are thus associated with marital fidelity. Such symbols and meanings imbue these screens with an overwhelmingly positive aura and strongly suggest that they were created to commemorate a marriage, the birth of a child, or other important life event.

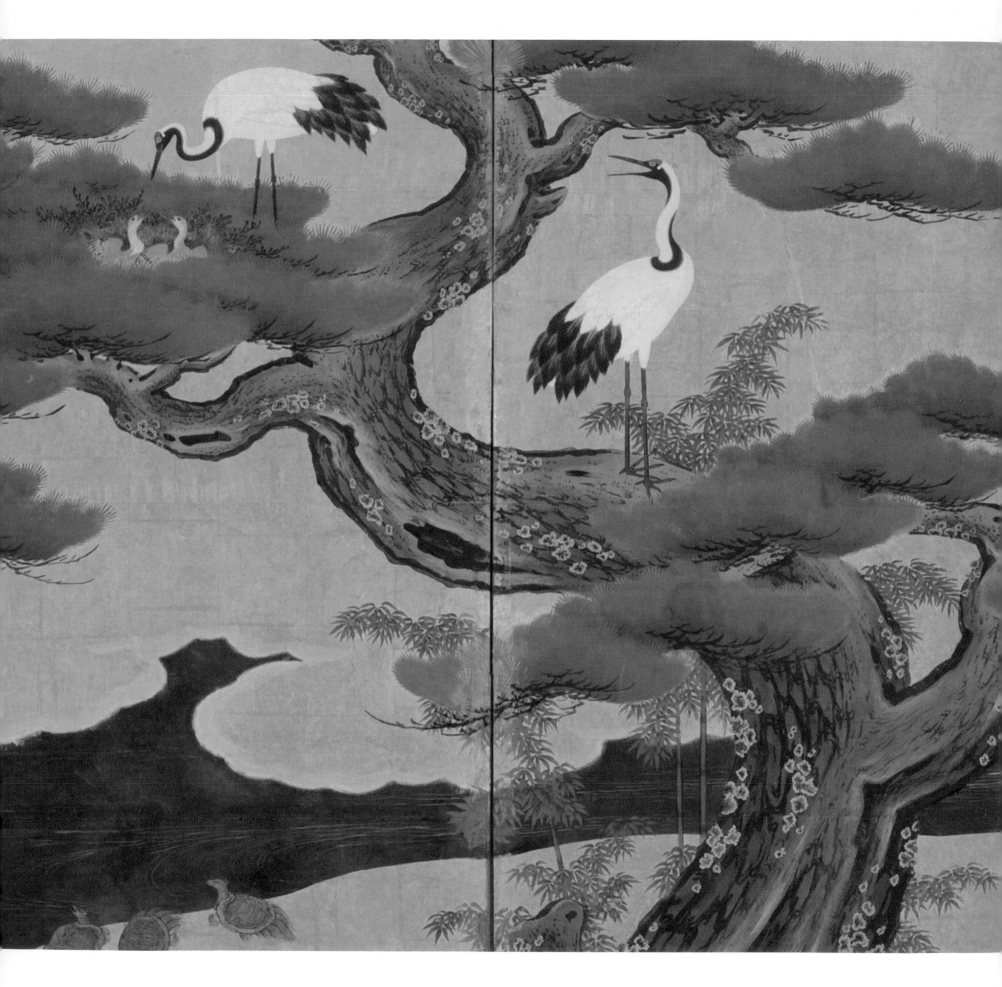

The four pairs of screen paintings described in this essay vividly illustrate the fertile creativity that propelled the Kano school in its first century and a half of activity from the sixteenth through mid-seventeenth century. At the forefront of the Kano workshops' efforts were imaginative and skilled painters who worked with established models borrowed and received from other, often much older painting traditions and reshaped them into entirely new compositions and formats. Kano Eitoku's screens of fans afloat a sea of wind-tossed waves reconceives older Chinese themes such as the Paragons of Filial Piety as a series of images that respond to a Japanese love of storytelling and reframes them into a work that exhibits a dynamic visual design. Sōshū's depictions of chapters from *The Tale of Genji* marks the Kano school's acquisition of an ancient theme of Japanese court painting and show one painter's redesign of the theme into an innovative new composition that emphasizes seasonal change while simultaneously revealing thematic trajectories of the *Tale*. Kano Jinnojō's *Battles of Ichinotani and Yashima* also takes a classical tale as its subject, but it brings out the frenzied action of warfare with hundreds of figures depicted in broad panoramas. In *Auspicious Pines, Bamboo, Plum, Cranes, and Turtles* Kano Sansetsu revives the *kinbyōbu* genre of his Kano ancestors and produces a work that is remarkable for its abstracted and exaggerated forms. Together these works attest to the infinite capacity of the screen painting, when wielded by technically adept and innovative painters, to impress and delight its viewers.

NOTES

1 Kano Einō, *Honchō gashi* (1693); in Kasai Masaaki, ed., *Yakuchū honchō gashi* (Tokyo: Dōhōsha, 1985), pp. 318–319.

2 Notable Western-language studies of Kano painting include: Takeda Tsuneo, *Kano Eitoku*, trans. H. Mack Horton and Catherine Kaputa (Tokyo: Kōdansha, 1977); Yoshiaki Shimizu, "Workshop Management of the Early Kano Painters, ca. A.D. 1530–1600," *Archives of Asian Art* 34 (1981): 32–47; Carolyn Wheelwright, "Kano Painters of the Sixteenth Century A.D.: The Development of Motonobu's Daisen'in Style," *Archives of Asian Art* 34 (1981): 6–31; Carolyn Wheelwright, "Kano Shōei," PhD diss., Princeton University, 1980; Quitman E. Phillips, "Kano Motonobu and Early Kano Narrative Painting," PhD diss., University of California, Berkeley, 1992; Karen Gerhart, *The Eyes of Power: Art and Early Tokugawa Authority* (Honolulu: University of Hawaii Press, 1999); and Yukio Lippit, *Painting of the Realm: The Kano House of Painters in Seventeenth-Century Japan* (Seattle: University of Washington Press, 2012).

3 The analysis of these screens is derived in part from the author's discussion of this work in International Symposium on the Conservation and Restoration of Cultural Property, *Capturing the "Original": Archives for Cultural Properties* (National Research Institute for Cultural Properties, Tokyo, 2010), pp. 41–44.

4 The first known reference to *ōgi-nagashi byōbu* (folding screens) appears in the diary of Fushiminomiya Sadafusa, *Kanmon gyoki*, in Eikyō 6 (1434).7.6. See Miyajima Shin'ichi, *Senmenga* (*Chūsei-hen*). Nihon no bijutsu 320 (Shibundō, 1993), p. 41.

5 *Kanenobu kō-ki* (diary of Lord Hirohashi Kanenobu): Ōei 8 (1401).5.28. See Miyajima, pp. 41–46.

6 These works include a pair of folding screens in ink monochrome by Kano Shoei in the Rakutō Ihōkan collection, a pair of folding screens with attached fan paintings in colors and gold by Kano Shōei in the collection of Honnōji, and a pair of folding screens in ink monochrome by Kano Eitoku screens in the Fukuoka City Museum. For illustrations, see Kyoto Kokuritsu Hakubutsukan, *Tokubetsu tenrankai: Muromachi jidai no Kano-ha* (Kyoto National Museum, 1996), pp. 162–163, 186–187; and Kyoto Kokuritsu Hakubutsukan, *Tokubetsu tenrankai: Kano Eitoku* (Kyoto National Museum, 2007), pp. 66–67.

7 The *Eight Views of Xiao and Xiang* by Yujian are included in the fifteenth-century document *Muromachi dono gyōkō okazariki*, where they are listed as separate hanging scrolls, to be hung on two sides of a room in the south *kaisho*. They are also listed, together with other sets of the *Eight Views*, in *Gyobutsu gyoga mokuroku*, the Ashikaga shogun's inventory compiled by Nōami. See Tokugawa Bijutsukan, *Muromachi shōgunke no shihō o saguru* (Tokugawa Bijutsukan, 2008), p. 207.

8 Lacking creases, however, the second fan appears to have been made for viewing flat, perhaps in an album, which in turn may have performed a second function as a painting manual.

9 For a discussion of the significance of Yujian's "Mountain Market, Clearing Mist" in the context of late sixteenth-century tea circles, see Andrew Watsky, "Locating 'China' in the Arts of Sixteenth-Century Japan," ch. 4 of *Location*, ed. Deborah Cherry and Fintan Cullen (Oxford: Blackwell Publishing, 2007), pp. 68–92.

10 Tani Akira, "Kenkyū shiryō: Chakai ki ni arawareta kaiga," *Bijutsu kenkyū* 363 (March, 1995): 237–263.

11 Illustrated in Gotō Bijutsukan, *Yamanoue no Sōji ki: Tenshū jōyonen no me* (Gotō Bijutsukan, 1995), p. 106.

12 See Tani, pp. 240–241.

13 Kyoto Kokuritsu Hakubutsukan, *Muromachi jida no Kano-ha*, p. 218.

14 For a detailed study of the career of Tosa Mitsunobu, see Melissa McCormick, *Tosa Mitsunobu and the Small Scroll in Medieval Japan* (Seattle: University of Washington Press, 2009).

15 Translation by Yayoi Shionoiri. Readers familiar with Japanese art will recognize the misrendering of the familiar term *hikime-kagihana* ("dash for an eye, hook for a nose") as *hikime-hikihana* in Kano Einō's text.

16 See Nakamachi Keiko, "Genji Pictures from Momoyama Painting to Edo Ukiyo-e," in *Envisioning The Tale of Genji: Media, Gender, and Cultural Production*, ed. Haruo Shirane (New York: Columbia University Press, 2008), pp. 171–173.

17 Chapter titles follow those in Royall Tyler's translation of *The Tale of Genji* (New York: Viking, 2001).

18 Kyoto Kokuritsu Hakubutsukan, *Tokubetsu tenrankai: Kano Eitoku* (Kyoto National Museum, 2007), p. 273.

19 Osaka Municipal Museum collection. For a stylistic analysis of Sōshū's Genji screens, see Yamamoto Hideo, "Genshū-in Genji monogatari zu byōbu," *Kokka* 1388 (2011): 26–33.

20 See Suntory Bijutsukan, *Genpei no bigaku: Heike monogatari no jidai* (Warrior Aesthetics: The Tale of the Heike and Its Period), exh. cat., Suntory Museum, 2002, cat. 86, p. 126.

21 For an analysis of a similar screen painting, see Matthew McKelway, "The Battle of Ichinotani," *Orientations* v. 42, no. 4 (May 2011), pp. 50–57.

22 See Matsuki Hiroshi, *Goyō eshi Kano-ke no chi to chikara* (Kōdansha, 1994), pp. 118–121.

23 Matsuki, pp. 127–128, 148, 150.

24 See Matsuki Hiroshi, "Kano Jinnojō no seibotsunen (1)," *Kobijutsu* 92 (October 1989), pp. 91–93, 96; and Matsuki, "Kano Jinnojō no seibotsunen (2)," *Kobijutsu* 93 (January 1990), p. 109.

25 See Bettina Klein, *Japanese Kinbyōbu: The Gold-leafed Folding Screens of the Muromachi Period (1333–1573)*, adapted and expanded by Carolyn Wheelwright (Ascona, Switzerland: Artibus Asiae, 1984).

26 For a biographical outline of Sansetsu's career, see Tsuji Nobuo, *Lineage of Eccentrics: Matabei to Kuniyoshi*, Aaron Rio trans. (Kaikai Kiki, 2012), pp. 58–62.

PLATE 19 (DETAIL) 33

NOTES

1 Joe Earle, *Flower Bronzes of Japan* (London: Michael Goedhuis, 1995), 10–11.

2 Joe Earle, *Flower Bronzes of Japan* (London: Michael Goedhuis, 1995), 68.

3 For a recently published example of such a pair of screens, see Koichi Yanagi Oriental Fine Arts, *Kokon Biannual Fall '12* (Exh. cat. New York: Koichi Yanagi Oriental Fine Arts, 2012), cat. 1, attributed to Soga Chokuan (active 1596–1610). See also cat. no. 18

4 Joe Earle, *Flower Bronzes of Japan* (London: Michael Goedhuis, 1995), 96.

5 For an example of such a commission, see Rinsensha, *Shinbun shūsei Meijihen nenshi*, 4 (1936–40), quoted in http://rnavi.ndl.go.jp/mokuji_html/000000867565-04.html, last accessed October 29, 2012.

6 Robert E. Haynes, *The Index of Japanese Sword Fittings and Associated Artists* (Ellwangen, Germany: Nihon Art Publishers, 2001), 575 (H 00757.0).

7 For a documented work commissioned by the Yamaguchi Company, see Tōkyō Kokuritsu Bunkazai Kenkyūjo (Tokyo National Research Institution of Cultural Properties), *Naikoku kangyō hakurankai bijutsuhin shuppin mokuroku* (Catalogs of objects exhibited at the National Industrial Expositions; Tokyo: Chūōkōron Bijutsu Shuppan, 1996), 302 (no. 609), a metal deer exhibited at the Fifth National Industrial Exposition in 1903.

8 Kendall H. Brown, *Deco Japan: Shaping Art and Culture, 1920–1945* (Alexandria, Virginia: 2012), 94.

9 Bevis Hillier, *Art Deco* (London: Studio Vista, 1968), 12. The term was popularized by Hillier, but its first appearance seems to have been as the subtitle to a French exhibition catalogue published two years earlier.

10 Kendall H. Brown, *Deco Japan: Shaping Art and Culture, 1920–1945* (Alexandria, Virginia: 2012), 45–47 and 96.

11 Kagedo Japanese Art, *Art Deco and Modernism: Archives*, www.kagedo.com/collections/3/KJA1695.html, last accessed October 29, 2012.

12 Kendall H. Brown, *Deco Japan: Shaping Art and Culture, 1920–1945* (Alexandria, Virginia: 2012), 47–50.

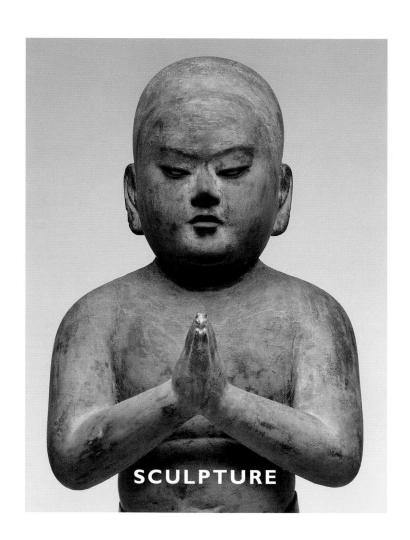

SCULPTURE

The Ellison collection includes a visual feast of some twenty-five works that present the entire range of production of religious art in Japan, from the ninth through the nineteenth century, in a full variety of forms, including Buddha figures; enlightened bodhisattva, strongman- and warrior-type protectors of Buddhist law; Shinto gods; and divinities in the form of beautiful women, children, and animals. These sculptures represent significant stylistic developments that occurred in Japan over the course of eleven centuries, as well as iconographic diversity, and expressions of religious awareness, joy, and deep, sublime trust. The six pieces selected for this exhibition give but a taste of the richness manifested in the Japanese sculptural tradition.

Buddhist icons were introduced to Japan from Korea in the sixth century with sculpted images produced in an archaic style that originated in China in the fifth century. The growing acceptance of Buddhism at the upper echelons of Japanese society was signaled by a decree from Emperor Tenmu (r. 676–682) stating, "In every house a Buddhist shrine should be provided, and an image of Buddha with Buddhist scriptures placed there. Worship was to be paid and offerings of food made at these shrines." From the seventh century onward temple workshops created hundreds of bronze and wood images to keep pace with the growing demand for religious sculpture.

The large seated austere male figure (cat. no. 1) dating to the ninth or early tenth century is a rare example of a sculpture that shows the early dominance of Buddhism in Japan, and its influence on native Shinto beliefs. Lacking a native tradition of icons in human form, Shinto temples used sculptures of male and female divinities dressed as priests or courtiers to represent natural *kami*. Life-sized, solid-block Shinto sculptures most commonly date to the early Heian (794–1185) period and their numbers are very small today.

As time progressed, wood sculpture took on a much lighter aspect, both in weight and expression. The bodies of the divinities and their garments became thinner in response to increased demand for religious sculpture and changes in taste. One example in the Ellison collection is the eleventh-century fierce guardian of the law, Fudō Myōō (cat. no. 2). This deity appeared in the ninth century with a heavy, fleshy body and scowling countenance. The Ellison example, however, is a friendlier version of Fudō, more in keeping with the spirit of the age. Most influential to the development of a truly Japanese style, however, was the remarkable eleventh-century Heian development of joined block construction, which made the body of the sculpture a hollow shell, thereby necessitating a shallower cut to define the details of body, decoration, and expression.

The late Heian style was in use for more than one hundred years in Japan, but by the turn of the thirteenth century Buddhist sculpture reached a new pinnacle when two talented men, Unkei and Kaikei, were called upon to repair works in the ancient capital, Nara, after civil war left temples and their art in ruins. Perhaps because of their exposure to early Buddhist art, and because of fresh influences from the continent, the Kei school developed a fresh new style that incorporated new iconography and decorative

elements from Song China (960–1279). New techniques that increase the sense of realism appeared as well, such as inserted painted-crystal eyes, and thick-walled hollowed sculpture that could be deeply carved to more accurately express drama in form and movement in sculpture.

Of the several Kamakura period works in the Ellison collection, the cheerful Seitaka Dōji (cat. no. 3), one of two boy-attendants to the fierce protector of Buddhist law, Fudō Myōō, conforms best to this new style. In particular, the deep undercutting of the garments helps to bring a lively energy to the form. The appealing figure of Shōtoku Taishi as a two-year old child, (cat. no. 5) on the other hand, is also charmingly lifelike, yet has a quiet, gentle aspect in keeping with its role as a compassionate divinity who desires to lead mankind to salvation. And no better example of Kamkura-period realism can be found than the charming pair of puppies at play, which bear a striking resemblance to the tradition of animal sculptures from the temple of Kōzanji in Kyoto (cat. no. 4).

Buddhism continued to prosper throughout Japanese history, giving support to new sects, such as Zen, which appealed to the warrior class, and to other aesthetic pursuits, such as tea, caligraphy, and painting. The tiny, crisply carved image of Kokūzō Bosatsu from the Edo period (cat. no. 6) perpetuates the tradition of esoteric Buddhist sculpture, which first flourished in the ninth and tenth centuries, and the custom of the same age of carving fragrant sandalwood into portable deities for individual worship.

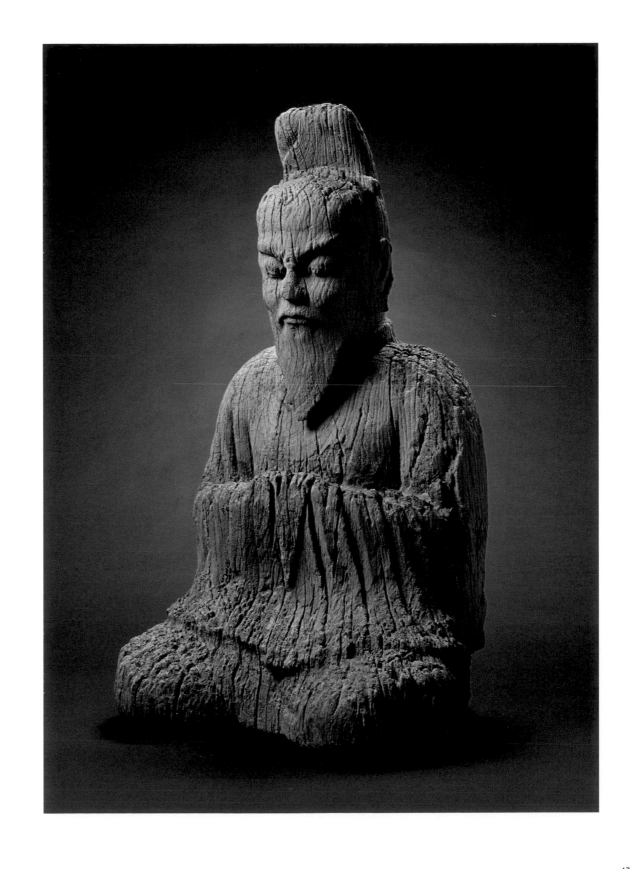

PLATE I

1

男神坐像　木造　平安時代

SEATED MALE SHINTO DEITY

Heian period (794–1185), 9th–10th century
Wood
H. 37 x W. 20½ x D. 16½ in.
2009.008

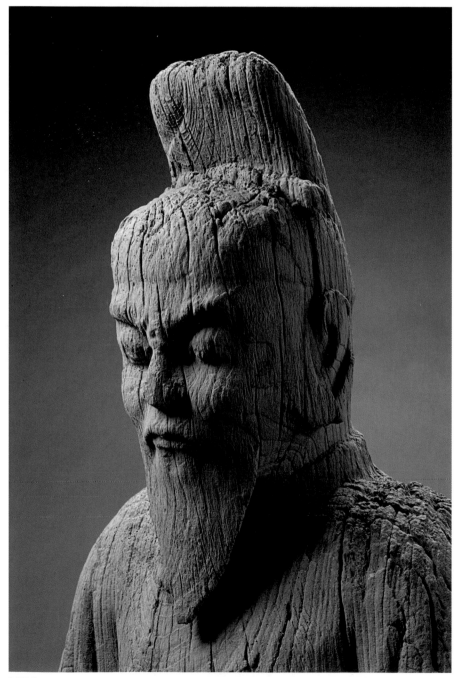

DETAIL

44

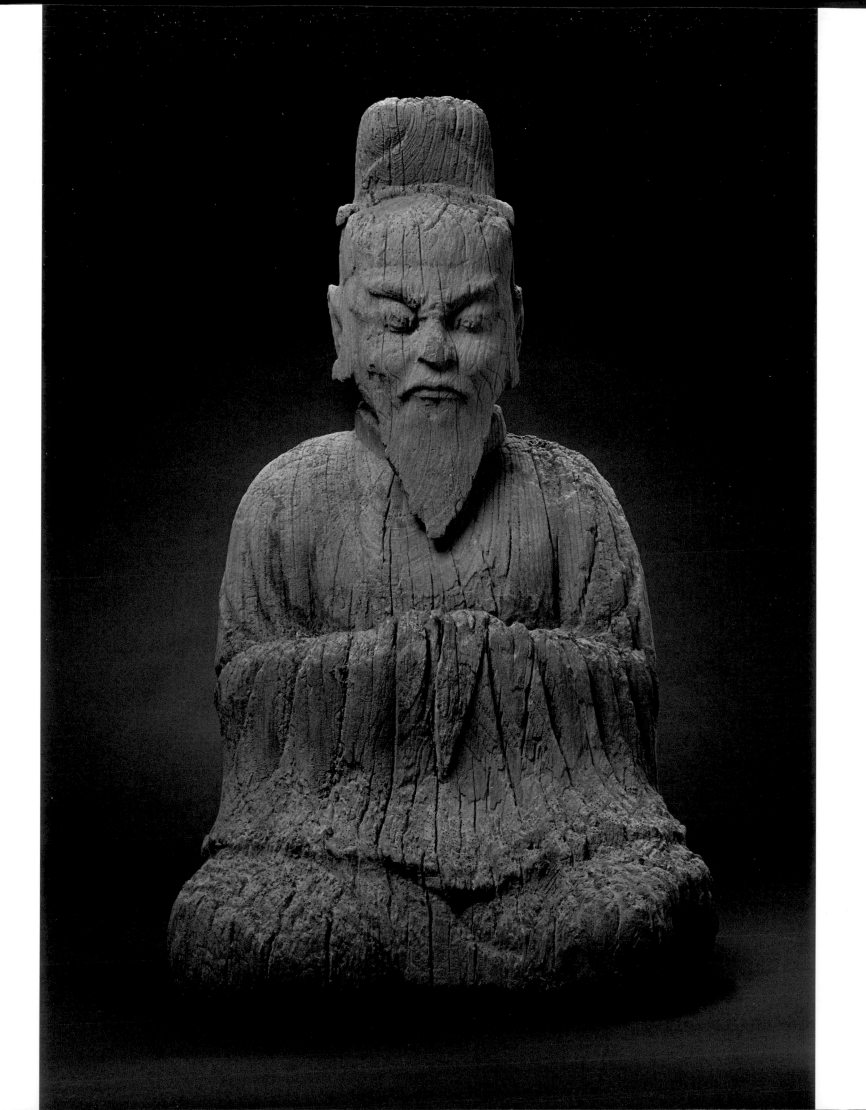

2

不動明王立像　木造　平安時代

STANDING FUDŌ MYŌŌ (ACHALA)

Heian period (897–1195), 11th century
Wood
H. 49½ x W. 17 x D. 12 in.
2008.020

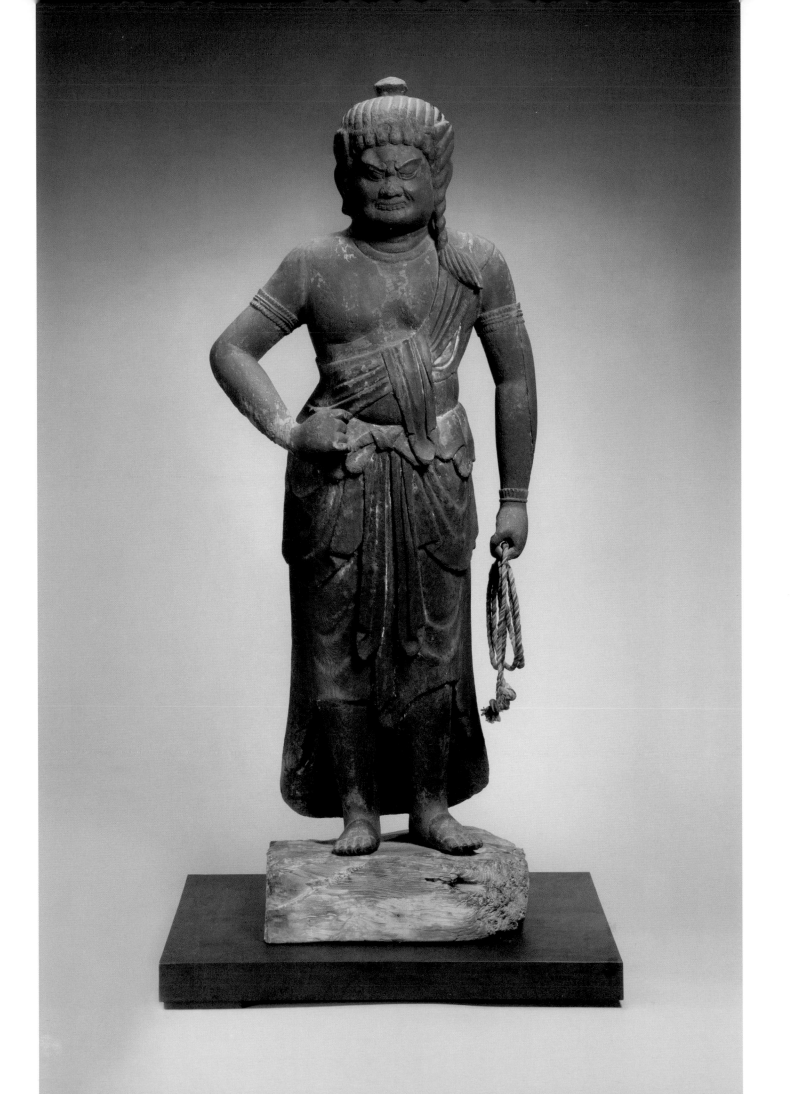

3

制多迦童子立像　木造彩色玉眼　鎌倉時代

SEITAKA DŌJI (BOY ATTENDANT TO FUDŌ MYŌŌ)

Kamakura period (1185–1333), 13th–14th century
Colors and lacquer on wood with crystal inlay
H. 40 x W. 20 x D. 14 in.
2009.064

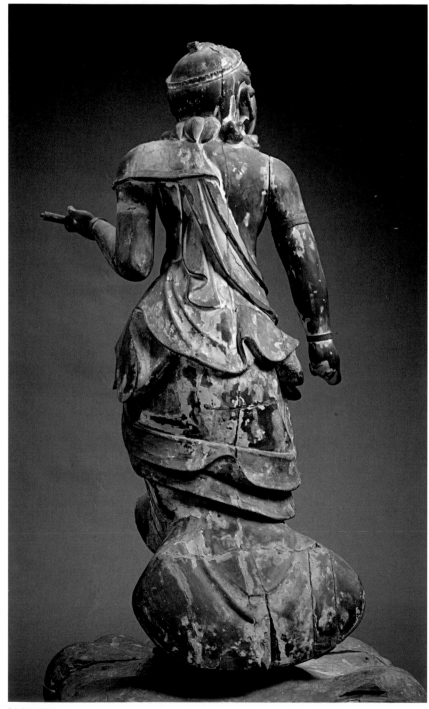

BACK VIEW

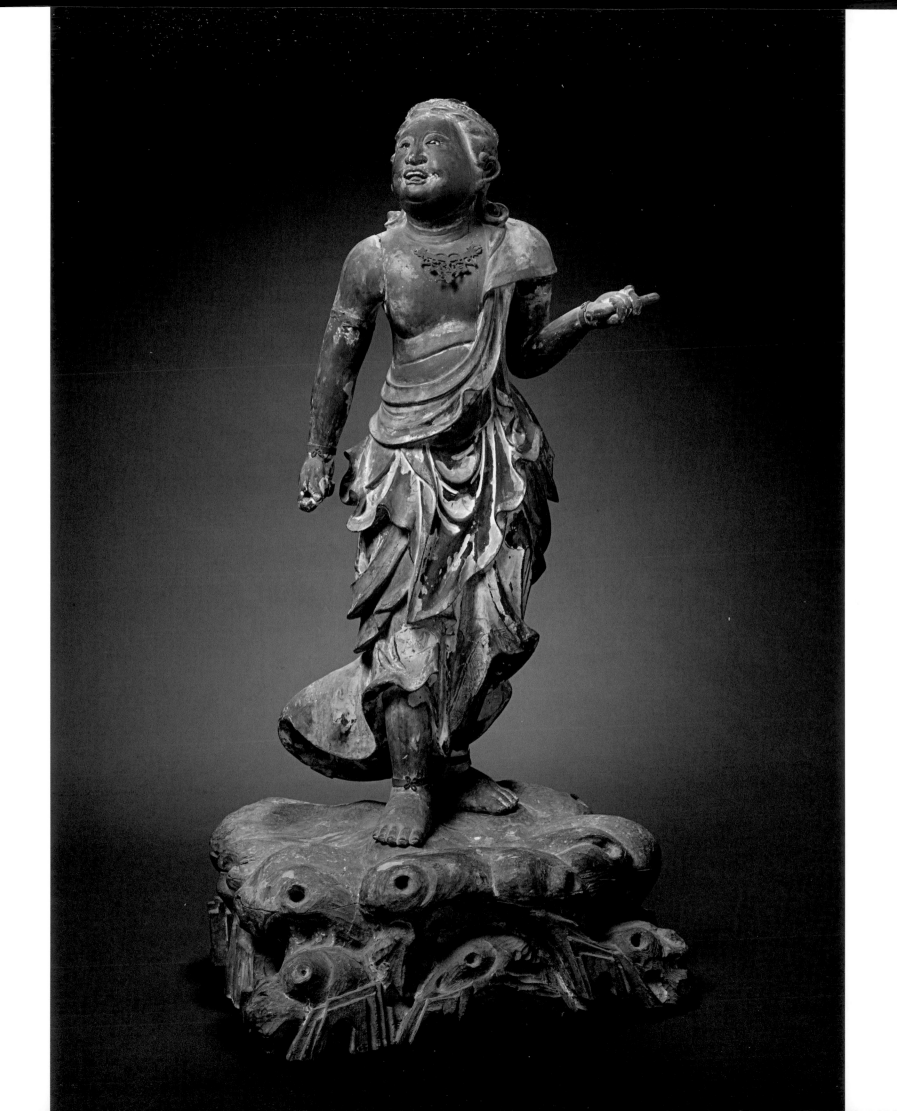

4

双狗児像　木造玉眼　鎌倉時代

TWO PUPPIES AT PLAY

Kamakura period (1185–1333), 13th century
Lacquer on wood with crystal inlay
H. 7½ x W. 11 x D. 9 in.
Published: Kuno Takeshi, "Mokuzō koinuzō," *Bijutsushi* 97 (1991), 119–121
2010.045.1

5

聖徳太子二歳立像（南無仏太子像）　木造彩色玉眼　鎌倉時代

STANDING SHŌTOKU TAISHI AT AGE TWO (NAMUBUTSU TAISHI)

Kamakura period (1185–1333), late 13th–14th century
Colors and lacquer on wood with crystal inlay
H. 27½ x W. 9 x D. 10 in.
2011.053

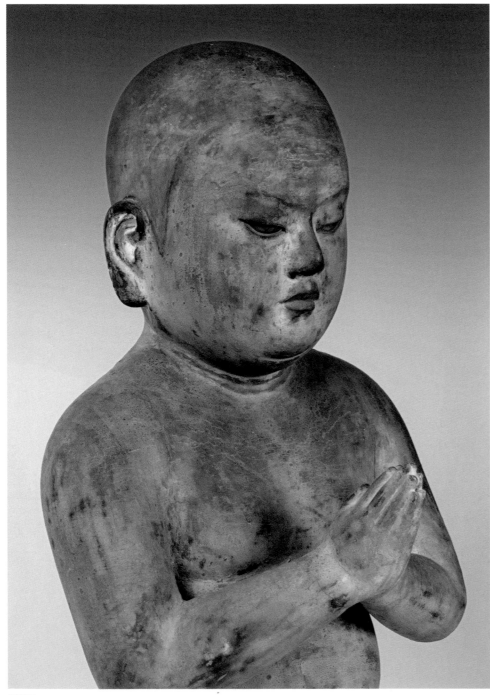

DETAIL

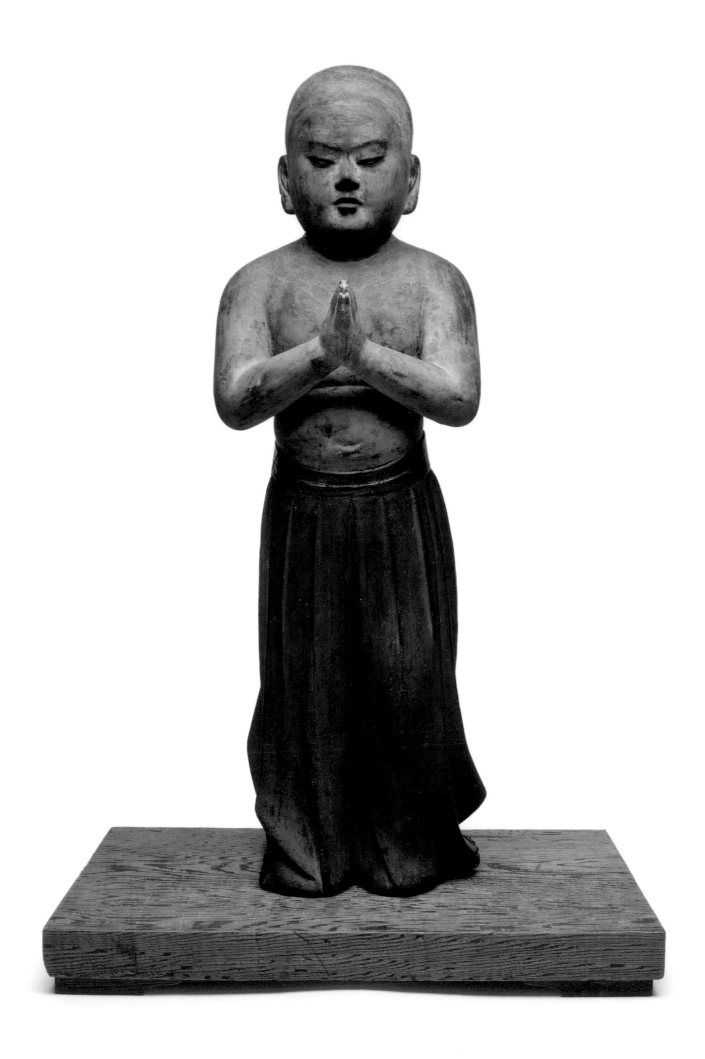

6

虚空蔵菩薩坐像　白檀造　江戸時代

SEATED KOKŪZŌ BOSATSU (AKASHAGARBHA BODHISATTVA)

Edo period (1615–1868)
Sandalwood
H. 7½ x W. 6½ x D. 6 in.
2009.058

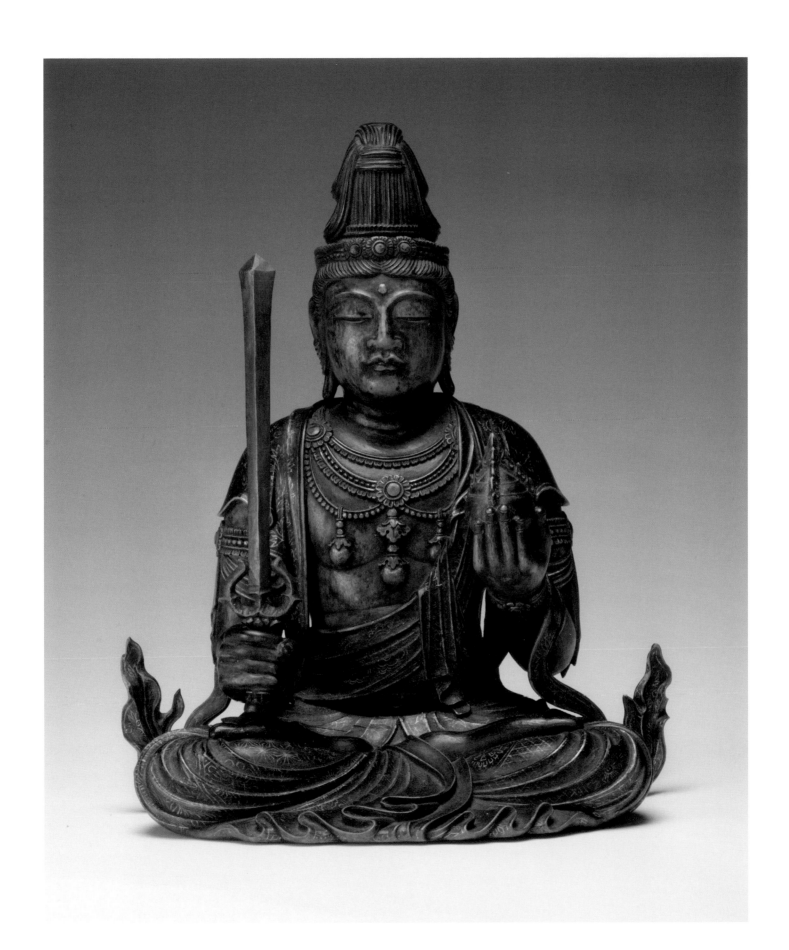

The Ellison collection includes a remarkable array of paintings, spanning some six centuries of Japanese history. Apart from a few fine religious subjects, though, the selection is focused on secular themes that engage the imagination and the eye. Thematically, the paintings tend toward the repertoire associated with professional painting workshops: many scenes from classical literature, both Chinese and Japanese; bird and flower pictures; landscapes; and studies of animals. In stylistic terms, the screens and hanging scroll paintings reflect the activities of artists in three major traditions: the Kano school in Kyoto in the late 1500s and early 1600s; Edo period Rinpa-style painters; and the innovative work of several eighteenth-century Kyoto masters.

Until the Edo period, most painters belonged to hereditary workshops, where they received rigorous training in orthodox subjects and styles. As noted in Matthew McKelway's essay, the most prominent of these was the Kano school, whose artists worked for high-ranking warriors, including the shogun. Kano school works in the Ellison collection include several famous literary subjects: fans painted with the Twenty-four Paragons of Filial Piety from the studio of Kano Eitoku (1543–1590); *Tale of Genji* screens by his younger brother Sōshū (1551–1601); and an important pair of screens depicting scenes from *The Tale of the Heike* by Sōshū's son Jinnojō (active early 1600s; cat. nos. 15–17). These detailed figure subjects in brilliant color and gold represent one specialty of the Kano line, while bird and flower subjects by Kano Sansetsu (1591–1651) demonstrate the mannered elegance of the seventeenth century Kyoto Kano school painters (cat. nos. 18–19).

While Kano artists kept this repertoire alive through a carefully controlled workshop system, a second painting tradition, known as Rinpa, was established by a loosely associated group of painters inspired by the work of Tawaraya Sōtatsu (d. approx. 1642) and Ogata Kōrin (1658–1716). A screen of fans floating on waves represents the Sōtatsu workshop style (cat. no. 14), and screens of corn and maize (cat. no. 32) show the Rinpa style in the hands of Kōrin's eighteenth-century followers. Two works by Suzuki Kiitsu (1796–1858) demonstrate the lasting vitality of the Rinpa tradition, in their emphasis on surface patterning and supple, curving outlines in images of birds, flowers, figures, and animals (cat. nos. 33–34).

The eighteenth-century Kyoto painters contribute several masterful animal subjects, as well as the only two landscapes in the group. Chief among them are works by three artists, Maruyama Ōkyo (1733–1795), Soga Shōhaku (1730–1781), and Itō Jakuchū (1716–1800); the menagerie they created includes a sleeping cat, chickens and puppies, audacious tigers, a gentle elephant, a crane, and deer (cat. nos. 20–24; 26–31). These animal pictures offer viewers a fascinating window into the methods artists use to portray other creatures: naturalistic or abstract, threatening, gentle or comic, they showcase the variety of artistic expression that exists in Japanese painting.

7

春日鹿曼荼羅　一幅　絹本着色　室町時代

KASUGA DEER MANDALA

Muromachi period (1392–1573), 15th century
Hanging scroll; ink, colors, and gold on silk
H. 69 x W. 22½ in.
Published: Koichi Yanagi Oriental Fine Arts, *Honji sui-jyaku: Manifestations of Japanese Kami*, no. 3.
2008.064

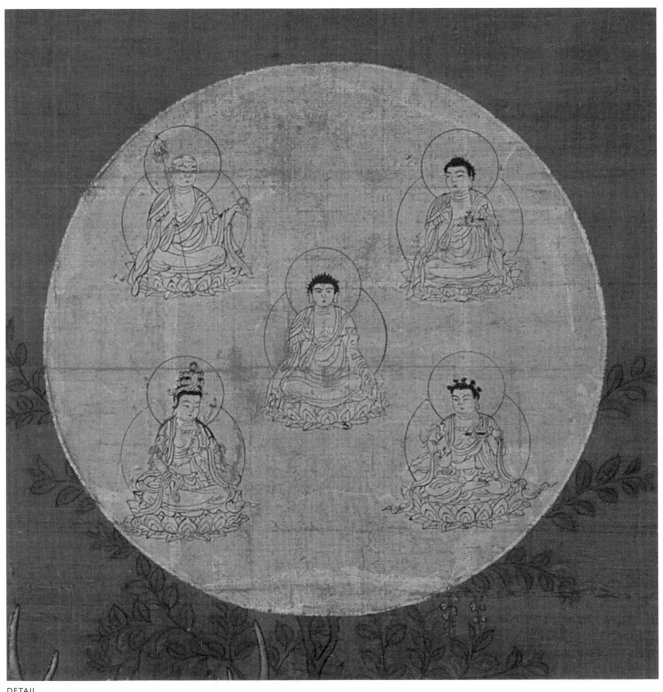

DETAIL

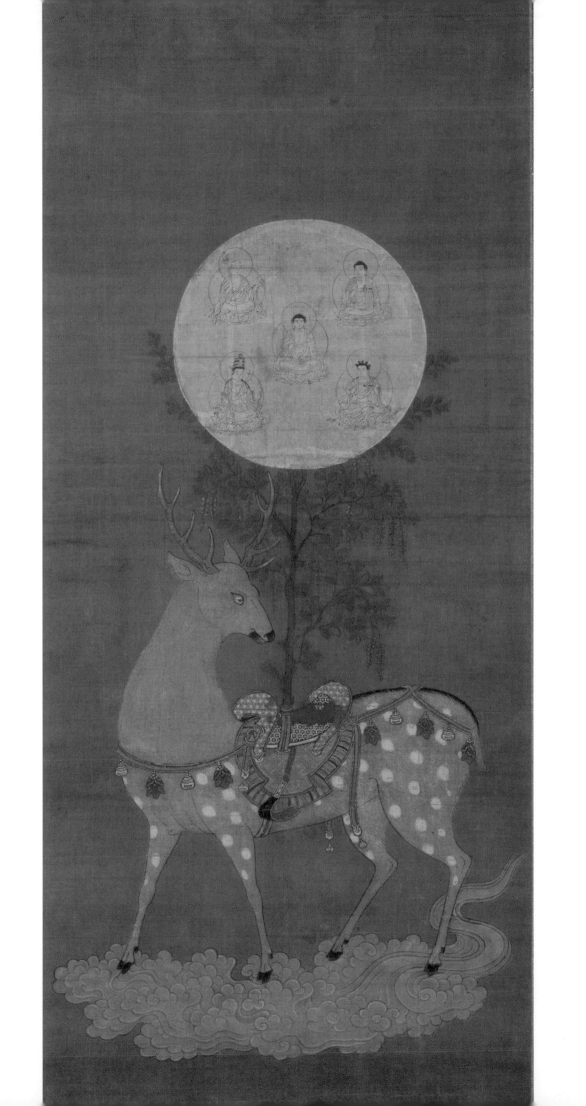

8

涅槃図　一幅　絹本着色　南北朝〜室町時代

PARINIRVANA OF THE BUDDHA

Nanbokuchō period (1333–1392) or Muromachi period (1392–1573)
Hanging scroll; ink, colors, and gold on silk
H. 60 x W. 49¼ in.
Published: *Kaikodo Journal/Kaikodō XIX*, no. 31 (2001), no. 31
2012.120

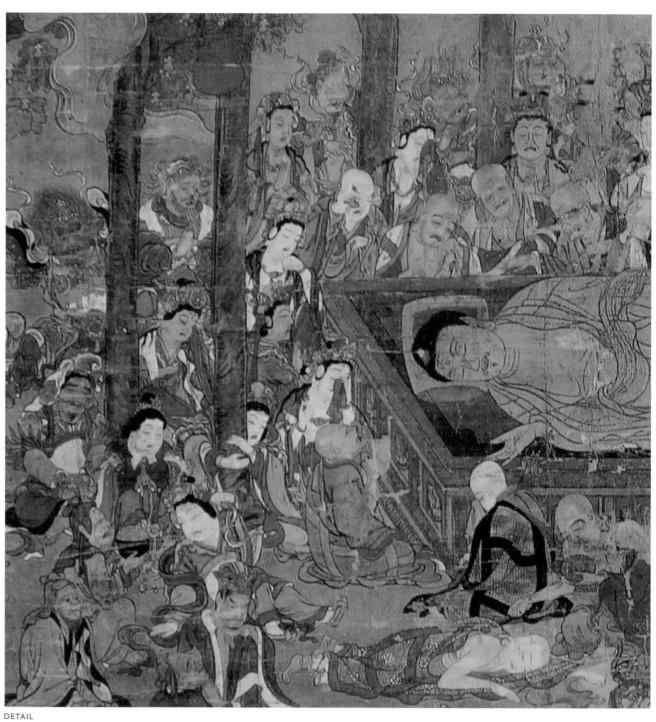

DETAIL

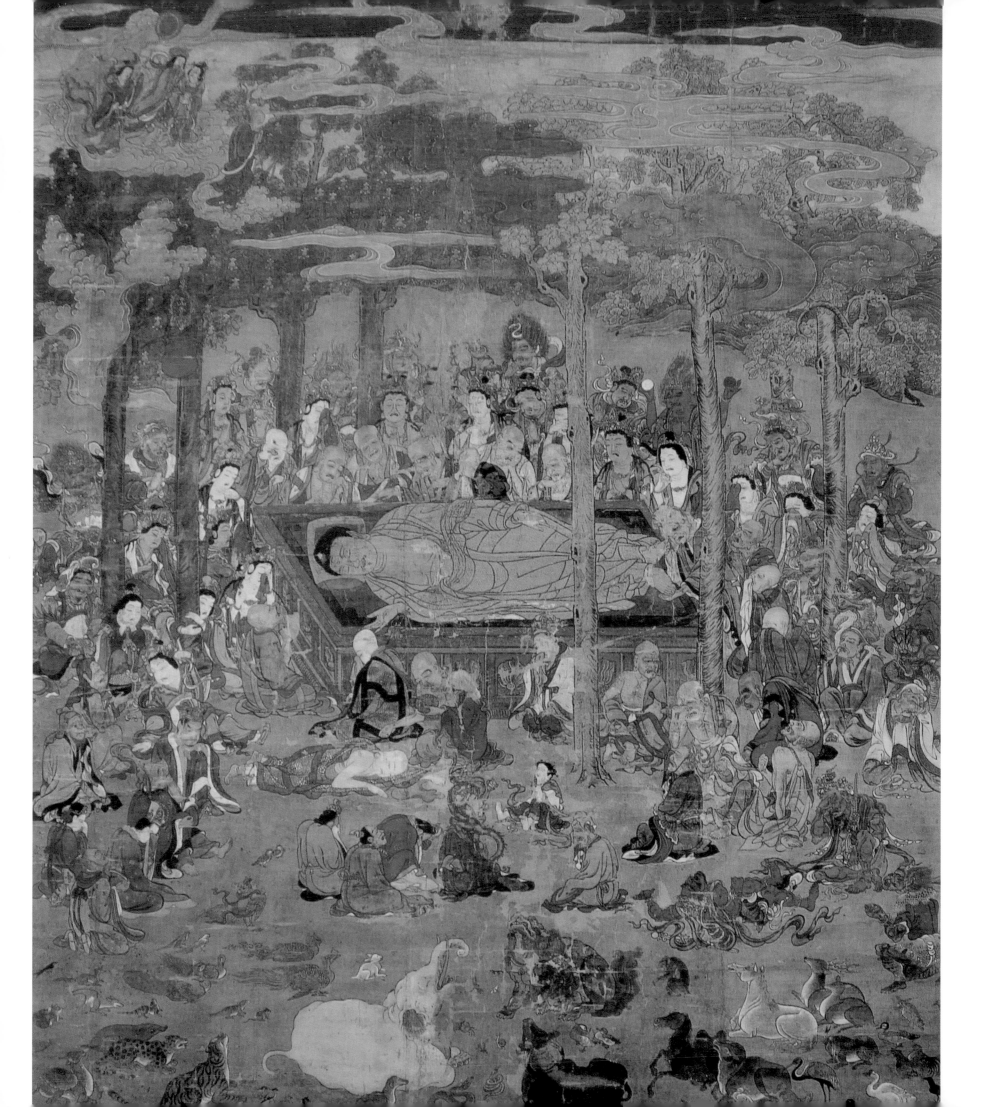

9

伝牧松周省　猫図　一幅　紙本墨画　室町時代

CAT

Attrib. to Bokushō Shūshō (died c. 1506)
Muromachi period (1392–1573), 16th century
Hanging scroll; ink on paper
H. 9½ x W. 13 in.
2008.023

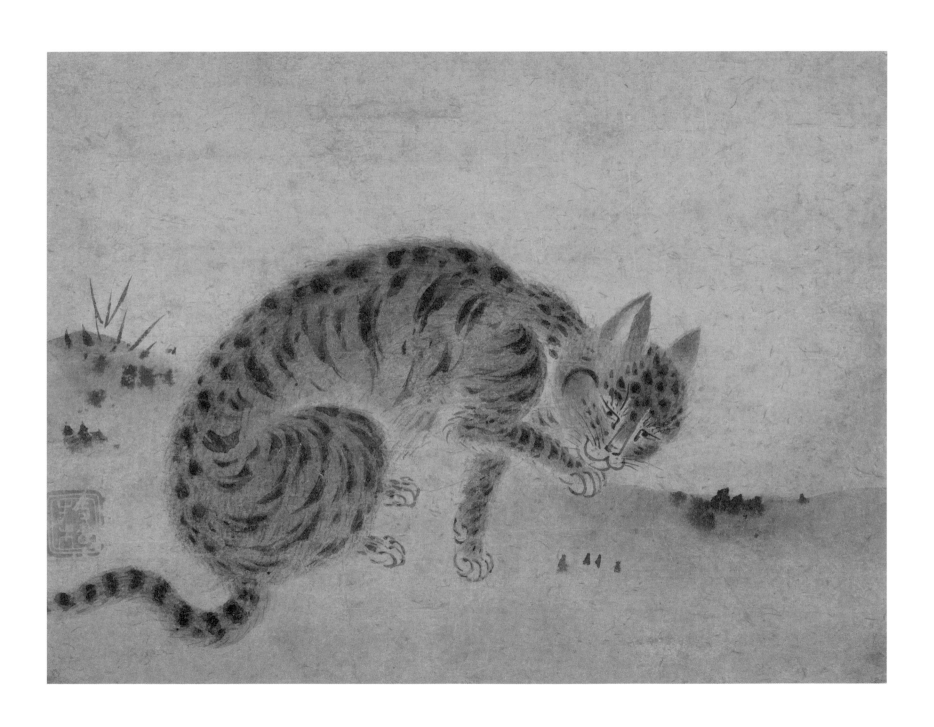

10

伝長谷川 勝親　　日月秋草図屏風　桃山時代

SUN AND MOON OVER AUTUMN PLANTS

Attrib. to Hasegawa Katsuchika (active c.1590–1615)
Momoyama period (1573–1615) or early Edo period (1615–1868), 16th–17th century
Pair of six-panel folding screens; ink, colors, and gold on paper
H. 67¹⁄₈ x W. 150 in. (each)
Artist's seal: Katsuchika
2005.001.1-2

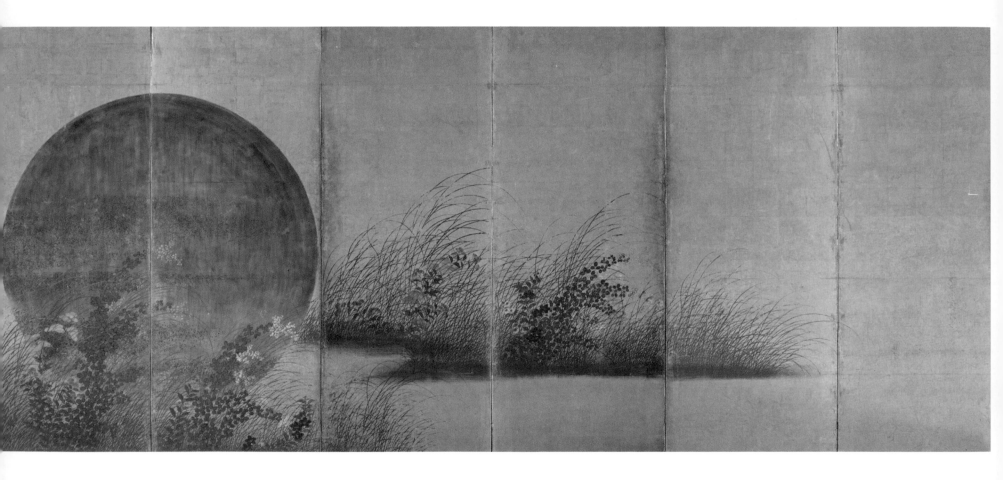

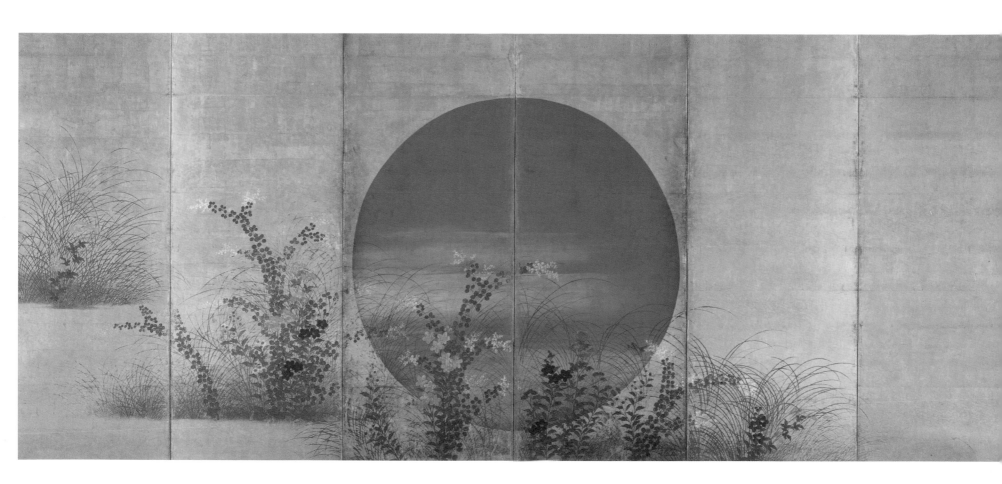

11

伝長谷川等学筆　波濤図屏風　六曲一双　紙本金地墨画淡彩　桃山時代〜江戸時代

WAVES AND ROCKS

Attrib. to Hasegawa Tōgaku (died 1623)
Momoyama period (1573–1615) or early Edo period (1615–1868), 17th century
Pair of six-panel folding screens; ink, light colors, and gold on paper
H. 70 x W. 151½ in. (each)
Published: Yamane, "Hasegawa Tōshū—Tōgaku kenkyū," fig. 12, p. 20; Motta, *Giappone. Potere e Splendore*,
Illus. IV, 172–175
2011.050.1-2

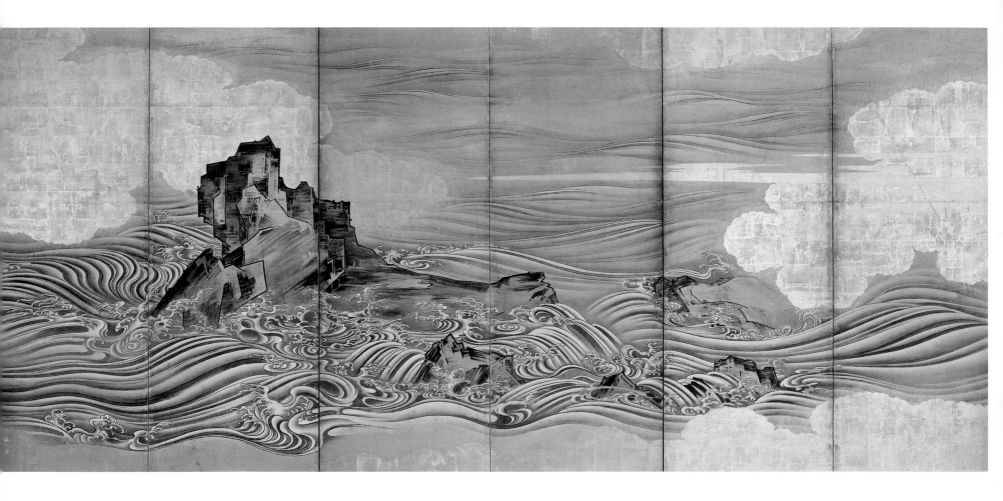

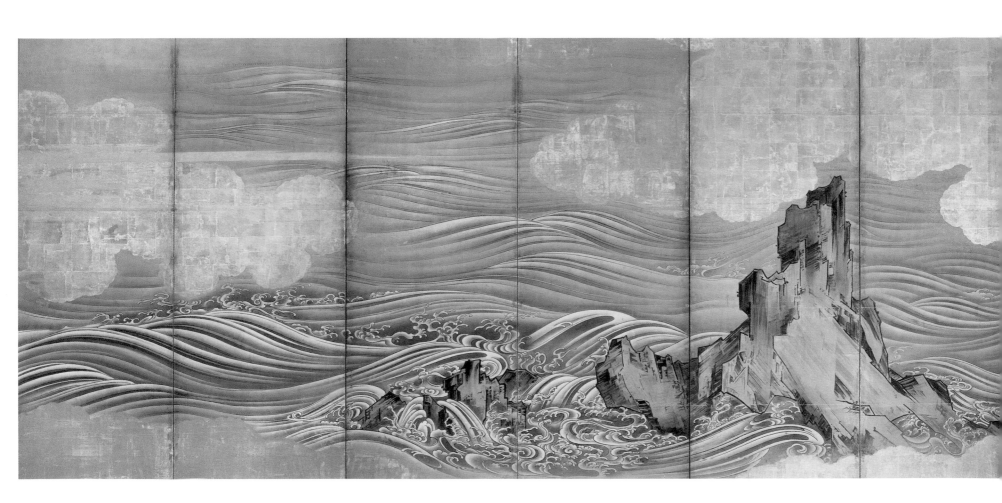

12

虎豹図屏風　六曲一双　紙本金地着色　桃山時代〜江戸時代

TIGERS AND LEOPARD

Momoyama period (1573–1615) or early Edo period (1615–1868)
Pair of six-panel folding screens; ink, colors, and gold on paper
H. 67½ x W. 150 in. (each)
2007.027.1-2

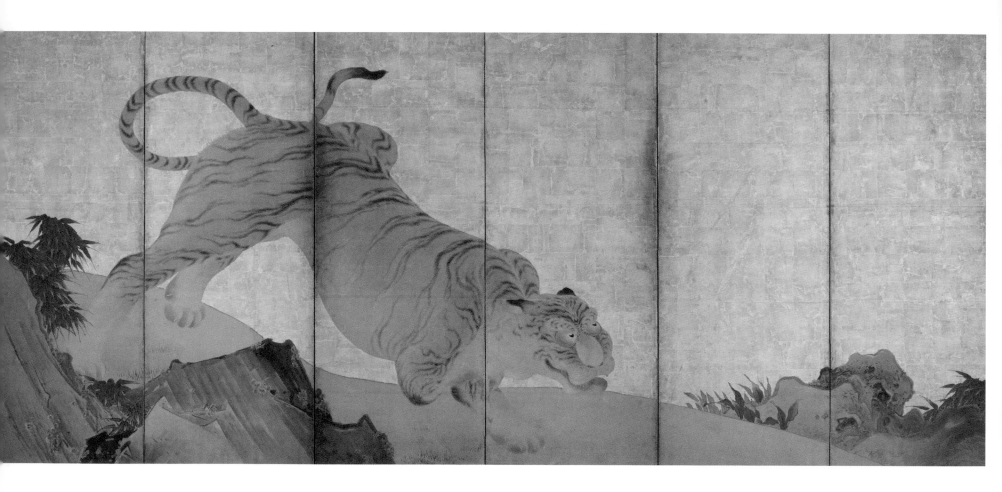

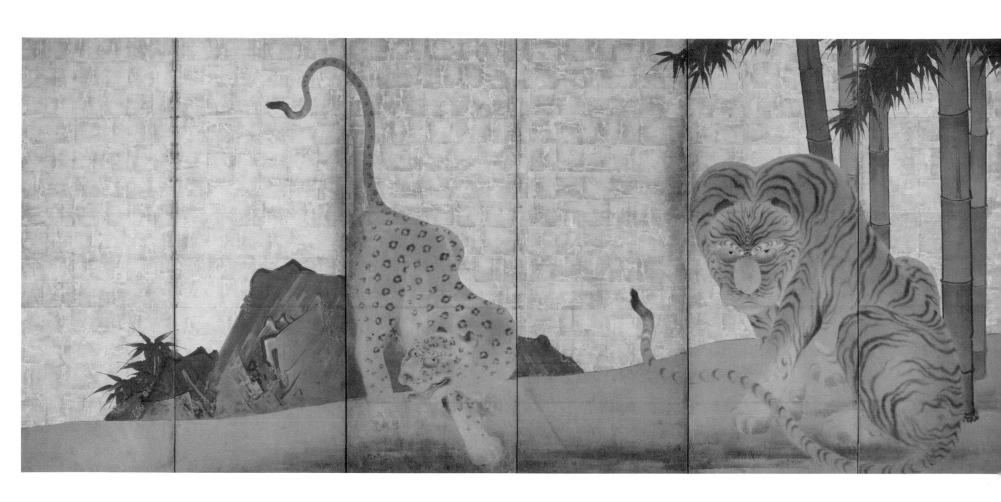

13

秋草朝顔に扇面散図和歌屏風　六曲一双　紙本金地着色　江戸時代

WAKA POEMS OVER AUTUMN GRASSES AND MORNING GLORIES
WITH SCATTERED FANS

Edo period (1615–1868), 17th century
Pair of six-panel folding screens; ink, colors, and gold on paper
H. 68¼ x W. 147 in. (each)
2009.107.1-2

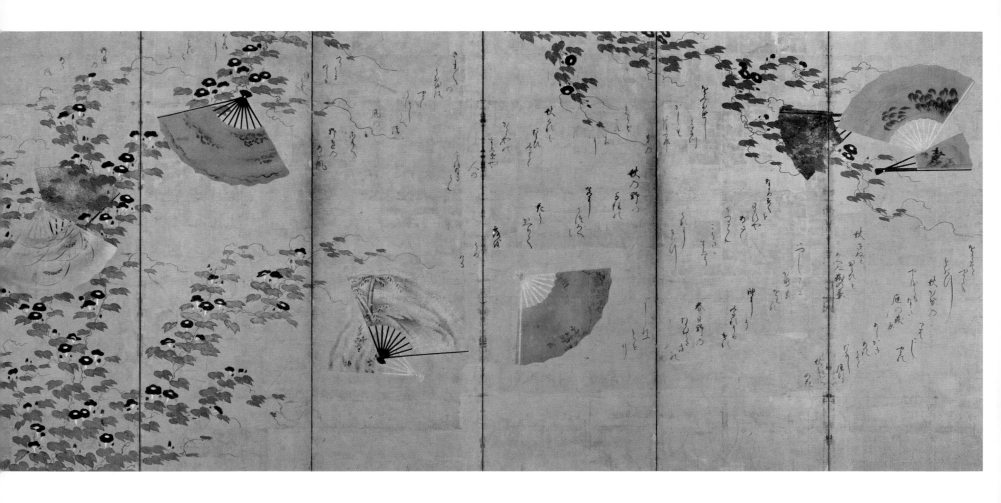

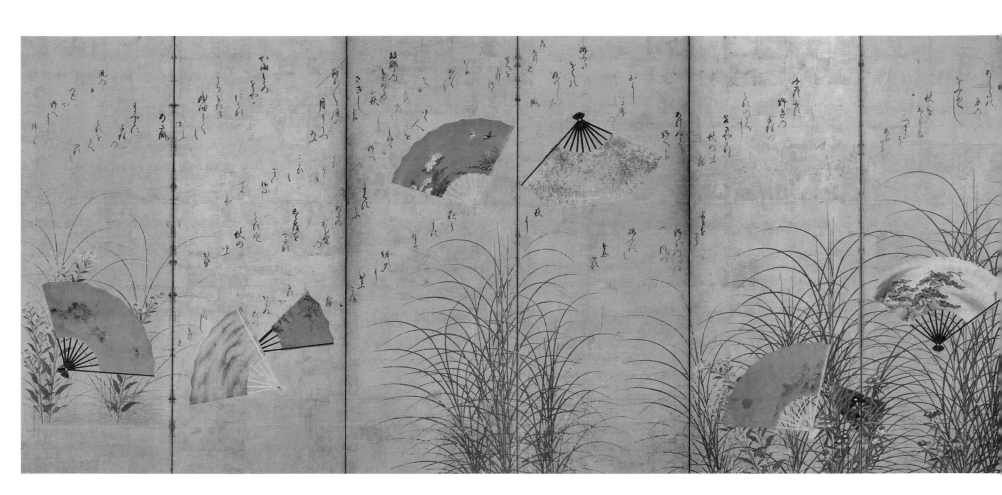

14

宗達派　扇面流し屏風　六曲一双　紙本金銀地着色　江戸時代

FLOATING FANS

School of Tawaraya Sōtatsu (died c. 1642)
Edo period (1615–1868), 17th century
Pair of six-panel folding screens; ink, colors, gold, and silver on paper
H. 65¾ x W. 150 in. (each)
Published: Tawaraya Sōtatsu, *Sōtatsu*, unpaginated; Gosudarstvennyĭ Ėrmitazh, *Schest Vekov Yaponski*, no. 20.
Murashige and Kobayashi, *Rinpa*, vol. 5, no. 21 and p. 215; Graham, "Fans Afloat," fig. 8, pp. 26–27
2007.033.1-2

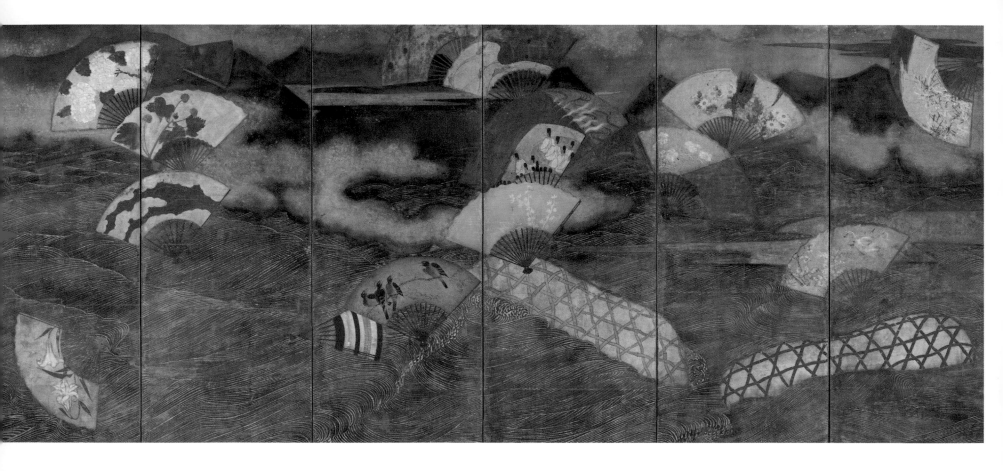

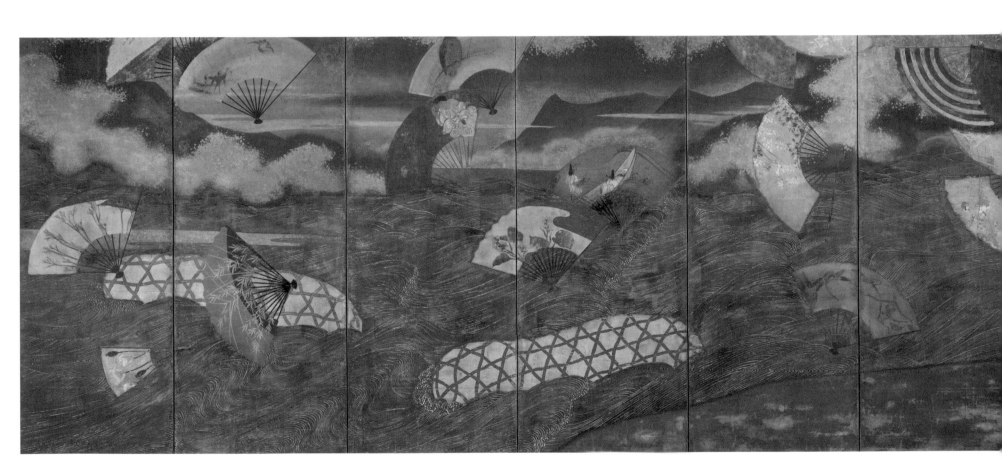

15

州信印　二十四孝花鳥山水図扇面流し屏風　六曲一双　紙本墨画淡彩　桃山時代

TWENTY-FOUR PARAGONS OF FILIAL PIETY, BIRD AND FLOWER, AND LANDSCAPE FANS ON FLOWING WATER

Seal of Kano Eitoku (1543 1590)
Momoyama period (1573–1615), c.1566–1615
Thirty-six fan papers mounted on a pair of six-panel folding screens; ink, light colors, and gold on paper
H. 68 x W. 144 in. (each)
Artist's seal: *Kuninobu* (19 fans)
Published: McKelway, "Muromachi jidai Kanoha," 53–70; Kyōto Kokuritsu Hakubutsukan,
Kano Eitoku, no. 30
2010.026.1-2

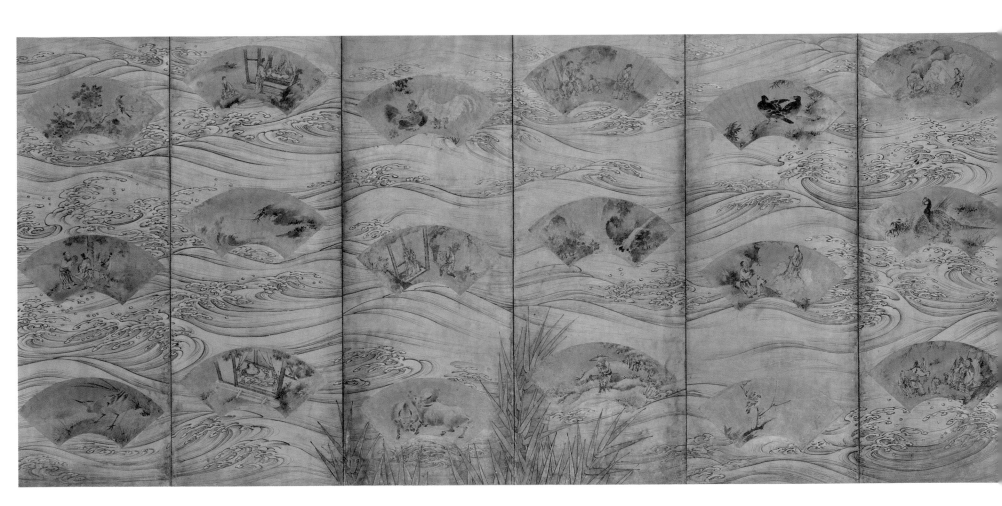

狩野宗秀筆　源氏物語図屏風　六曲一双　紙本金地着色　桃山時代

SCENES FROM *THE TALE OF GENJI*

By Kano Sōshū (1551–1601)
Momoyama period (1573–1615)
Pair of six-panel folding screens; ink, colors, and gold on paper
H. 68 x W. 145 in (each)
Artist's seals: *Genshū* (or *Motohide*), *Kano Sōshū*
2012.037.1-2

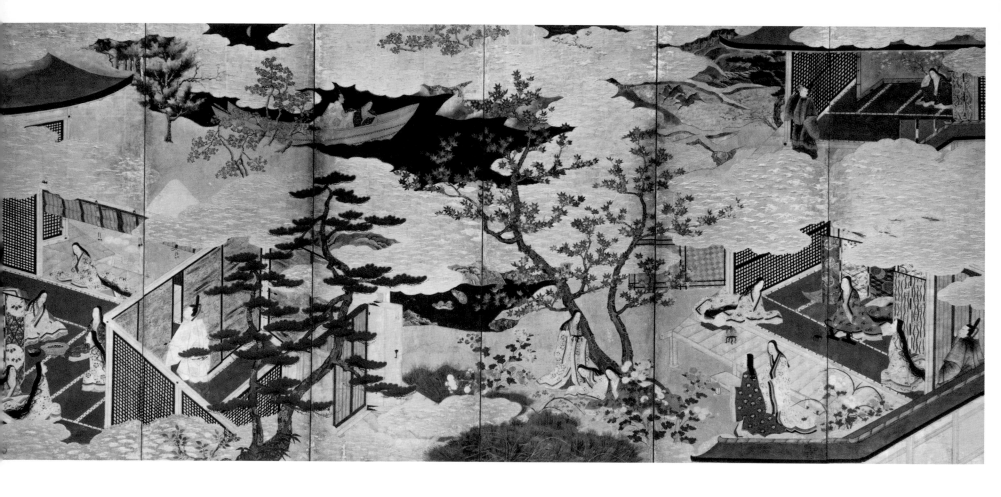

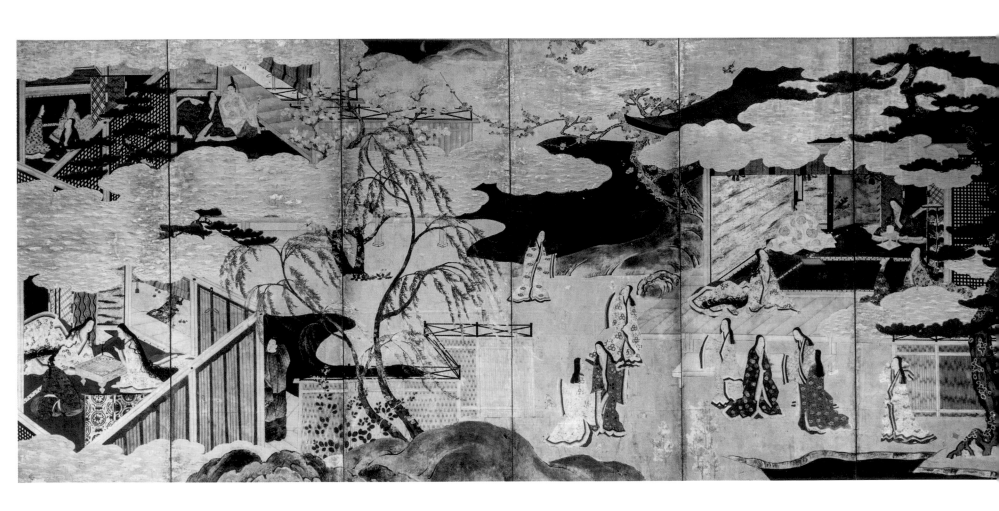

17

狩野甚之丞筆　一の谷屋島合戦図屏風　六曲一双　紙本金地着色　江戸時代

THE BATTLES OF ICHINOTANI AND YASHIMA, FROM *THE TALE OF THE HEIKE*

By Kano Jinnojō (active early 1600s)
Edo period (1615–1868)
Pair of six-panel folding screens; ink, colors, and gold on paper
H. 69⅝ x W. 153 in. (each)
Artist's seal: *Genshū* (or *Motohide*)
2009.025.1-2

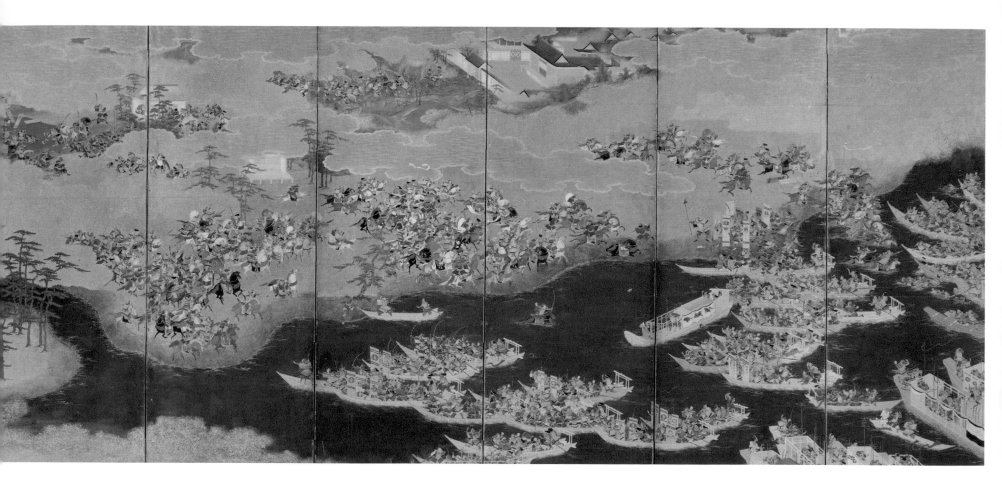

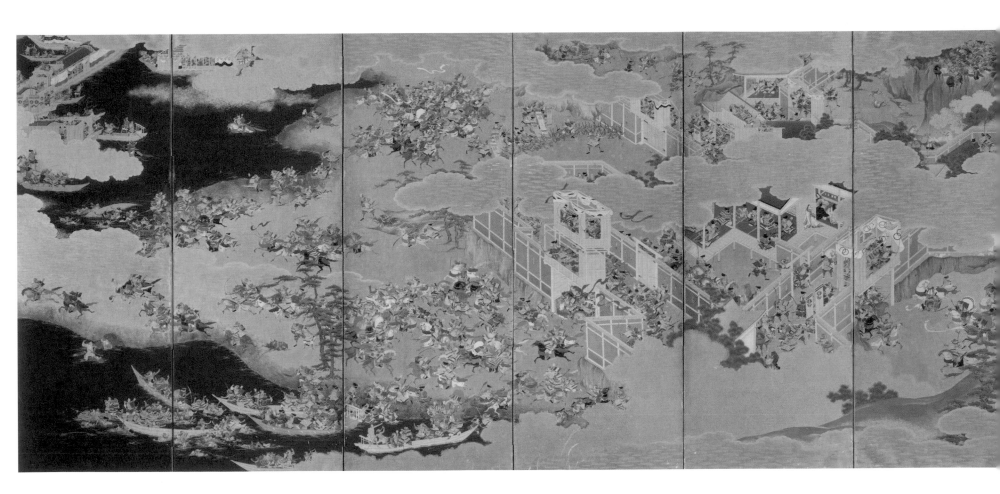

18

狩野山雪筆　四季花鳥図屏風　六曲一双　紙本墨画淡彩　江戸時代

BIRDS AND FLOWERS OF THE FOUR SEASONS

By Kano Sansetsu (1590–1651)
Edo period (1615–1868)
Pair of six-panel folding screens; ink, light colors, and gold on paper
H. 67¼ x W. 149¼ in. (each)
Signed: *Sansetsu*
Artist's seal: *Sansetsu*
Published: Kōno, "Kano Sansetsu hitsu kachōzu," pl. 5 and pp. 37–38
2007.031.1-2

19

狩野山雪筆　松竹梅鶴亀図屏風　六曲一双　紙本金地着色　江戸時代

AUSPICIOUS PINES, BAMBOO, PLUM, CRANES AND TURTLES

By Kano Sansetsu (1590–1651)
Edo period (1615–1868)
Pair of six-panel folding screens; ink, colors, and gold on paper
H. 67¼ x W. 150 in. (each)
Signed: *Kano Nuidonosuke hitsu*
Artist's seal: *Sansetsu*
2007.028.1-2

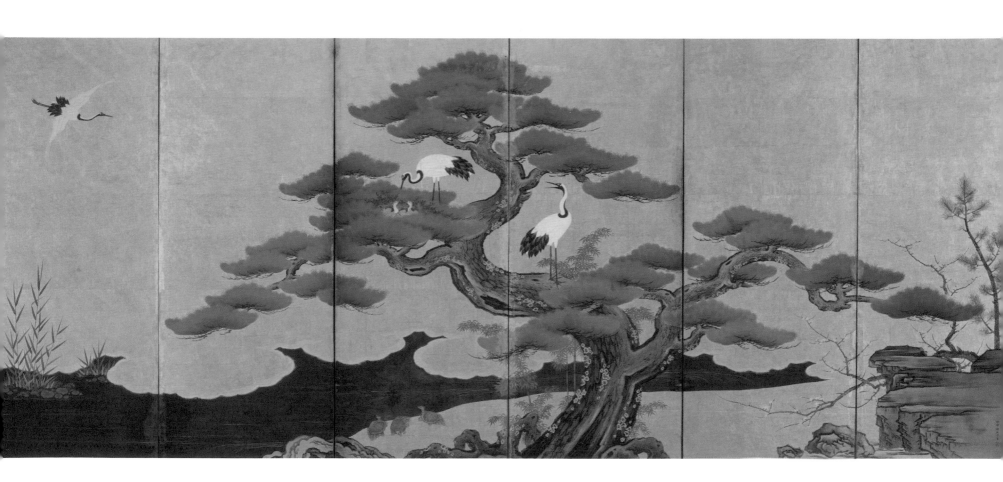

20

円山応挙筆　梅鶏図・芭蕉狗子図　二幅　紙本金地着色・紙本墨画　江戸時代

ROOSTER, HEN, AND CHICKS WITH PLUM BLOSSOMS; PUPPIES WITH JAPANESE BANANA PLANT

By Maruyama Ōkyo (1733–1795)

Edo period (1615–1868), 1785

Pair of hanging scrolls; ink, colors, and gold on paper (chickens); ink and gold on paper (puppies)

H. 52¼ x W. 53⅜ in. (each)

Signed: *Ōkyo utsusu* (chickens); *Ōkyo* (puppies)

Artist's seal: *Ōkyo no in, Chūsen* (each)

Dated (puppies): *Tenmei kinoto mi shoshū utsusu Ōkyo* (Painted by Ōkyo, early autumn 1785)

Published: Minamoto, *Maruyama Ōkyo gashū*, vol. 1, 398; Sasaki *Maruyama Ōkyo kenkyū*, Vol. 2, 442

2008.060.1-2

DETAIL

21

円山応挙筆　龍虎図屏風　六曲一双　紙本墨画　江戸時代

DRAGON AND TIGER

By Maruyama Ōkyo (1733–1795)
Edo period (1615–1868), c.1781–1788
Pair of six-panel folding screens; ink on paper
H. 67½ x W. 150 in. (each)
Signed: *Ōkyo hitsu*
Artist's seal: *Ōkyo*
Published: McKelway, *Traditions Unbound*, no. 29; Minamoto, *Maruyama Ōkyo gashū*, no. 499
2008.003.1-2

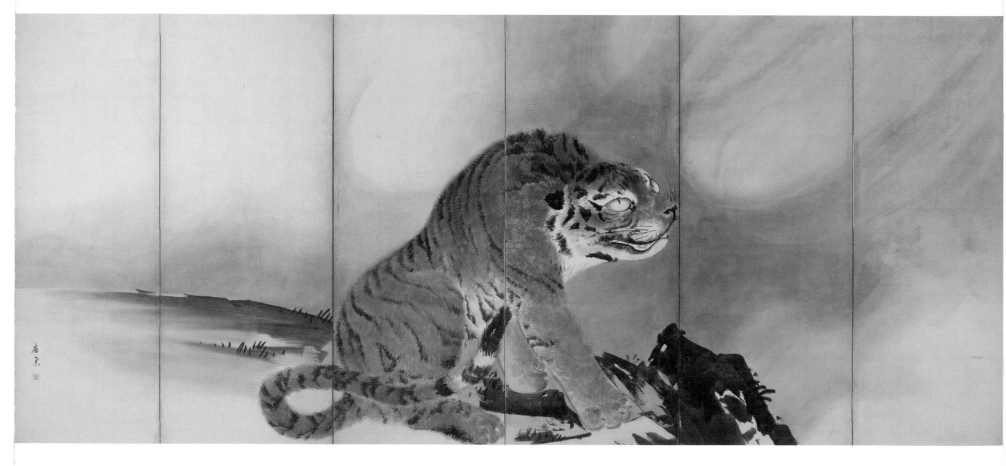

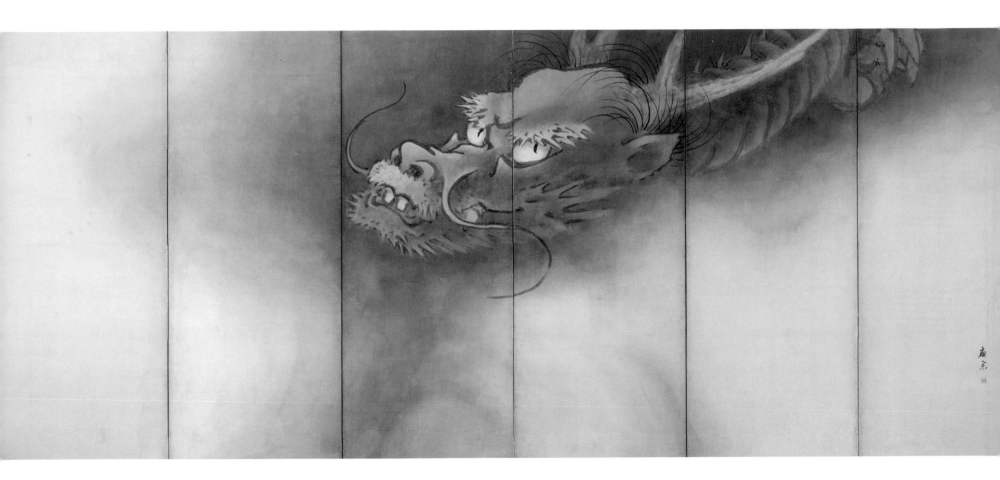

22

円山応挙筆　虎図　二幅　紙本墨画淡彩
江戸時代　1779年

TIGERS

By Maruyama Ōkyo (1733–1795)
Edo period (1615–1868), 1779
Pair of hanging scrolls; ink and light colors on paper
H. 45¾ x W. 20½ in. (each)
Signed: *Ōkyo utsusu* (right), *An'ei tsuchinoto i shotō* [*ni*]
utsusu Ōkyo (Painted by Ōkyo, early winter 1779; left)
Published: Minamoto, *Maruyama Ōkyo gashū*, Vol. 1,
no. 237, p. 105; Kyōto Kokuritsu Hakubutsukan,
Maruyama Ōkyo jojō to kakushin, no. 44
2011.112.1-2

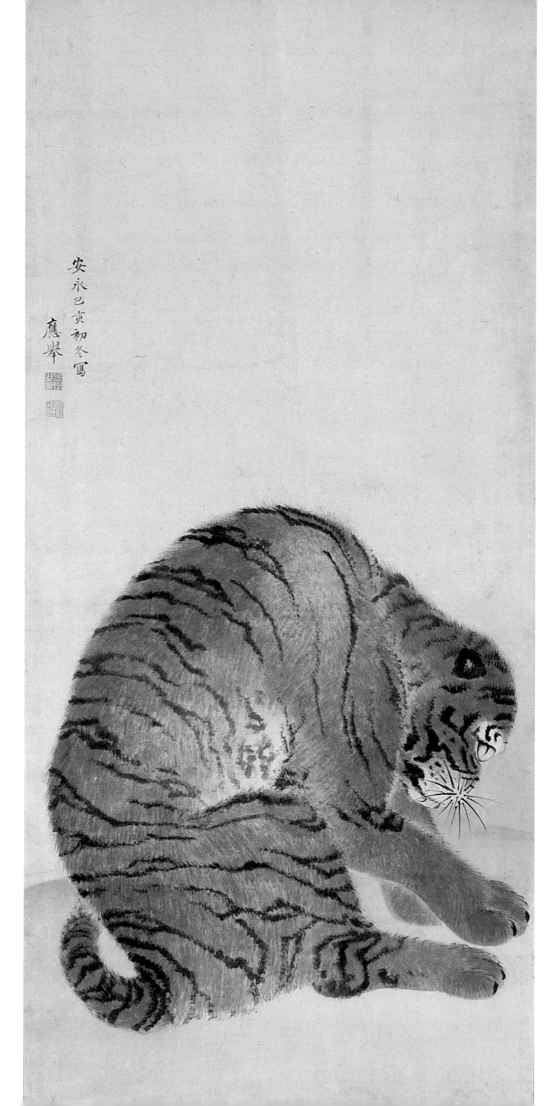

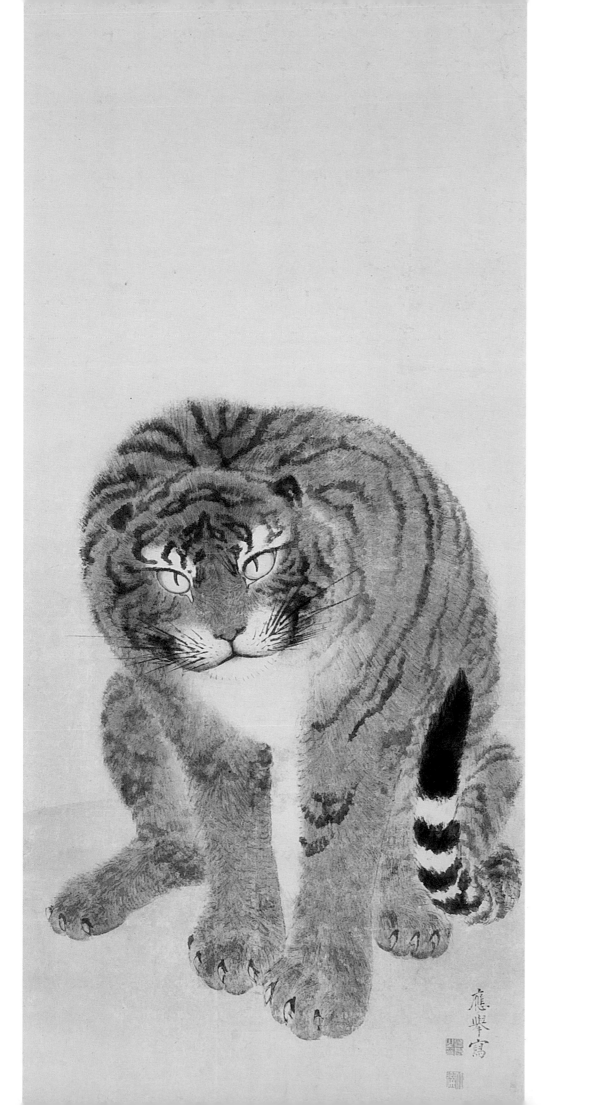

23

円山応挙筆　雪ノ下に猫図　一幅　紙本着色　江戸時代

YOUNG CAT SLEEPING UNDER SAXIFRAGE (*YUKINOSHITA*)

By Maruyama Ōkyo (1733–1795)
Edo period (1615–1868)
Hanging scroll; ink and colors on paper
H. 14½ x W. 13¾ in.
Inscription by Kunii Ōyō (1868–1923) attesting that the painting is by Maruyama Ōkyo
2010.107

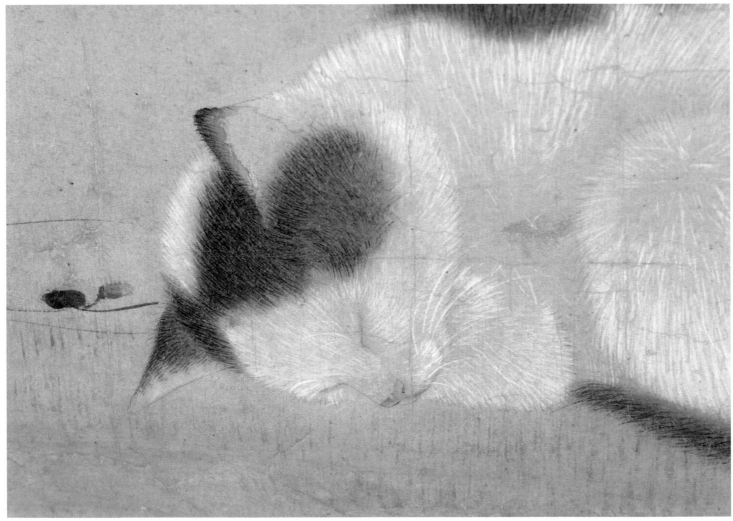

DETAIL

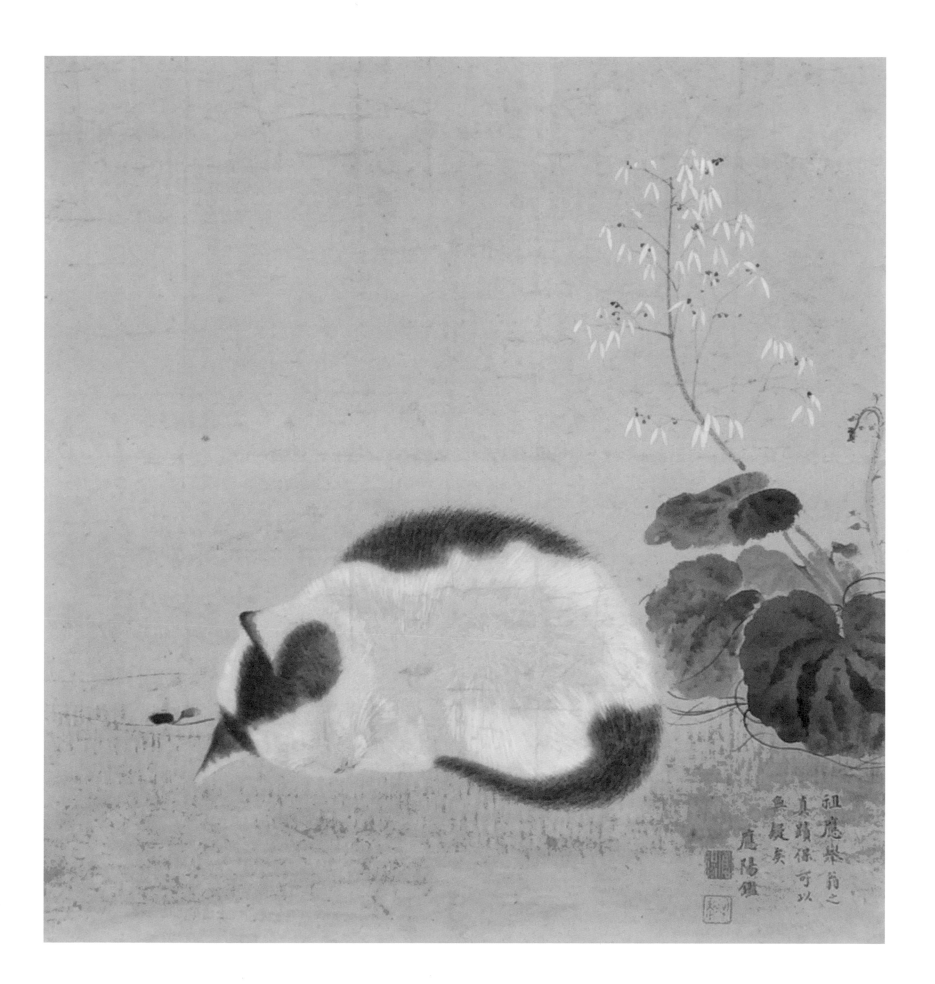

24

長沢芦雪印　鷲•熊図　二幅　絹本墨画淡彩
江戸時代

EAGLE AND BEAR

Seal of Nagasawa Rosetsu (1754–1799)
Edo period (1615–1868)
Pair of hanging scrolls; ink and light colors on silk
H. 56 1/8 x 27 3/4 in. (Eagle); H. 56 3/8 x W. 27 1/2 in. (Bear)
Signed: *Rosetsu utsusu* (Eagle) and *Motome ni ōjite
Chō Inkyo utsusu* (Bear)
Artist's seal: *Gyo*
Published: Fuchū Bijutsukan, *Dōbutsu kaiga
no 100 nen*, no. 34; Shizuoka Kenritsu Bijutsukan,
Jakuchū to kyō no gakka tachi, no. 23
2008.004.1-2

25

曽我蕭白筆　山水図屏風　六曲一双　紙本墨画　江戸時代

MOUNTAIN AND RIVER LANDSCAPES

By Soga Shōhaku (1730–1781)
Edo period (1615–1868)
Pair of six-panel folding screens; ink and gold on paper
H. 65 x W. 144 in. (each)
Signed: *Soga Shōhaku ga*
Artist's seals: *Yūson, Shiryū*
2008.002.1-2

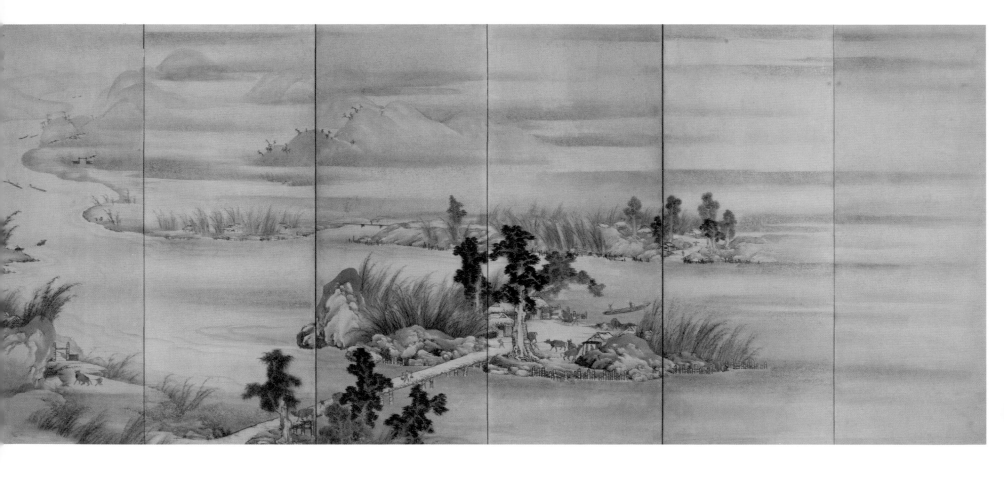

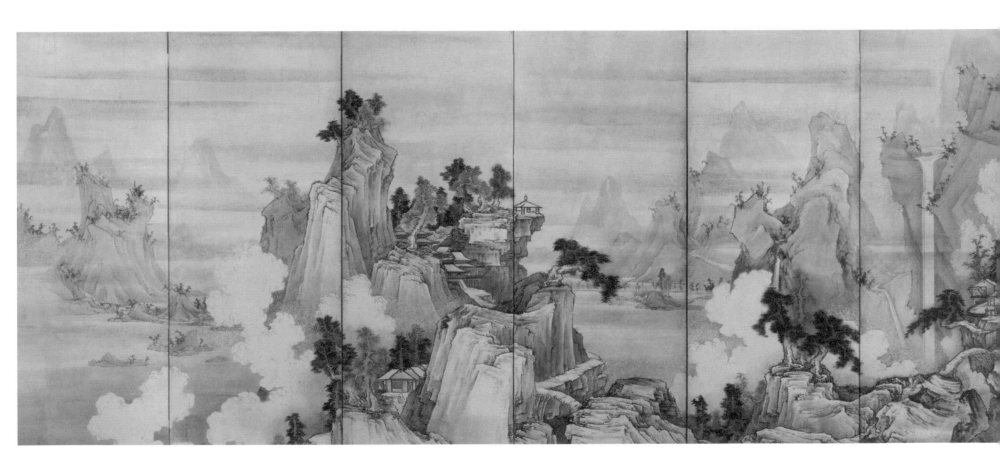

26

曽我蕭白筆　鶴・鹿図　二幅　絹本墨画淡彩　江戸時代

CRANES AND DEER

By Soga Shōhaku (1730–1781)
Edo period (1615–1868)
Pair of hanging scrolls; ink and light colors on silk
H. 46¹⁄₂ x W. 19⁵⁄₈ in. (each)
Artist's seals: *Jasokuken Shōhaku* and *Kiichi*
Published: Mie Kenritsu Bijutsukan, *Soga Shōhaku ten*, no. 42
2012.95.1-2

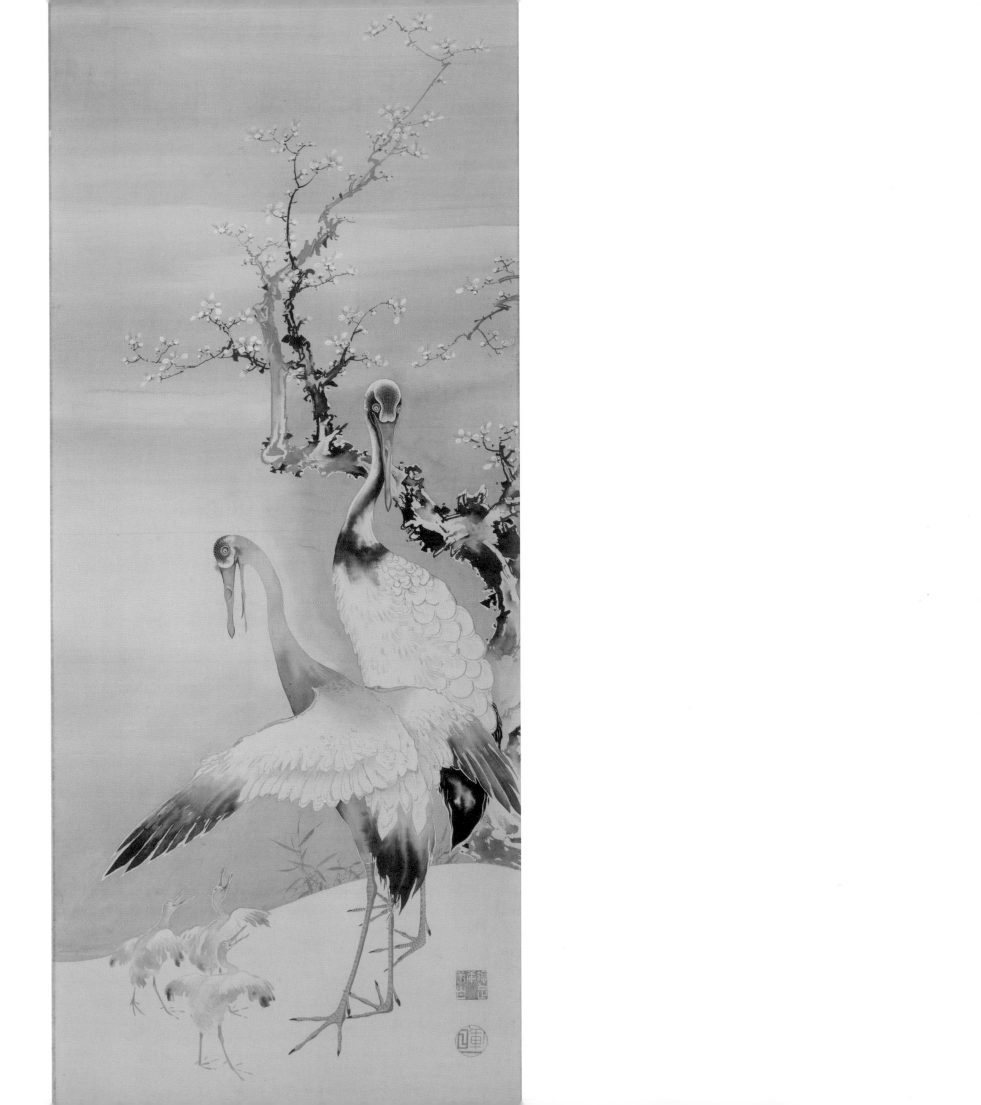

伊藤若冲筆　遊鮎図　一幅　絹本着色　江戸時代　1752年頃

SWEETFISH

By Itō Jakuchū (1716–1800)
Edo period (1615–1868), c. 1752
Hanging scroll; ink and colors on silk
H. 41½ x W. 18⅜ in.
Signed: *Heian Jakuchū sei* (Made by Jakuchū in Kyoto)
Artist's seals: *Jokin, Tansei wa masa ni oi no itaru o shirazu*
2012.099

DETAIL

28

伊藤若冲筆　柿木に叭々鳥図　一幅　紙本墨画　江戸時代　1763年

MYNAH BIRD IN A PERSIMMON TREE

By Itō Jakuchū (1716–1800)

Edo period (1615–1868), 1763

Hanging scroll; ink on paper

H. 44³/₈ x W. 11³/₄ in.

Artist's seals: *Tō Jokin in, Jakuchū koji*

Inscription by the Ōbaku monk Musen Jōzen (Tangai, 1693–1764), at the age of seventy–one, with seals *Jōzen no in* and *Un'an Gyōjin*

Published: Lim, *Aziatische Kunst*, no. 76; Yamane, Shimada and Akiyama, eds. *Zaigai nihon no shihō*, Vol. 6, no. 78; Satō, *Itō Jakuchū*, pl. 89, p. 59

2012.098

29

伊藤若冲筆　白衣観音・鶴・亀図　三幅　絹本墨画　江戸時代　1793年

WHITE-ROBED KANNON (AVALOKITESHVARA), CRANES, AND TURTLES

By Itō Jakuchū (1716–1800)
Edo period (1615–1868), 1793
Set of three hanging scrolls; ink on silk
H. 51 1/2 x W. 16 1/8 in. (Kannon); H. 51 1/2 x W. 16 3/8 in. (Cranes and turtles)
Signed: *Beito-ō toshi hachijū sai ga* (Painted by Old Man Beito, age eighty)
Artist's seals: *Tō Jokin in, Jakuchū koji*
2012.097.1-3

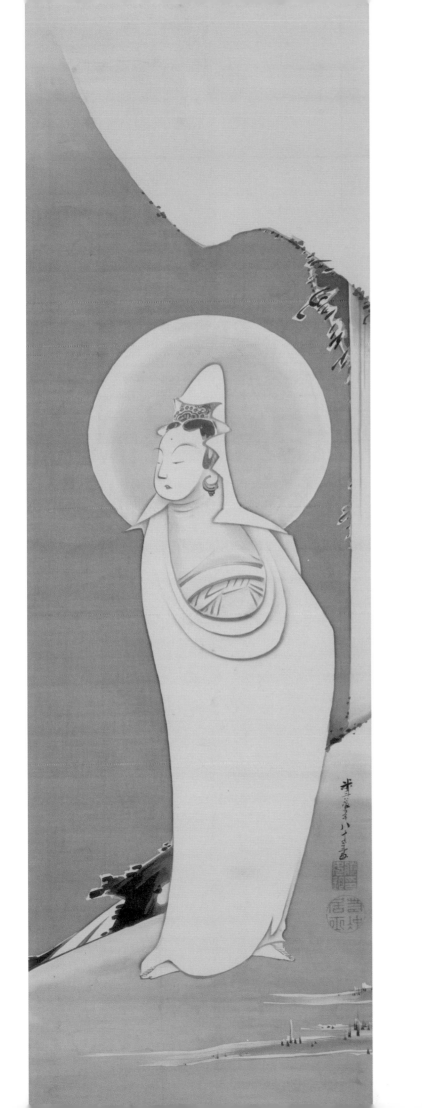
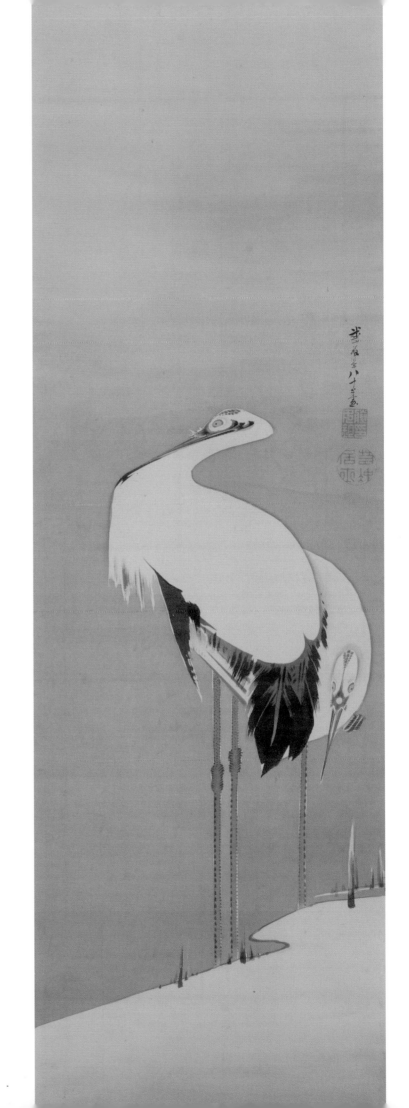

30

伊藤若冲筆　白象図　一幅　紙本墨画　江戸時代　1768年頃

WHITE ELEPHANT

By Itō Jakuchū (1716–1800)
Edo period (1615–1868), c. 1768
Hanging scroll; ink on paper
H. 43¼ x W. 12 in.
Artist's seals: *Tō Jokin in, Jakuchū koji*
Published: Kyoto Kokuritsu Hakubutsukan, *Itō Jakuchū taizen*, no. 119
2009.004

31

伊藤若冲印　鶴図　一幅　紙本墨画　江戸時代

CRANE

Seal of Itō Jakuchū (1716–1800)
Edo period (1615–1868)
Hanging scroll; ink on paper
H. 45½ x W. 11½ in.
Artist's seals: *Tō Jokin in, Jakuchū koji*
2008.021

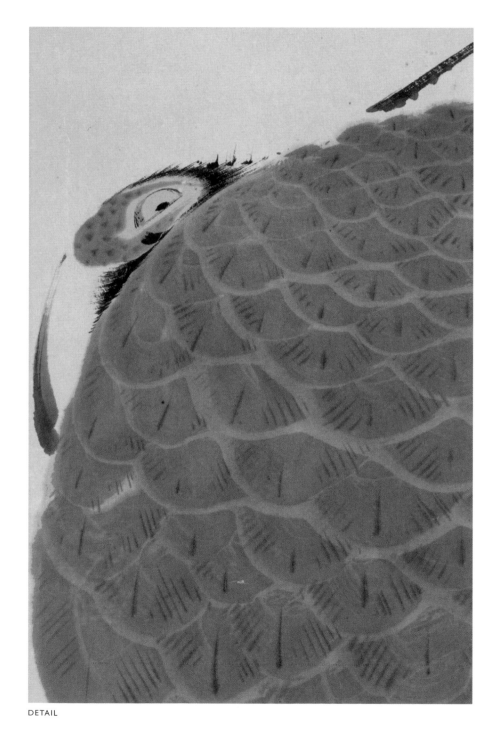

DETAIL

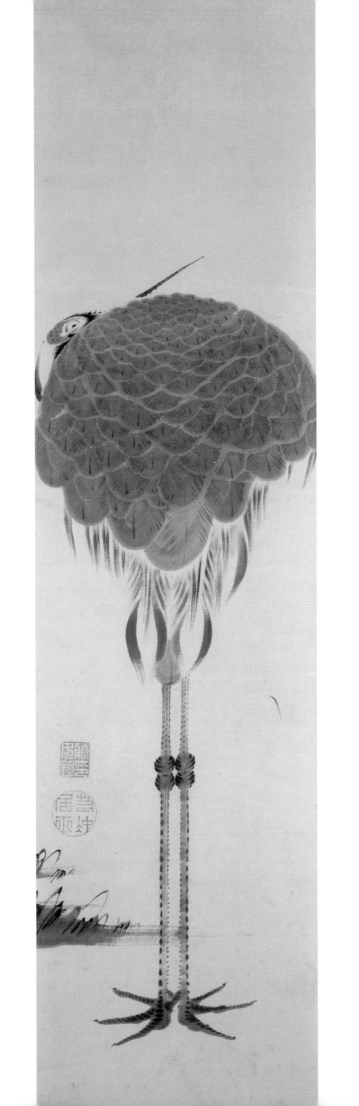

32

玉蜀黍図屏風　六曲一双　紙本金地着色　江戸時代

MAIZE AND COXCOMB

Edo period (1615–1868), 18th century
Pair of six-panel folding screens; ink, colors, and gold on paper
H. 69 x W. 145 in. (each)
Published: Kano, *Rinpa bijutsukan*, no. 23, pp. 38–39; Kobayashi, *Rinpa*, vol. 2,
no. 309 and pp. 188–189, 285, 327; Takeda, *Nihon byōbu-e shūsei*, 105;
Ishikawa-ken Bijutsukan, *Nihon sōshokuga no nagare*, no. 15; Akiba, *Kinpeki sōshoku
gashū*, unpaginated
2012.081.1-2

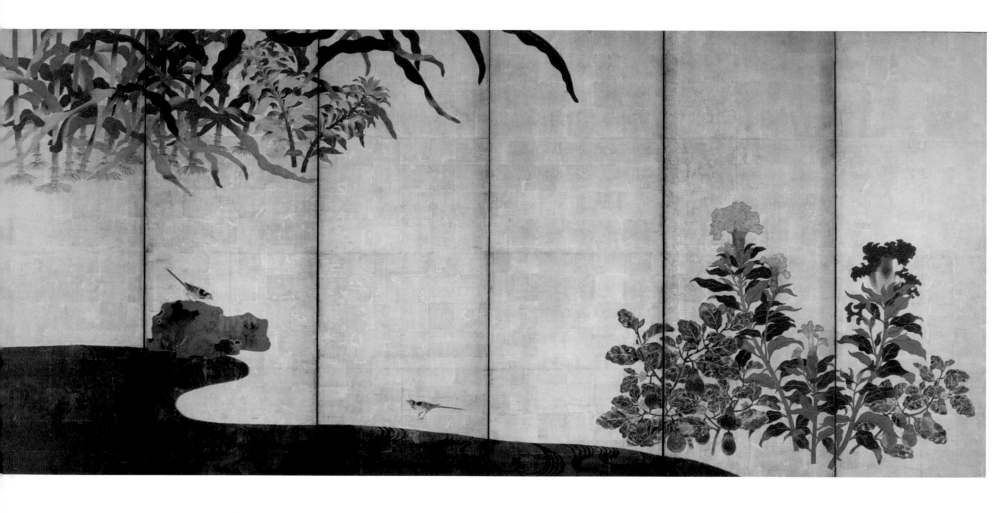

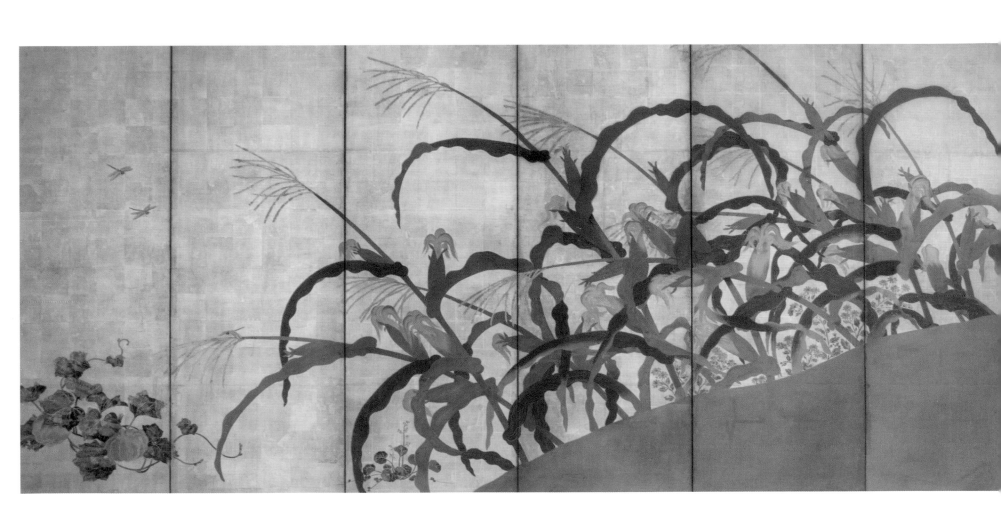

鈴木其一筆　春秋草花図屏風　二曲一双　絹本着色　江戸時代

SPRING AND AUTUMN PLANTS

By Suzuki Kiitsu (1796–1858)
Edo period (1615–1868), 1850s
Pair of two-panel folding screens; ink, colors, and gold on silk
H. 60 x W. 66 in. (overall)
Signed: *Seisei*
Artist's seal: *Shukurin*
Published: McKelway, *Silver Wind*, no. 57
2008.061.1-2

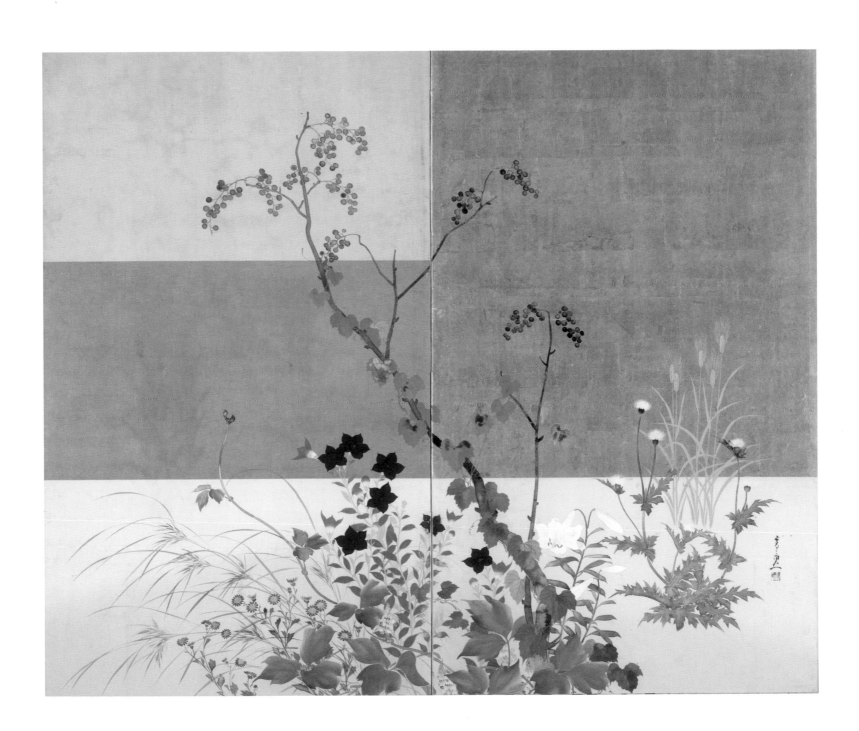

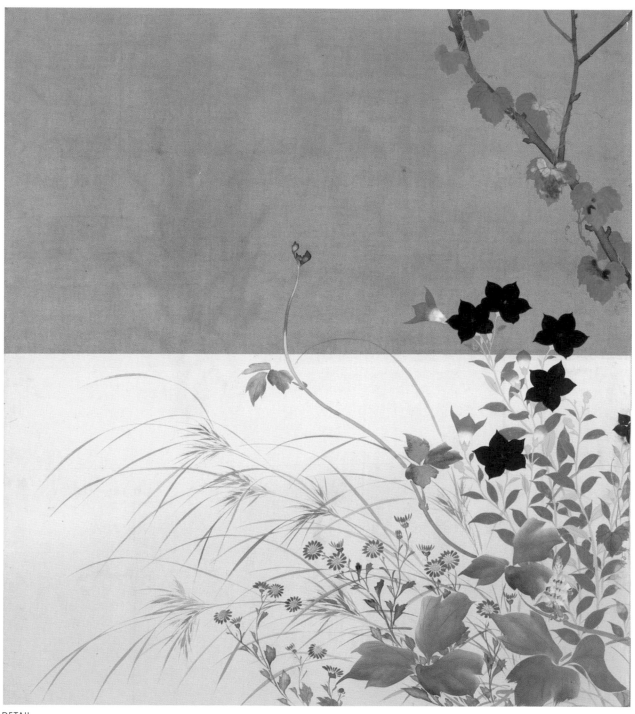

DETAIL

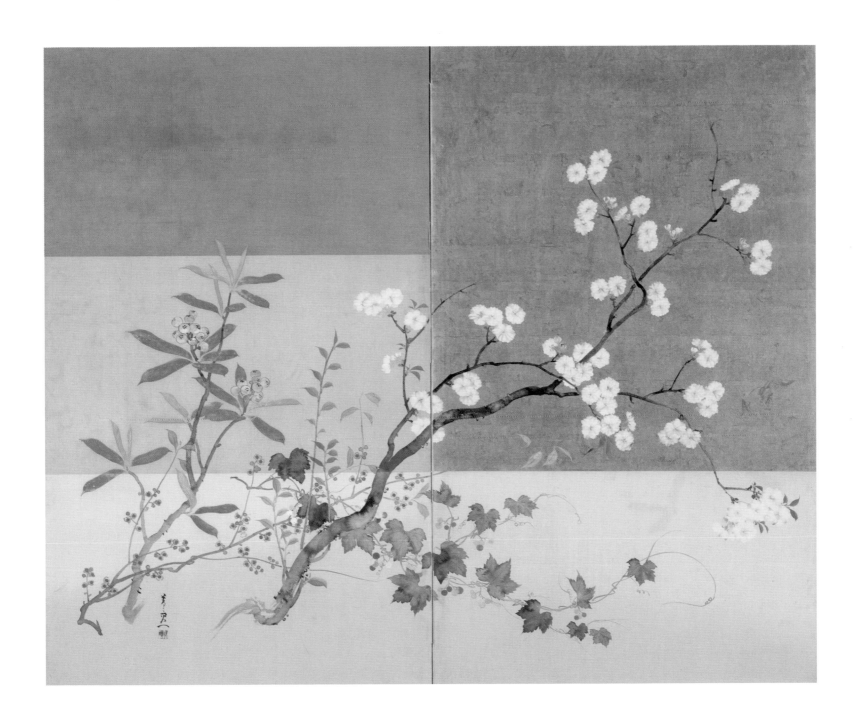

34

鈴木其一筆　寿老・群鹿・群鶴図　三幅　絹本着色　江戸時代

JURŌJIN, DEER, AND CRANES

By Suzuki Kiitsu (1796–1858)
Edo period (1615–1868), c. 1844–1858
Set of three hanging scrolls; ink and colors on silk
H. 37 x W. 13¾ in. (each)
Signed: *Seisei Kiitsu* (Jurōjin)
Artist's seal: *Shukurin* (Jurōjin), *Kiitsu* (deer, cranes)
Published: McKelway, *Silver Wind*, no. 20; Machida Shiritsu Kokusai Hanga
Bijutsukan, *Rinpa: Han to kata*, no. 20; Itabashi Kuritsu Bijustukan, *Suzuki Kiitsu ten*,
no. 40; Murashige, *Rinpa*, vol. 4, no. 175; Murashige, *Rinpa*, vol. 3, no. S15 (deer)
2008.062.1-3

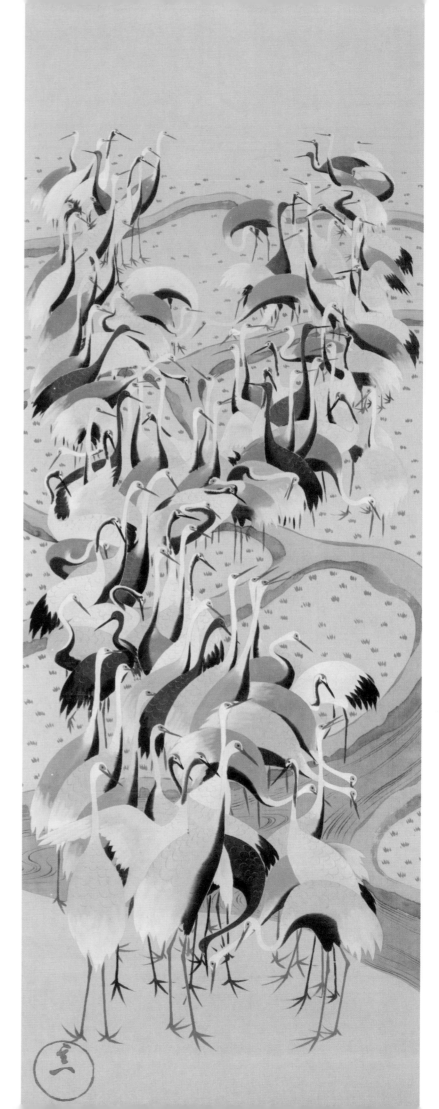

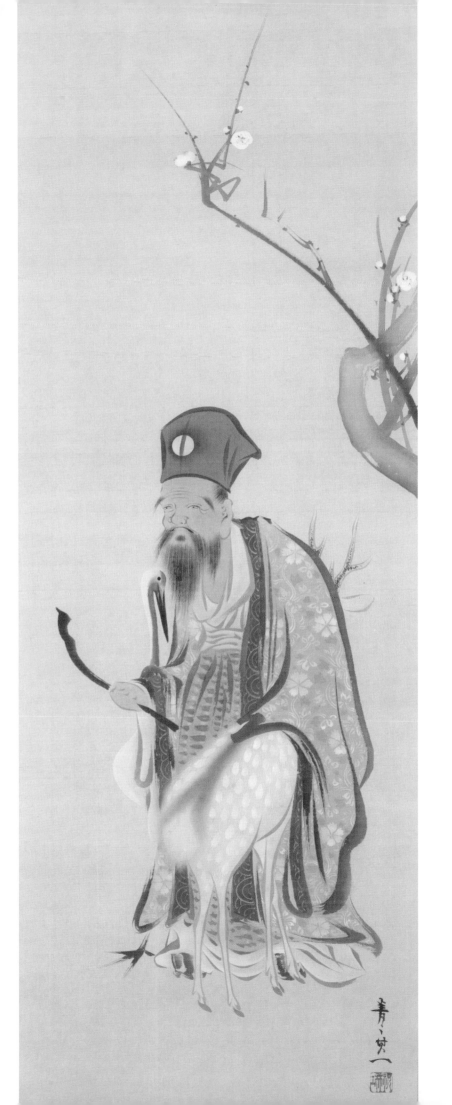
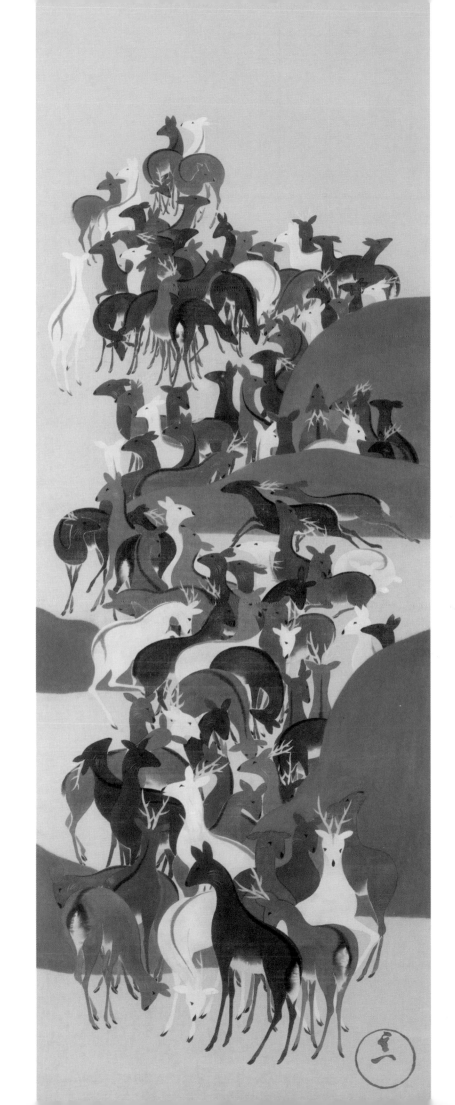

35

与謝蕪村筆　鳶図　一幅　紙本墨画淡彩　江戸時代

KITE IN RAIN

By Yosa Buson (1716–1783)
Edo period (1615–1868)
Hanging scroll; ink and light colors on paper
H. 50¾ x W. 22¼ in.
Signed: *Heian Sha Shunsei Yahantei ni oite utsusu* (Painted by Sha Shunsei at Yahantei in Kyoto)
Artist's seals: *Sha Shunsei, Sha Chōkō*
Published: Kobayashi, "Yosa Buson hitsu tobizu," 24–26
2008.022

DETAIL

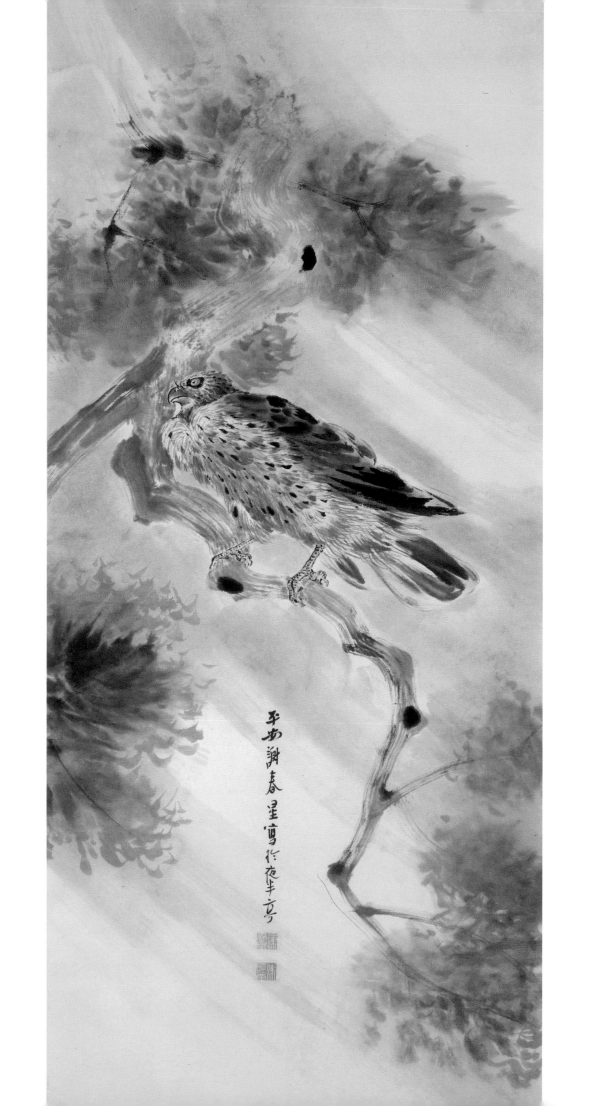

36

池大雅筆　楼閣山水図　一幅　紙本墨画淡彩　江戸時代

LANDSCAPE WITH PAVILION

By Ike Taiga (1723–1776)
Edo period (1615–1868)
Hanging scroll; ink and light colors on paper
H. 49 x W. 16¼ in.
Signed: *Kyūka Sanshō shiboku* (fingerpainted by Kyūka Sanshō)
Artist's seal: *Raiseikan*
2009.054

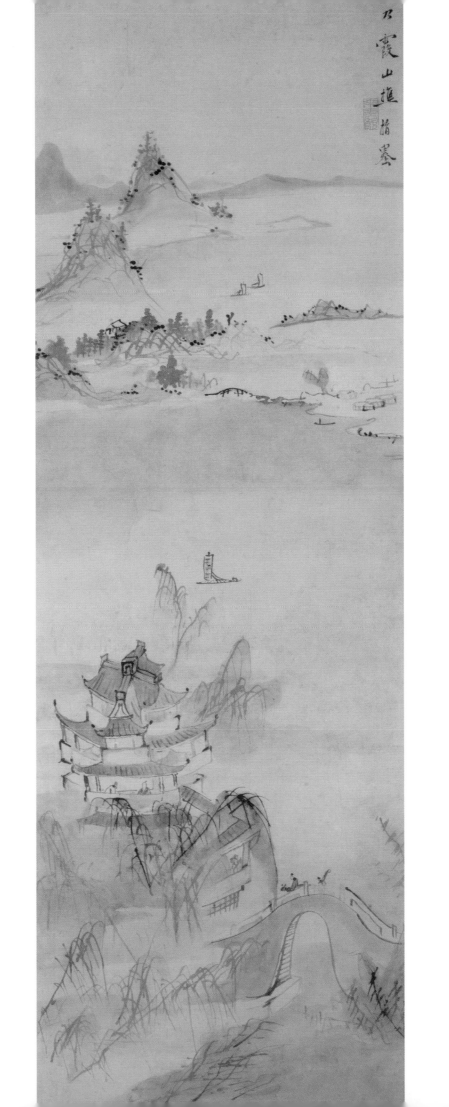

37

葛飾北斎筆　龍図　一幅　紙本墨画　江戸時代　1839年

DRAGON

By Katsushika Hokusai (1760–1849)
Edo period (1615–1868), 1839
Hanging scroll; ink and gold on paper
H. 52¾ x W. 11⅝ in.
Signed: *Gakyō rōjin Manji hitsu, yowai hachijū* (Painted by Manji, the old man
mad about painting, at age eighty)
Artist's seal: *Katsushika*
2011.049.1-2

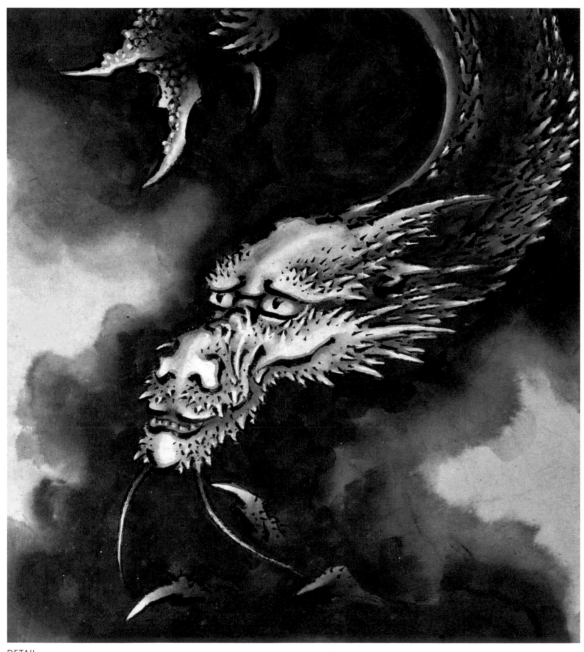

DETAIL

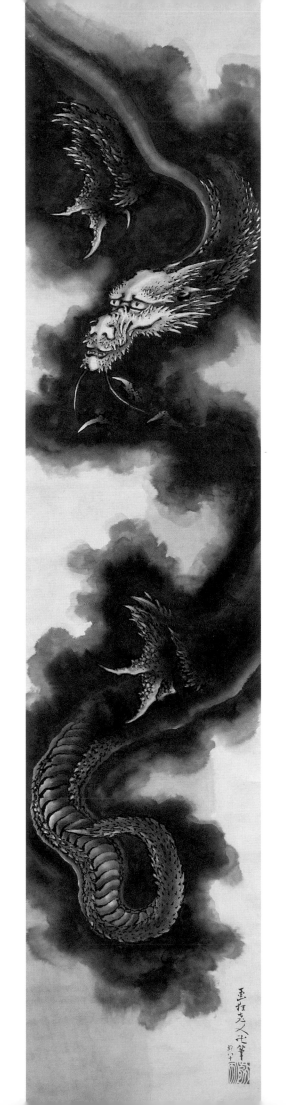

38

西山完瑛筆　群虫行列図　一幅　絹本淡彩　江戸時代〜明治時代

INSECT PROCESSION

By Nishiyama Kan'ei (1833–1897)
Edo period (1615–1868) or Meiji period (1868–1912)
Hanging scroll; ink and light colors on silk
H. 12¼ x W. 37 in.
Artist's seal: *Nishiyama Ken in*
2009.166

DETAIL

内海輝邦筆　孔雀鳥図屏風　六曲一双　絹本銀地着色　大正時代

PEACOCK AND RAVEN

By Usumi Kihō (born 1873)

Taishō period (1912–1926)

Pair of six-panel folding screens; ink, colors, silver, gold, and lacquer on silk

H. 69 x W. 138 in. (each)

Signed: *Kihō*

Artist's seal: *Hiroaki*

Published: Thomsen, *Japanese Paintings*, no. 5

2010.027.1-2

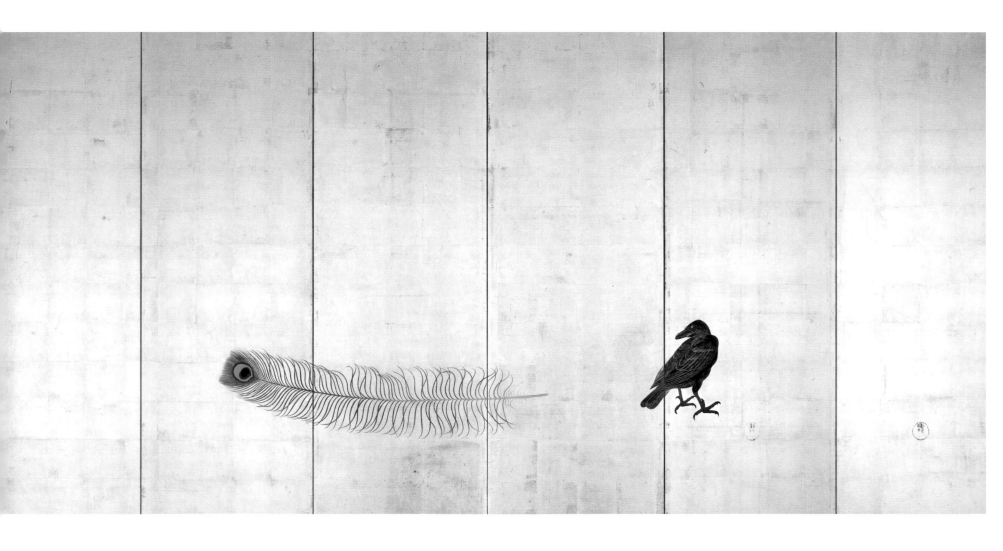

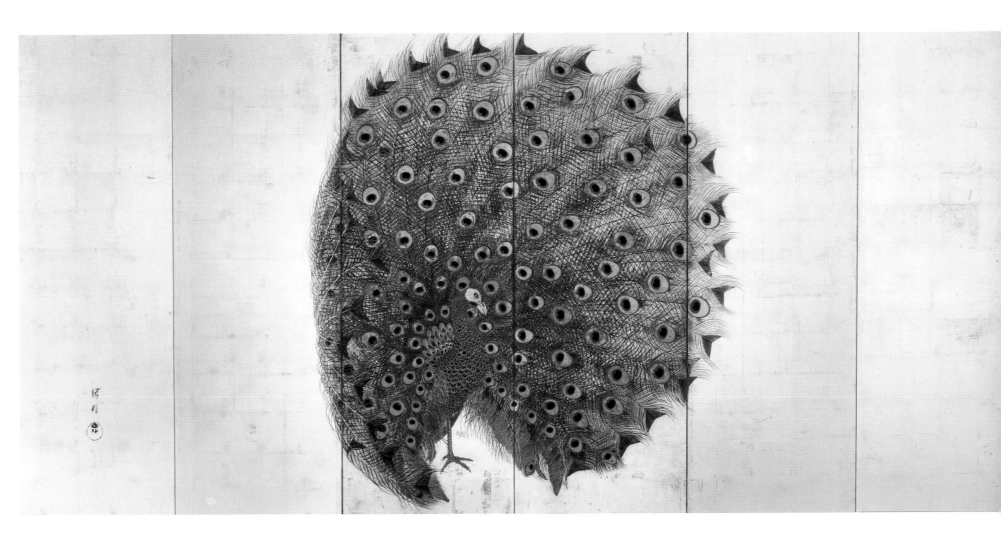

LACQUER

The lacquers in the Ellison Collection, while small in number, include representative examples of two major stylistic trends of Edo period lacquer work: Rinpa and Ritsuō.

Rinpa-style lacquers are distinguished by their shapes, materials, and classical literary imagery. The writing box (*suzuribako*) with ferns attributed to Hon'ami Kōetsu (1558–1637) is decorated with designs of gold powder sprinkled into wet lacquer (*hiramakie*). The appliqued lead characters on the top of the lid and the lead and mother-of-pearl rabbits on the underside of the lid are typical of lacquers by Kōetsu and his followers—and make the box extremely heavy. The surfaces are embellished with the same lacy *Davallia* fern motif and poetic inscription found on a Kōetsu writing box in the Tokyo National Museum, designated an Important Art Object. On the lid is the second part of a well-known *waka* poem by Minamoto Tōru from the tenth century imperial anthology *Kokinshū*. It incorporates a triple entendre on the term *shinobu*—which can refer to a geographic location, a type of fern, or romantic yearning.

> [Like the cloth printed / with ferns in far Shinobu of the deep north] / if not for you / for whom would I / dye my heart with tangled love[1]

> [*Michinoku no / Shinobu mojizuri*] /*tare yue ni / midaremu to omou /ware naranaku ni*

The representations of deer and bush clover on another writing box exemplify both the distinctive aesthetics of Ogata Kōrin (1658–1716) and the literary motifs favored by Rinpa artists. The two-tiered box has an unusual, elongated shape pioneered by Kōrin, with an overhanging lid cut high on either side, making it easier to open. The top tier holds an inkstone and water dropper. The pairing of deer and bush clover iconography in artworks derives from earlier imagery in classical waka poetry, such as the example below, also from the *Kokinshū*. Bush clover (*hagi*) blooms during the autumnal mating season, when the belling of deer arouses feelings of loneliness and longing. Edwin Cranston has noted that bush clover is sometimes referred to as the "wife" of the stag.[2]

> Autumn bush clover / trampling, tangling in the fields, / the belling deer / cannot be seen by the searching eye— / but, oh, the clearness of their call![3]

> *akihagi o / shigaramifusete / naku shika no / me ni wa miezute / oto no sayakesa*

Ogawa Haritsu (1663–1747), the progenitor of the eponymous Ritsuō (literally, "old man Ritsu") style, was known for his highly eclectic, distinctive treatment of everyday subjects, as in the Ellison Collection sliding wooden doors decorated with books. Ritsuō-style lacquers frequently incorporate high-relief appliques of such materials as ceramic, tin, shell, and stone in addition to high- and low-relief *makie* ("sprinkled pictures")—designs of gold and other metallic powders suspended in lacquer. For these wooden doors, the artist has showcased his technical virtuosity through varied depictions of patterned frontispieces and book covers.

[1] Translation adapted from Laurel Rasplica Rodd and Mary Catherine Henkenius, trans., *Kokinshū: A Collection of Poems Ancient and Modern* (Boston: Cheng and Tsui Co., 1996) 257.

[2] Edwin A. Cranston, *A Waka Anthology: Volume II, Grasses of Remembrance, Part A.* (Stanford: Stanford University Press, 2006) 148.

[3] Translation adapted from *ibid.*, 149.

40

伝本阿弥光悦作　忍蒔絵硯箱　江戸時代

WRITING BOX WITH FERNS AND POETIC INSCRIPTION

Attrib. to Hon'ami Kōetsu (Japanese, 1558–1637)

Edo period (1615–1868)

Lacquered wood with makie (sprinkled gold powder) decoration and lead and
mother-of-pearl inlays

H. 1¾ x W. 9⁷⁄₁₆ x D. 10¼ in.

Published: Koichi Yanagi Oriental Fine Arts, *Kokon Biannual: Fall '09*; Shibuya
Kuritsu Shōtō Bijutsukan, *Kaikan 15 shūnen kinen tokubetsu ten, Mojie to emoji
no keifu*, no. 6

2009.161.a-g

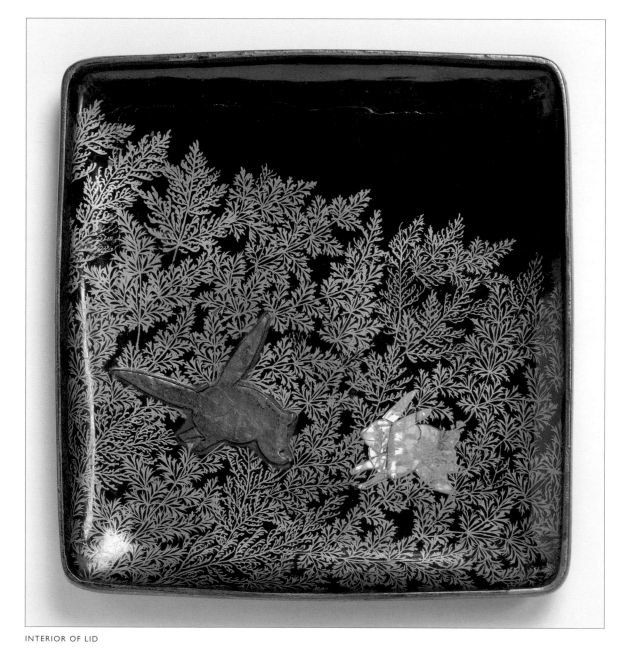

INTERIOR OF LID

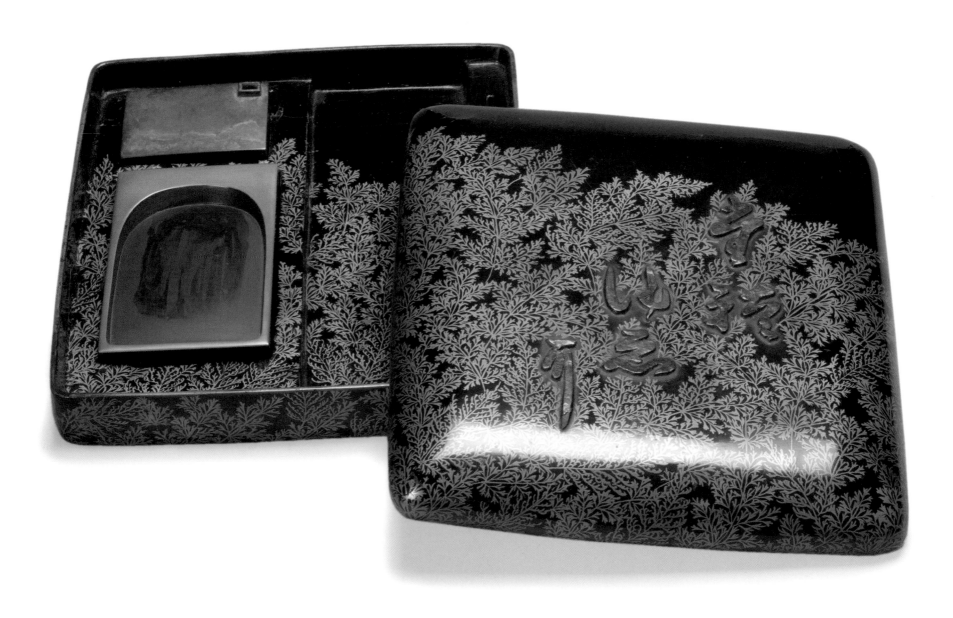

41

伝尾形光琳作　萩鹿蒔絵硯箱　江戸時代

WRITING BOX WITH DEER AND BUSH CLOVER

Attrib. to Ogata Kōrin (1658–1716)
Edo period (1615–1868)
Lacquered wood with makie (sprinkled gold powder) decoration and
mother-of-pearl, tin, and lead inlays
H. 4 5/16 x W. 10 5/16 x D. 6 1/2 in.
Published: Koichi Yanagi Oriental Fine Arts, *Kokon Biannual: Fall '11*, no. 4
2011.157.a-e

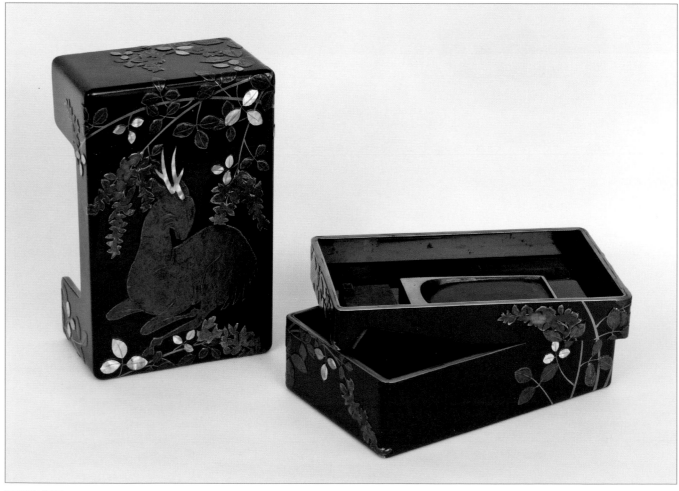

OPENED BOX

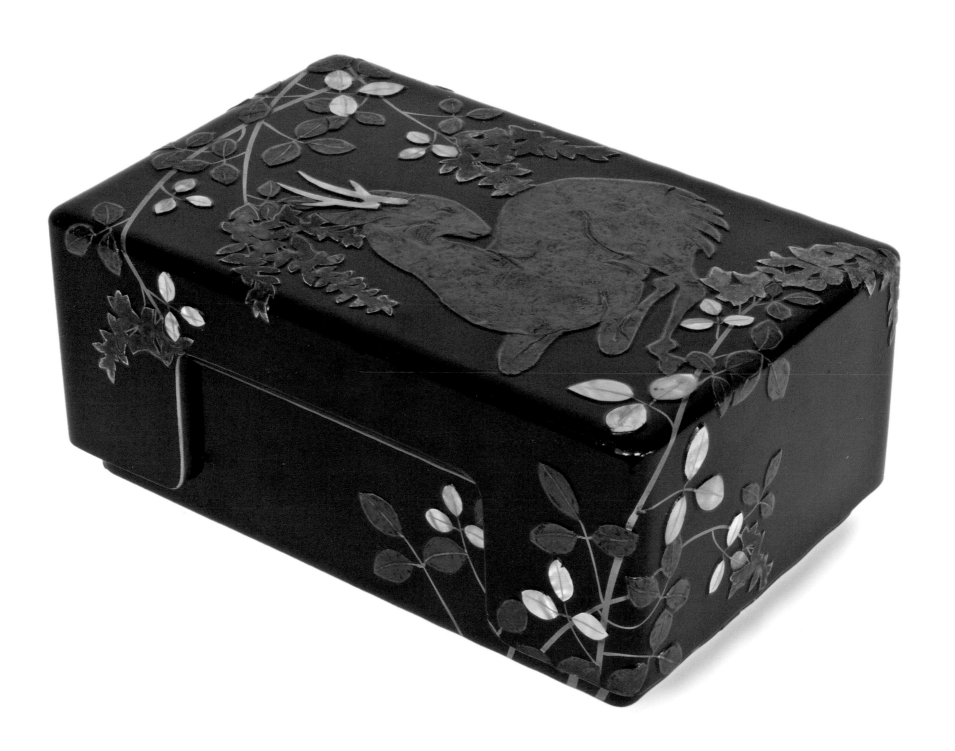

42

小川破笠印　冊子文板戸　江戸時代

SLIDING WOODEN DOORS WITH BOOKS

Seal of Ogawa Haritsu (Japanese, 1663–1747)
Edo period (1615–1868)
Pair of sliding wood doors (*itado*); cypress wood with lacquer, metal, and ceramic inlays
H. 68⁵/₁₆ x W. 34⁷/₁₆ x D. 1¹/₁₆ in. (each)
Signed: *Ukanshi Ritsuō sei*
Seal: *Kan*
Published: Moss, *One hundred years of beatitude*, no. 26, 212–219
2009.106.1-2

DETAIL

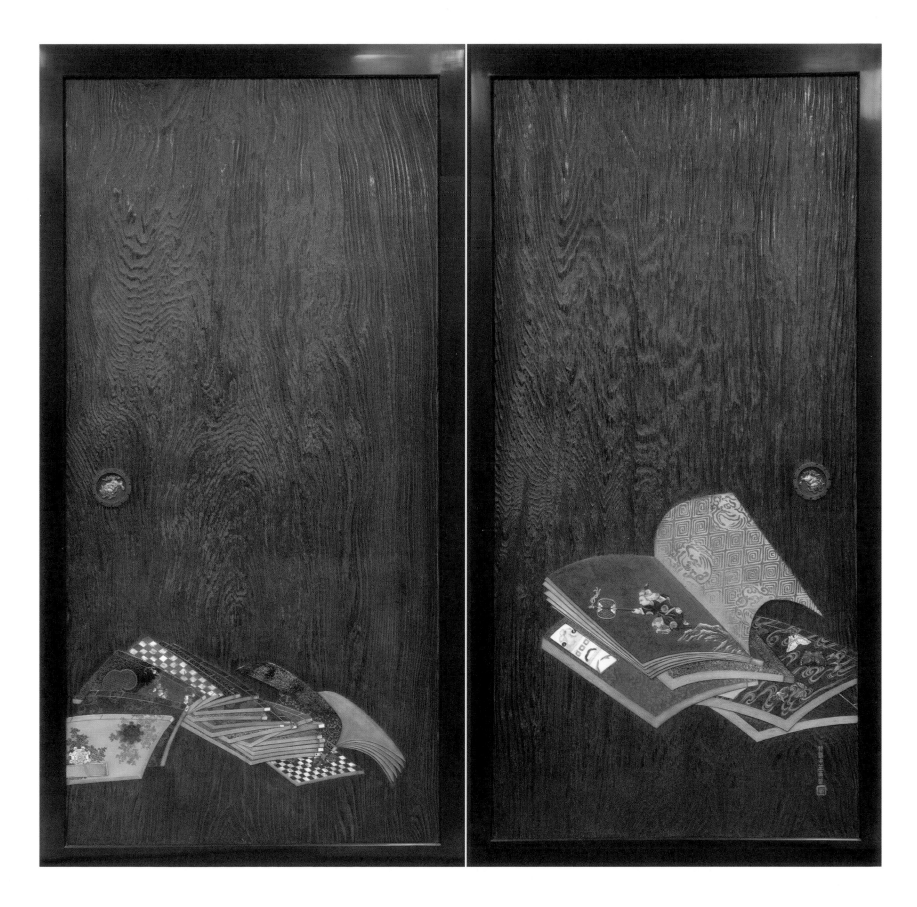

ARMOR AND METALWORK

To judge from the contents of ancient tombs, the tradition of Japanese armor-making extends back at least to the Kofun period (300–552). A type of flexible armor composed of small metal plates tied together with cord was the norm from the Heian period (794–1185) on, though design and construction details varied to meet the needs of different types of warfare. Both suits of armor included here belong to the type known as *gusoku* ("full equipment"). Developed in the 1500s for use by foot soldiers fighting with swords, gusoku was eventually adopted for use by the shogun and other high-ranking members of the warrior class. Edo period (1615–1868) armor often combines sophisticated craftsmanship in several techniques and materials: hammered iron plates and iron mail, leather, lacquer, silk, and printed textiles. Brightly colored silk cords, used to bind together lacquered iron plates, compete visually with lavish gold lacquer details and exotic imported textiles. These elements add a sumptuous quality suggesting that the armor was used on ceremonial occasions rather than in actual warfare. Two spectacular early Edo period helmets—one of exaggerated, swallowtail form, the other with a gold lacquered rabbit ornament, indicate a similar taste for bold and showy displays of wealth and authority.

Bronze is an alloy of copper, with smaller amounts of tin, zinc, and lead. It has been used to manufacture ceremonial objects in Japan since the Yayoi period (300 BCE–300 CE). With the introduction of Buddhism to Japan in the 500s, craftsmen began to employ bronze for sculpture and temple lanterns, as well as the flower vases, incense burners, and other objects used in religious rituals. By the 1500s, bronze objects began appearing in decorative arrangements within elite residences; the magnificent life-size bronze goose included here is one example of this type. Demand for containers to support the tall, vertical flower arrangements (*ikebana*) popular in the seventeenth century led to further advances in the bronze-maker's art, including the adaptation of Chinese bronze forms.

Due to the Meiji period (1868–1912) proscription against carrying two swords, bronze production underwent something of a revival, as sword makers searched for new markets for their skills. Exquisitely crafted decorative object were made for export to the West, often combining materials such as bronze with silver, copper alloys (*shakudo* and *shibuichi*), or enamel. Many of the early twentieth century bronzes shown here instead represent the domestic Japanese demand for bronzes whose sleek geometric abstraction participates in the international Art Deco aesthetic of the 1920s and 1930s.

43

黒漆塗燕尾形兜　江戸時代

SWALLOWTAIL-SHAPED HELMET

Edo period (1615–1868), 17th–18th century
Iron, lacquer, papier-mâché, and silk
H. 35 x W. 22 x D. 14 in.
2009.042

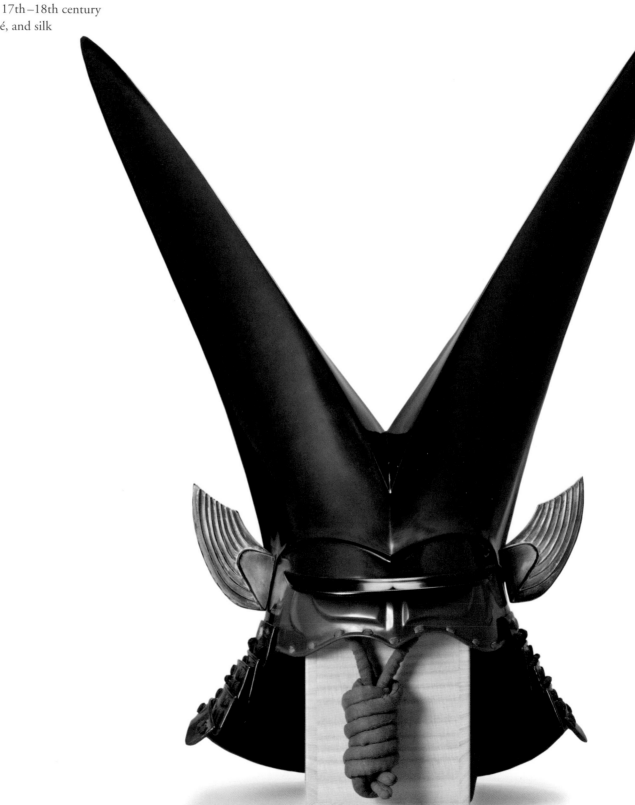

鉄錆地六枚張烏帽子形兜　江戸時代

SIX-PLATE COURTIER HAT-SHAPED HELMET

Edo period (1615–1868), late 17th century
Iron, silver, gilded copper, shakudo, silk, gilded wood, gold lacquer,
leather, gold leaf
H. 22 x W. 15½ x D. 16 in.
2010.065

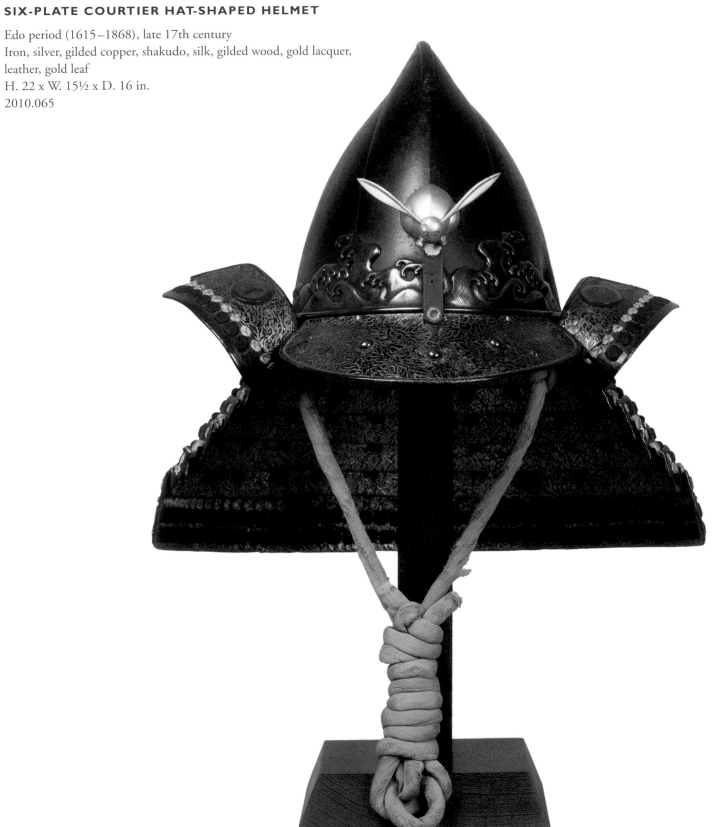

45

紫浅葱糸威二枚胴具足　江戸時代

GUSOKU-TYPE ARMOR WITH PURPLE AND LIGHT BLUE LACING

Edo period (1615–1868), 18th century
Iron, lacquer, leather, silk, lacquer, copper alloy, wood, gilding, animal hair, hemp
H. 55 x W. 24 x D. 23 in.
2010.066

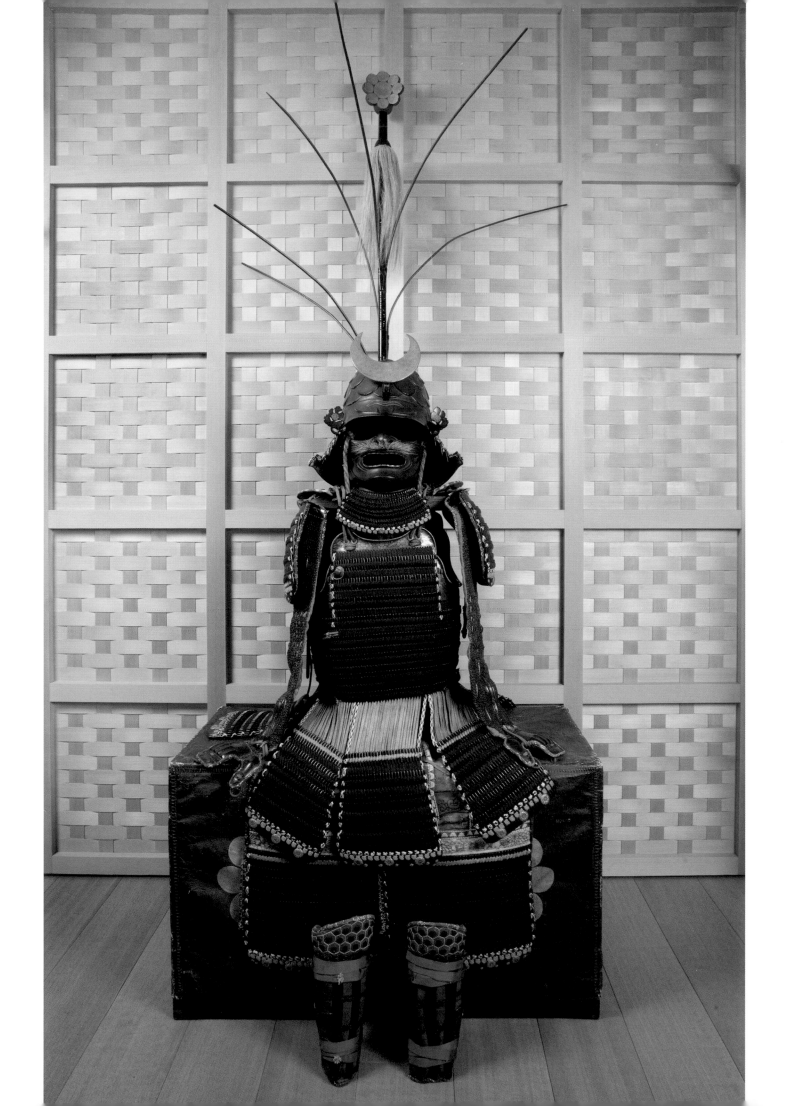

46

紺糸威二枚胴具足　江戸時代

GUSOKU-TYPE ARMOR WITH DARK BLUE LACING

Edo period (1615–1868), 17th–early 18th century
Iron, lacquer, leather, silk, gilding, animal hair
H. 56 x W. 17 x D. 22 in.
2011.031

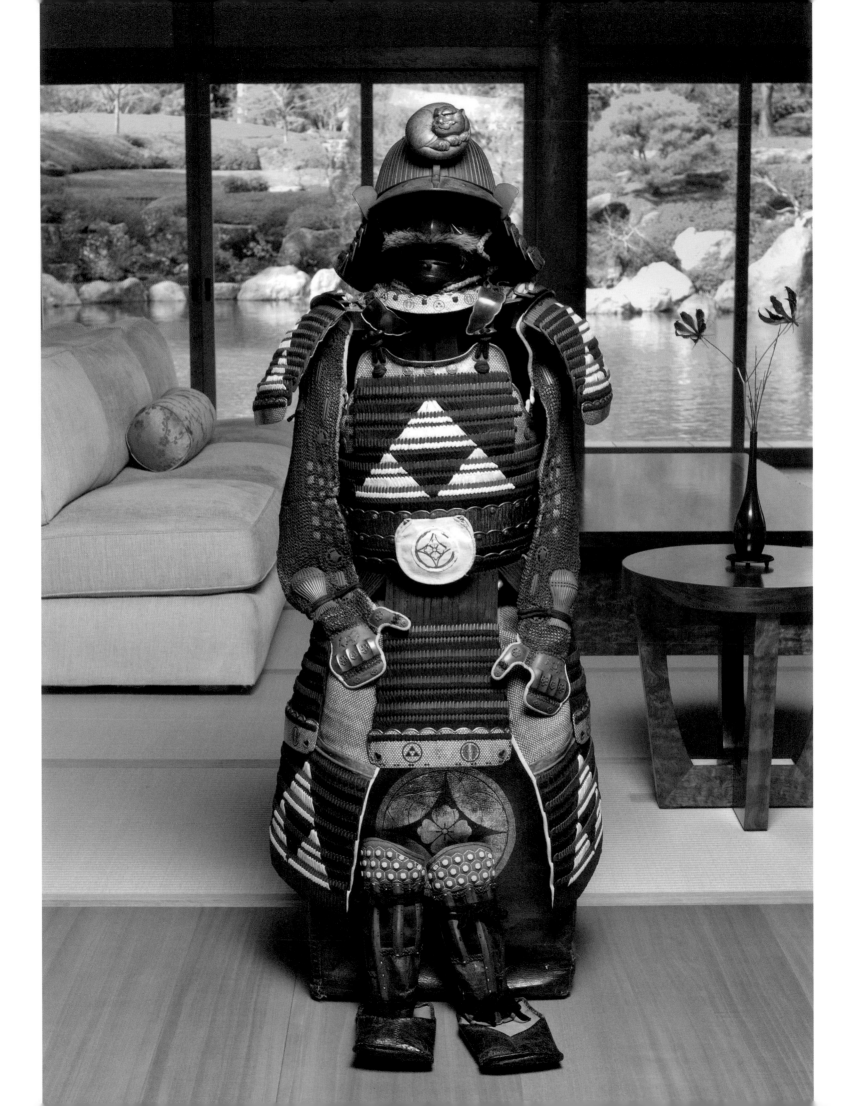

47

鋳銅雁形香炉　室町時代

INCENSE BURNER IN THE SHAPE OF A GOOSE

Muromachi period (1392–1573), 16th century
Cast bronze
H. 23¼ x W. 8 x D. 16 in.
2007.035

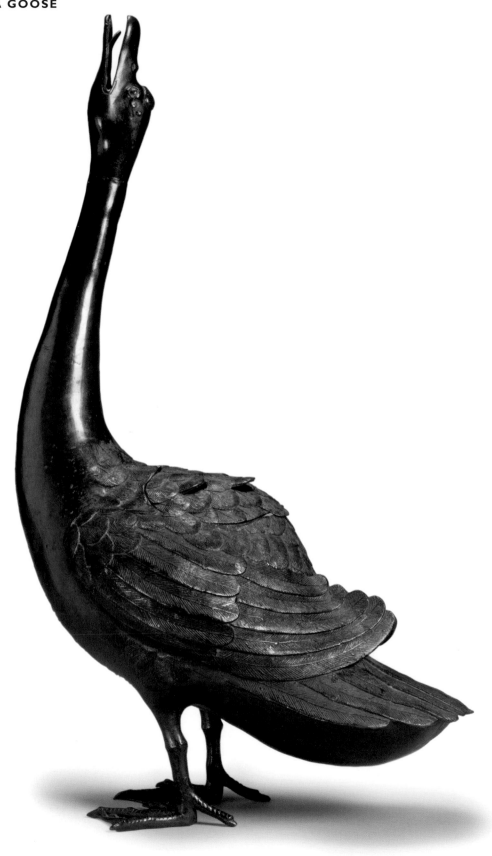

鋳銅四方薄端花瓶　江戸時代

SQUARE VASE WITH FLARING MOUTH (*USUBATA* TYPE)

Edo period (1615–1868), late 17th century
Cast bronze
H: 12¾ x W. 12½ x D. 12½ in.
T.150.AIG

49

鋳銅中口下蕪獅子耳立花瓶　江戸時代

VASE WITH FLARING MOUTH, BULBOUS LOWER SECTION, AND LION LUGS

Edo period (1615–1868), late 18th–19th century
Cast bronze
H. 11½ x Diam. 8 in.
T.144.AIG

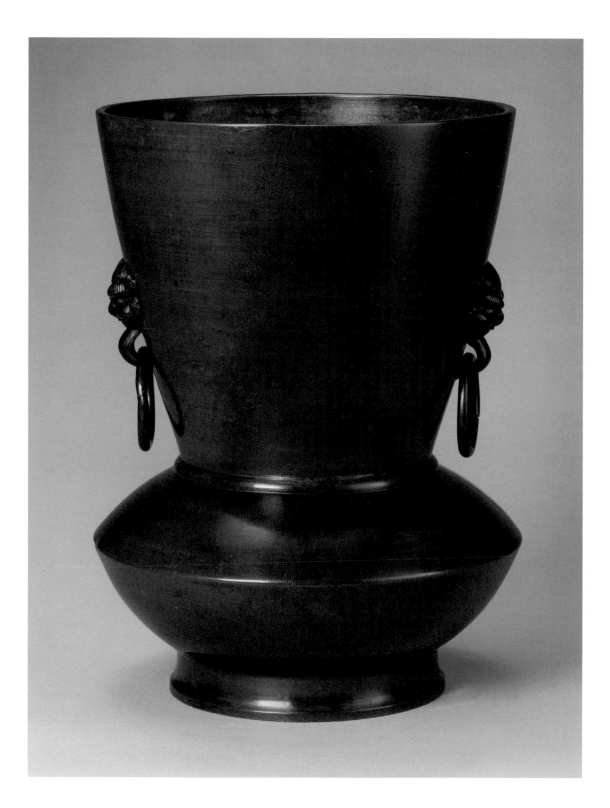

50

鋳銅中口下蕪立花瓶　江戸時代

VASE WITH FLARED MOUTH AND BULBOUS LOWER SECTION

Edo period (1615–1868), 18th century
Cast bronze
H: 14 x Diam. 10 in. (at top)
T.1531

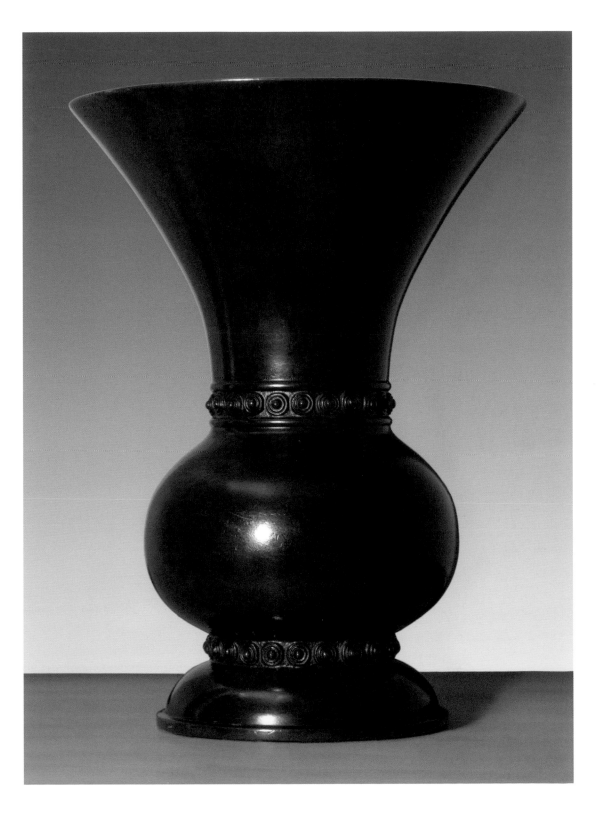

51

長谷川 一清（玉東斎）作　銀鶴形香炉　明治時代

INCENSE BURNER IN THE SHAPE OF A CRANE

By Hasegawa Issei (Gyokutōsai)
Meiji period (1868–1912)
Silver, *shibuichi*, *shakudō*, with enamel details
H. 9½ x W. 5 x L. 11 in
Signed: *Gyokutōsai*
2011.109

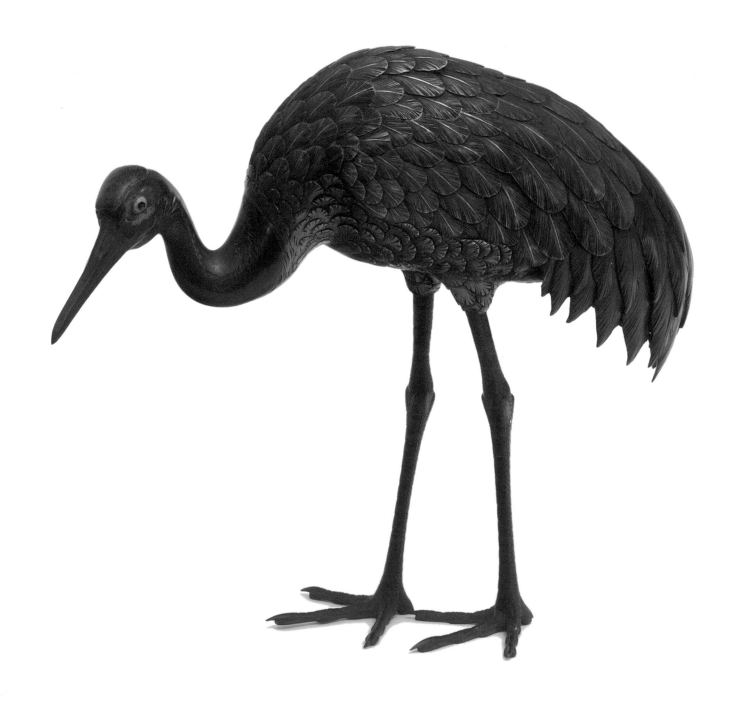

52

鋳銅鷺置物　明治時代

OKIMONO OF STANDING EGRET

Meiji period (1868–1912)
Cast bronze
H. 16 x W. 11¾ x D. 8½ in.
2010.064

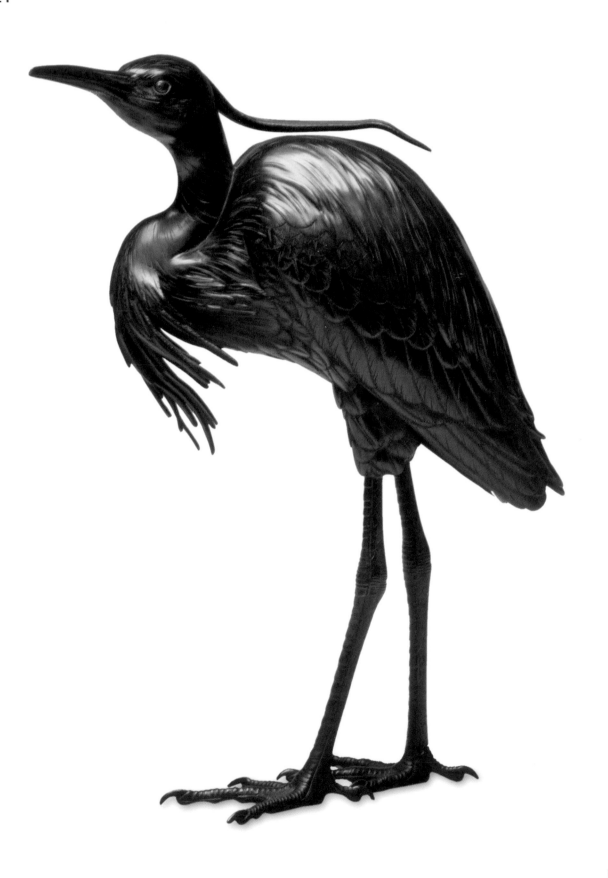

53

美海（丹金山口金正堂）作　「朧銀　牡牝猪置物」

OKIMONO OF MALE AND FEMALE BOARS WITH TEXTURED SURFACE

By Bikai of the Tankin Yamaguchi Kinshōdō workshop (Osaka)
Late Meiji period (1868–1912) or Taishō period (1912–1926), early 20th century
Copper-silver alloy (*shibuichi/oborogin*)
H. 7 x L. 8⅛ x D. 6 in. (male); H. 5 x L. 10 x D. 4 in. (female)
Signed: *Bikai saku*
2011.036.1-2

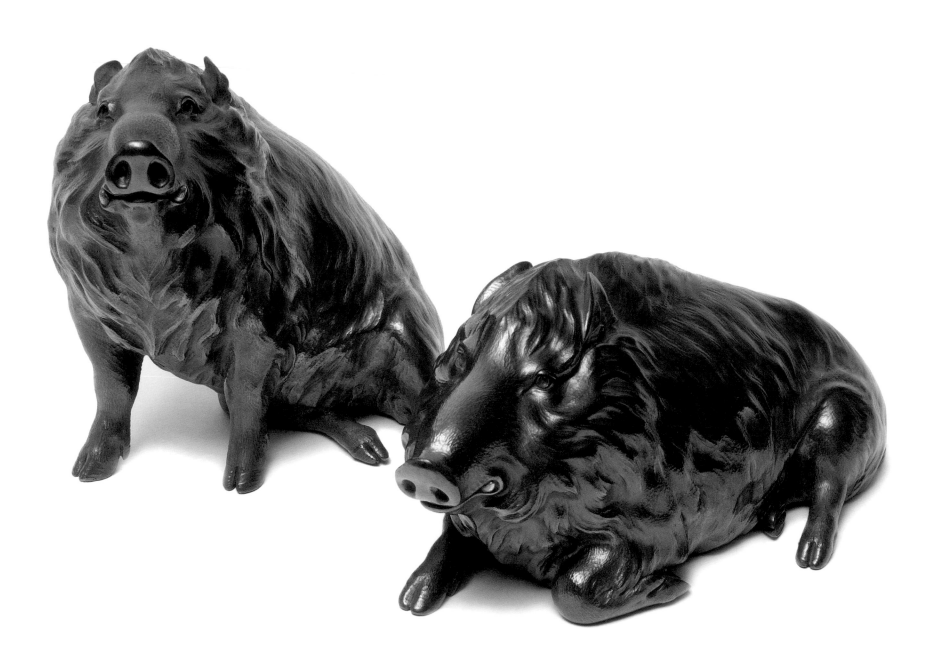

54

伝 伊藤勝英作　石橋文吊香炉　明治時代

SPHERICAL INCENSE BURNER WITH LIONS AND PEONIES

Attrib. to Itō Katsuhide (active c. 1890 –1920)
Meiji period (1868 –1912)
Copper and shibuichi with gold, silver, shakudo and shibuichi inlays
H. 9 x Diam. 6 in.
2008.019.1

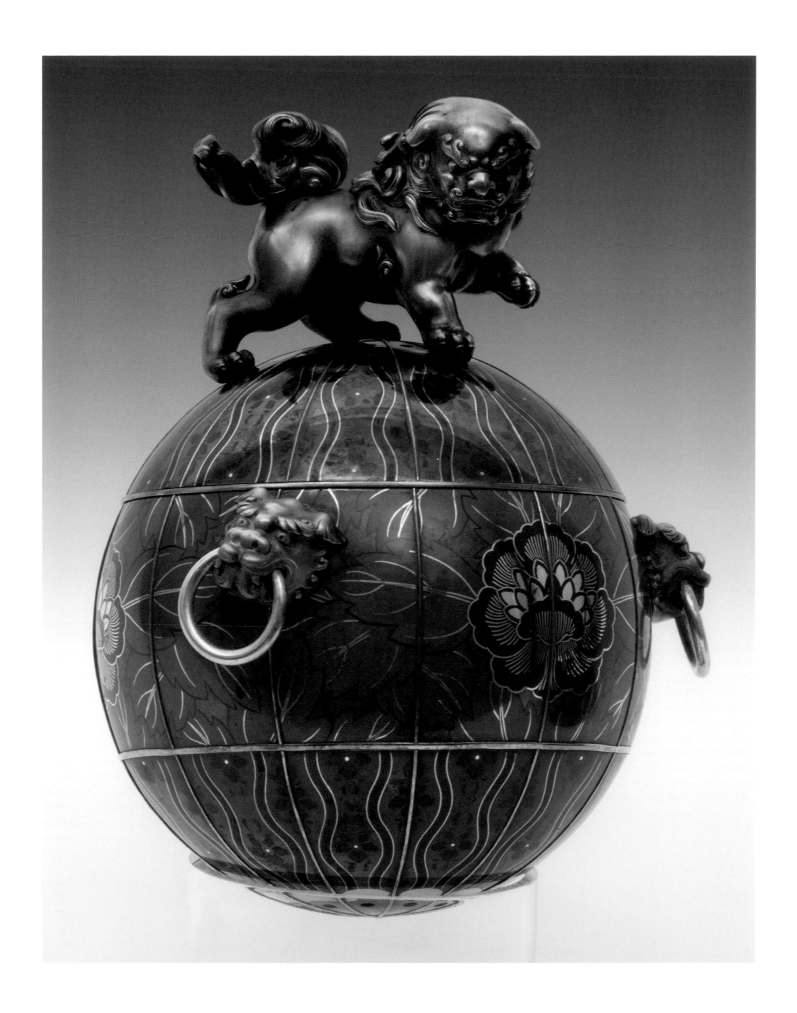

55

橋本一至作　「宣徳花入」　明治時代

NARROW FLOWER VASE WITH WAVES AND RISING SUN

By Hashimoto Isshi I (1820–1896) or Hashimoto Isshi II (active late 19th century–early 20th century)
Meiji period (1868–1912), c. 1875–1912
Sentoku bronze with speckled finish and gold inlay
H. 10¾ x Diam. 3 in.
Seal: *Isshi*
2007.016.1

DETAIL

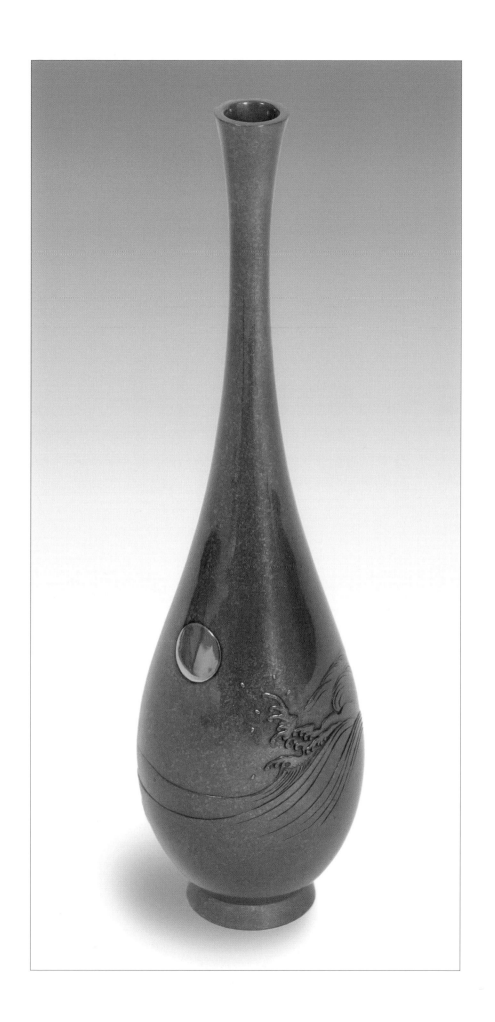

津田 信夫　鋳銅稲妻形花瓶　1943年

OVOID FLOWER VASE WITH STYLIZED LIGHTNING DESIGN

By Tsuda Shinobu (Japanese, 1875–1946)
Shōwa period (1926–1989), 1943
Cast bronze
H. 11¾ x Diam. 10 in.
Signed: *Daiju tsukuru*
2007.079.1

57

初代 中島保美作 「鋳銅線文壷」 大正時代〜昭和時代

GLOBULAR JAR WITH PLEATED WALLS

By Nakajima Yasumi I (1877–1952)
Taishō period (1912–1926) or Shōwa period (1926–1989)
Cast bronze
H. 10 x Diam. 10½ in.
Signed: *Yasumi*
2011.002.1

58

初代 中島保美作 「希望 鋳銅花瓶」 昭和時代

**JAR-SHAPED VASE WITH FOUR LOZENGE-SHAPED
PROTUBERANCES, ENTITLED *HOPE***

By Nakajima Yasumi I (1877–1952)
Early Shōwa period (1926–1989), 1926–1940
Cast bronze
Published: Cline and Knospe, *Kagedo Japanese Art*: Spring 2010,
no. 61, and p. 121
H. 13½ x Diam: 6½ in.
2010.074.1

59

佐々木象堂作 「花瓶」 昭和時代

OVOID FLOWER VASE WITH GEOMETRIC DESIGN

By Sasaki Shōdō (1882–1961)
Early Shōwa period (1926–1989), c. 1926–1930
Cast bronze
H. 7 x Diam. 9 in.
Seal: *Shōdō*
2007.074.1

60

高村豊周　鋳銅幾何文透彫「筆筒」　昭和時代　1928年頃

CYLINDRICAL BRUSHPOT WITH ABSTRACT GEOMETRIC OPENWORK

By Takamura Toyochika (1890–1972)
Shōwa period (1926–1989), c. 1928
Cast bronze, gilt copper
H. 5½ x Diam. 3⅜ in.
Seal: *Toyochika*
2011.210.1

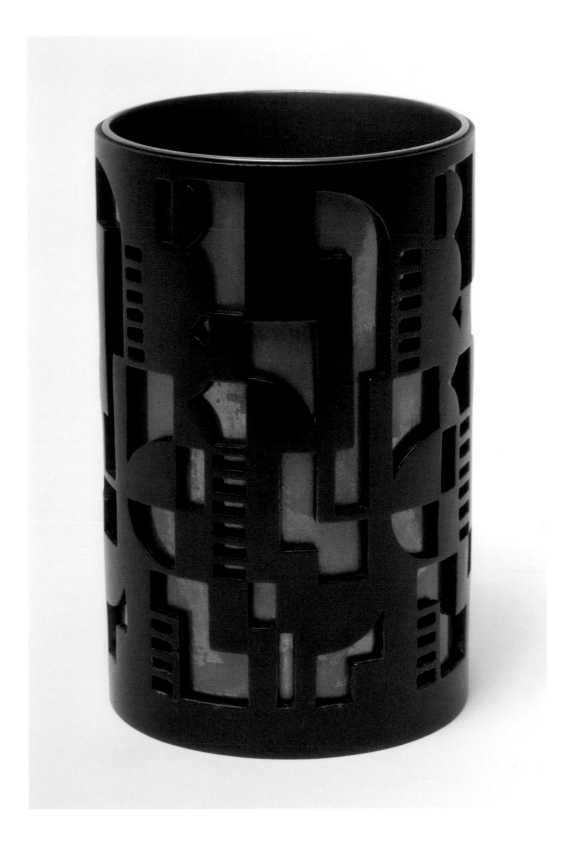

61

鹿島一谷作　「彫金　彩雲飛天　鉄花器」　昭和時代

FLOWER BASIN WITH APSARAS AND AUSPICIOUS CLOUDS

By Kashima Ikkoku (1898–1996)
Shōwa period (1926–1989)
Iron, gilding, and silver
H. 7 x W. 11 x D. 7 in.
Signed: *Ikkoku* (*kao*)
2008.015.1

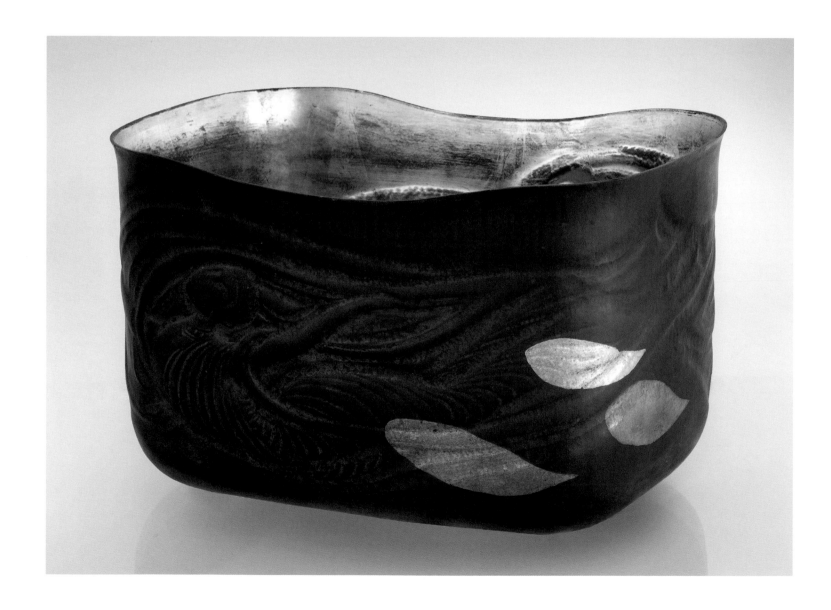

香取正彦作　鋳銅母子鹿置物　昭和時代前期

OKIMONO OF DOE AND FAWN

By Katori Masahiko (1899–1988)
Early Shōwa period (1926–1989)
Cast yellow bronze
H. 6¾ x W. 9½ x D. 3½ in. (doe); H. 4½ x W. 2¾ x D. 5¾ (fawn)
Signed: *Masahiko*
2010.037.1-2

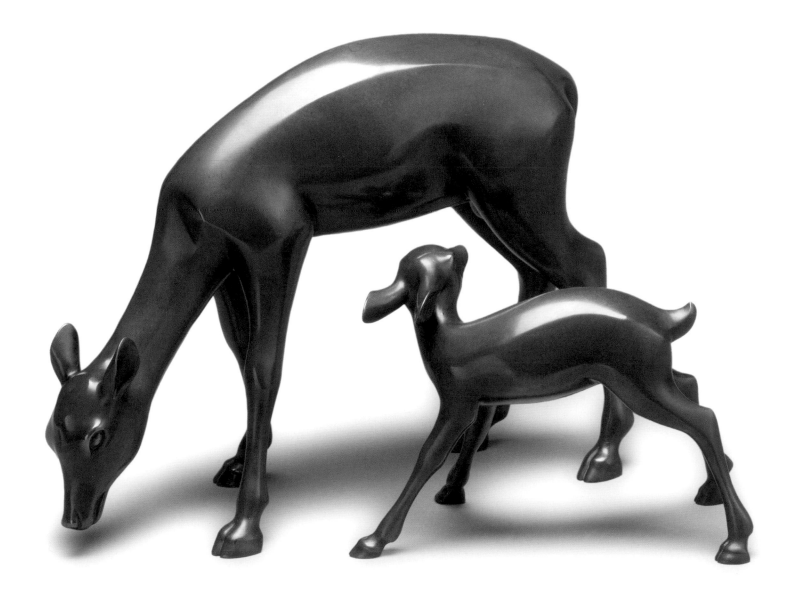

63

二代宮田藍堂「鋳銅線文花瓶」　昭和時代　1936年頃

CYLINDRICAL FLOWER VASE WITH
LINEAR RELIEF DECORATION

By Miyata Randō II (1902–1988)
Early Shōwa period (1926–1989), c. 1936
Cast bronze
H. 14¾ x Diam: 7¾ in.
Seal: *Randō*
2009.102.1

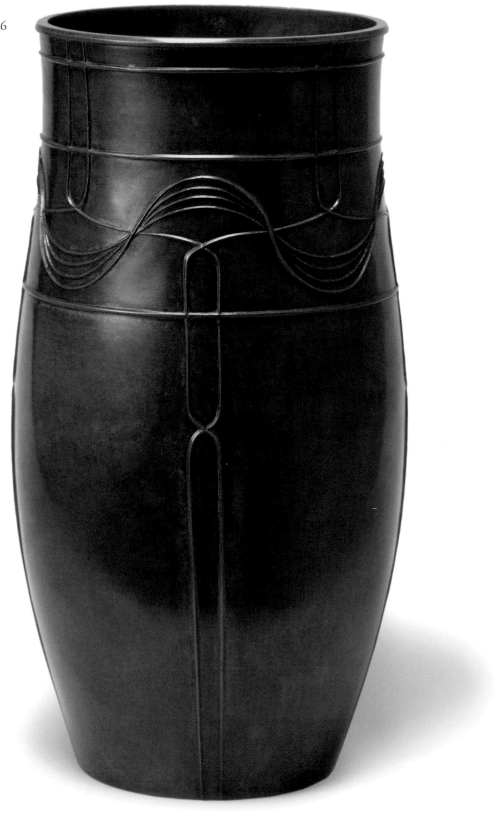

木村正太郎作　鋳銅花瓶　昭和時代　1939年頃

OVOID VASE WITH QUATREFOIL DECORATION AND LUGS

By Kimura Shōtarō (1909–1985)
Shōwa period (1926–1989), c.1939
Cast bronze
H. 12 x Diam: 11⅛ in
Signed: *Shōtarō saku*
2011.042.1

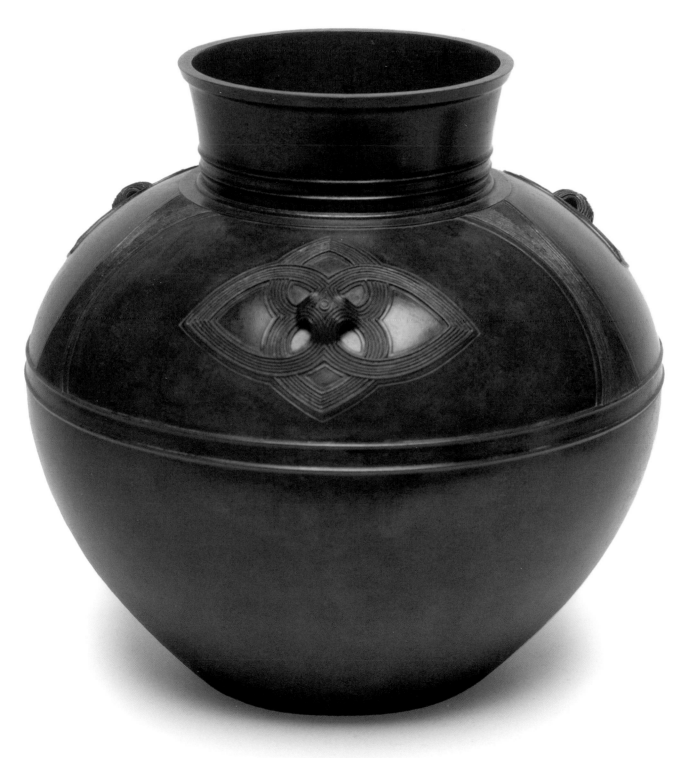

小林尚珉作　「碧空　鉄打出金象嵌麒麟置物」　昭和30年

OKIMONO OF GIRAFFE ENTITLED *BLUE SKY*

By Kobayashi Shōmin (1912–1994)
Shōwa period (1926–1989), 1955
Hammered iron with gold inlay and lacquer
H. 29 x W. 9½ x D. 5⅜ in.
Signed: *Shōmin saku*
Published: *Nittenshi*, vol. 18 (1955)
2011.104.1

66

山本秀峰作 「鋳銅花瓶 流水文象嵌」 昭和時代

OVOID FLOWER VASE WITH STYLIZED FLOWING WATER

Yamamoto Shūhō (1918–1999)
Shōwa period (1926–1989), c. 1975–1985
Cast bronze with silver inlay
H. 12 x Diam: 10¼ in.
Signed: *Shūhō*
2007.082.1

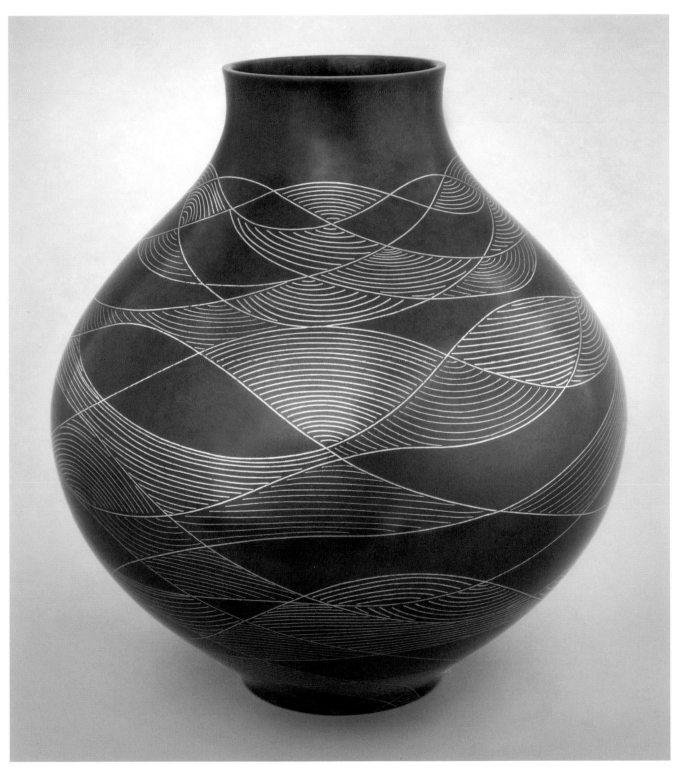

Works Cited

Akiba Kei, ed. Kinpeki *Sōshoku gashū*. Tokyo: Jurakusha, 1930.

Aston, William George, trans. *Nihongi: Chronicles of Japan from the Earliest Times to A.D. 697*. London: Allen & Unwin, 1956 (reprint of 1896 ed.).

Brown, Kendall H. *Deco Japan: Shaping Art and Culture, 1920–1945*. New York: Japan Society, 2012.

Cline, Jeffrey and William Knospe. *Kagedo Japanese Art*. Spring 2010.

Como, Michael. *Shōtoku: Ethnicity Ritual, and Violence in the Japanese Buddhist Tradition*. New York: Oxford University Press, 2008.

Carr, Kevin Grey. "The Lives of Shōtoku: Narrative Art and Ritual in Medieval Japan." Unpublished PhD diss., Princeton University, 2005.

Earle, Joe. *Flower Bronzes of Japan*. London: Michael Goedhuis, 1995.

Fuchū Bijutsukan. *Dōbutsu kaiga no 100 nen*. Tokyo: Fuchū Bijutsukan, 2007.

Gerhart, Karen. *The Eyes of Power: Art and Early Tokugawa Authority*. Honolulu: University of Hawaii Press, 1999.

Gosudarstvennyĭ Ėrmitazh. *Schest Vekov Yaponski Zhivopisi*. Tokyo: Tokyo Shinbun, 1989.

Gotō Bijutsukan. *Yamanoue no Sōji ki: Tenshū jōyonen no me*. Tokyo: Gotō. Bijutsukan, 1995.

Graham, Patricia. "Fans Afloat: Samurai Taste in Yamatoe Design." *Orientations 34* (December 2003).

Haynes, Robert E. *The Index of Japanese Sword Fittings and Associated Artists*. Ellwangen, Germany: Nihon Art Publishers, 2001.

Hillier, Bevis. *Art Deco*. London: Studio Vista, 1968.

Ishikawa-ken Bijutsukan. *Nihon sōshokuga no nagare*. Kanazawa: Ishikawa-ken Bijutsukan,1964.

Itabashi Kuritsu Bijutsukan. *Suzuki Kiitsu ten: Edo Rinpa no kisai*. Tokyo: Itabashi Kuritsu Bijutsukan, 1993.

Kagedo Japanese Art. *Art Deco and Modernism: Archives*, www.kagedo.com/collections/3/KJA1695.html.

Kaikodo. *Kaikodo Journal/Kaikodō*. Vol. IX: 31 (2001).

Kano Einō. *Honchō gashi* (1693); in Kasai Masaaki, ed., *Yakuchū honchō gashi*. Tokyo: Dōhōsha, 1985.

Kano Hiroyuki, Okudaira Shunroku and Yasumura Toyonobu, eds. *Rinpa bijutsukan*, vol. 2: *Kōgei to Rinpa kankaku no tenkai*. Tokyo: Shūeisha,1993.

Klein, Bettina. *Japanese Kinbyōbu: The Gold-leafed Folding Screens of the Muromachi Period (1333–1573)*, adapted and expanded by Carolyn Wheelwright. Ascona, Switzerland: Artibus Asiae,1984.

Kobayashi Tadashi, ed. *Rinpa*, vol. 2: *Kachō II*. Kyoto: Shikōsha, 1990.

Kobayashi Tadashi. "Yosa Buson hitsu tobizu," *Kokka* 1209 (1996).

Koichi Yanagi Oriental Fine Arts. *Honji Sui-jyaku: Manifestations of Japanese Kami*. New York: Koichi Yanagi Oriental Fine Arts, 2008.

Koichi Yanagi Oriental Fine Arts. *Kokon Biannual: Fall '09*. New York: Koichi Yanagi Oriental Fine Arts, 2009.

Koichi Yanagi Oriental Fine Arts. *Kokon Biannual Fall '11*. New York: Koichi Yanagi Oriental Fine Arts, 2011.

Koichi Yanagi Oriental Fine Arts. *Kokon Biannual Fall '12*. New York: Koichi Yanagi Oriental Fine Arts, 2012.

Kōno Motoaki. "Kanō Sansetsu hitsu shiki kachōzu byōbu." *Kokka* 1315 (2005).

Kuno Takeshi, "Mokuzō," *Bijutsushi* 97 (1991), 119–121.

Kyōto Kokuritsu Hakubutsukan. *Itō Jakuchū taizen*. Tokyo: Shōgakkan, 2002.

Kyōto Kokuritsu Hakubutsukan. *Kano Eitoku: tokubetsu tenrankai*. Kyoto: Kyoto National Museum, 2007.

Kyōto Kokuritsu Hakubutsukan. *Maruyama Ōkyo jojō to kakushin botsugo nihyakukunen: tokubetsu tenrankai*. Kyoto: Kyōto Kokuritsu Hakubutsukan, 1995.

Kyōto Kokuritsu Hakubutsukan. *Muromachi jidai no Kano-ha: tokubetsu tenrankai*. Kyoto: Kyōto Kokuritsu Hakubutsukan,1996.

Lee, Kenneth Doo Young. *The Prince and the Monk: Shōtoku Worship in Shinran's Buddhism*. Albany, NY: State University of New York Press, 2007.

Lim, K. W., *Aziatische Kunst uit het bezit van leden*. Amsterdam: Vereniging van Vrienden der Aziatische Kunst, 1979.

Lippit, Yukio. *Painting of the Realm: The Kano House of Painters in Seventeenth-Century Japan*. Seattle: University of Washington Press, 2012.

Machida Shiritsu Kokusai Hanga Bijutsukan. *Rinpa: han to kata no tenkai*. Machida: Machida Shiritsu Kokusai Hanga Bijutsukan, 1992.

PLATE 39 (DETAIL)

169

Matsuki Hiroshi. *Goyō eshi Kano-ke no chi to chikara*. Tokyo: Kōdansha, 1994.

McCormick, Melissa. *Tosa Mitsunobu and the Small Scroll in Medieval Japan*. Seattle: University of Washington Press, 2009.

McKelway, Matthew P. "The Battle of Ichinotani." *Orientations 42:4* (May 2011).

McKelway, Matthew P. "Muromachi jidai Kanoha senmenga no "orijinaru"—sōga to no kanren," in Tōkyō Bunkazai Kenkyūjo, ed., *Orijinaru" no yukue: bunkazai o tsutaeru tame ni*. Tokyo: Heibonsha, 2010.

McKelway, Matthew P. *Silver Wind: The Arts of Sakai Hoitsu*. New York: Japan Society, 2012.

McKelway, Matthew P., Yoko Woodson, et al., *Traditions Unbound: Groundbreaking Painters of Eighteenth Century Kyoto*. San Francisco: Asian Art Museum, 2007.

Mie Kenritsu Bijutsukan. *Soga Shōhaku ten*. Tsu: Mie Kenritsu Bijutsukan, 1987.

Minamoto Toyomune, ed. *Maruyama Ōkyo gashū*. Kyoto: Kyōto Shinbunsha, 1999.

Miyajima, Shin'ichi. *Senmenga (Chūsei-hen). Nihon no bijutsu* 320. Tokyo: Shibundō, 1993.

Moss, Paul. *One Hundred Years of Beatitude: Centenary Exhibition of Japanese Art*. London: Sydney L. Moss, 2011.

Motta, Federico. *Giappone. Potere e Splendore 1568/1868*. Milan: 24 Ore Motta Cultura, 2009.

Murashige Yasushi, ed. *Rinpa*, vol. 3: *Fūgetsu, chōjū*. Kyoto: Shikōsha, 1991.

Murashige Yasushi, ed. *Rinpa*, vol. 4: *Jinbutsu*. Tokyo: Shikōsha, 1991.

Murashige Yasushi and Kobayashi Tadashi, eds. *Rinpa,* vol. 5: *Sōgō*. Kyoto: Shikōsha,1989.

Nakamachi Keiko."Genji Pictures from Momoyama Painting to Edo Ukiyo-e," in *Envisioning The Tale of Genji: Media, Gender, and Cultural Production*, ed. Haruo Shirane. New York: Columbia University Press, 2008.

Phillips , Quitman E."Kano Motonobu and Early Kano Narrative Painting." PhD diss., University of California, Berkeley, 1992.

Rosenfield, John M. "The Sedgwick Statue of the Infant Shōtoku Taishi." *Archives of Asian Art* 22 (1968–1969).

Sakazaki Shizuka. *Nihon garon taikan*. Tokyo: Arusu, 1927–1929.

Sasaki Jōhei. *Maruyama Ōkyo kenkyū*. Tokyo: Chūōkōronsha, 1996.

Shibuya Kuritsu Shōtō Bijutsukan. *Kaikan 15 shūnen kinen tokubetsu ten, Mojie to emoji no keifu*. Tokyo: Shibuya Kuritsu Shōtō Bijutsukan, 2009.

Shizuoka Kenritsu Bijutsukan. *Jakuchū to kyō no gakatachi*. Shizuoka: Shizuoka Kenritsu Bijutsukan, 2005.

Suntory Bijutsukan. *Genpei no bigaku: Heike monogatari no jidai*. Tokyo: Suntory Museum, 2002.

Takeda Tsuneo. *Kano Eitoku*, trans. H. Mack Horton and Catherine Kaputa. Tokyo: Kōdansha, 1977.

Takeda Tsuneo, Yamane Yūzō, Yoshikawa Chū, eds. *Nihon byōbu-e shūsei, bekkan* [vol. 18]: *Byōbu-e taikan*. Tokyo: Kōdansha,1981.

Tani Akira. "Kenkyū shiryō: chakai ki ni arawareta kaiga," *Bijutsu kenkyū* 363 (March, 1995).

Tawaraya Sōtatsu. *Sōtatsu*. Tokyo: Takamizawa Mokuhansha,1940.

Thomsen, Erik. *Japanese Paintings and Works of Art*. New York: Erik Thomsen. Asian Art, 2010.

Tokugawa Bijutsukan. *Muromachi shō gunke no shihō o saguru*. Tokugawa Bijutsukan, 2008.

Tōkyō Kokuritsu Bunkazai Kenkyūjo. *Naikoku kangyō hakurankai bijutsuhin shuppin mokuroku*. Tokyo: Chūōkōron Bijutsu Shuppan, 1996.

Tōkyō Kokuritsu Hakubutsukan. *Shōtoku Taishi ten*. Tokyo: NHK Art Publication Design Center, 2001.

Tsuji Nobuo. *Lineage of Eccentrics: Matabei to Kuniyoshi*, Aaron Rio trans. Tokyo: Kaikai Kiki, 2012.

Tyler, Royall, trans. *The Tale of Genji*. New York: Viking, 2001.

Watsky, Andrew. "Locating 'China' in the Arts of Sixteenth-Century Japan," in *Location*, ed. Deborah Cherry and Fintan Cullen. Oxford: Blackwell Publishing, 2007.

Wheelwright, Carolyn. "Kano Shōei," PhD diss., Princeton University, 1980.

Wheelwright, Carolyn. "Kano Painters of the Sixteenth Century A.D.: The Development of Motonobu's Daisen'in Style," *Archives of Asian Art* 34 (1981).

Yamamoto Hideo, "Genshū-in Genji monogatari zu byōbu," *Kokka* 1388 (2011).

Yamane Yūzō, "Hasegawa Tōshū–Tōgaku kenkyū," *Kokka* 1228 (1998), 13 –26.

Yamane Yūzō, Shimada Shūjirō, and Akiyama Terukazu, eds. *Zaigai nihon no shihō*. Tokyo: Mainichi Shinbun, 1979–81.

Yoshiaki Shimizu, "Workshop Management of the Early Kano Painters, ca. A.D. 1530 –1600," *Archives of Asian Art* 34 (1981).

About the Authors

Laura W. Allen is Curator of Japanese Art at the Asian Art Museum, San Francisco. She received her PhD in the history of Japanese art from the University of California, Berkeley, and is author of numerous essays on Japanese narrative painting and woodblock prints. Her most recent publication is *The Printer's Eye: Ukiyo-e from the Grabhorn Collection* (2013), co-edited with Melissa M. Rinne.

Joe Earle occupied senior museum positions over a period of thirty years, ranging from Keeper of the Far Eastern Department at the Victoria and Albert Museum in London to Director of Japan Society Gallery in New York. He currently serves as a Senior Consultant to the Japanese Art Department of Bonhams. A graduate of Oxford University, he has authored, translated, edited, or contributed to more than twenty major publications on Japanese art. Among the books he has written is *Flower Bronzes of Japan*.

Matthew P. McKelway is the Takeo and Itsuko Atsumi Associate Professor of Japanese Art History at Columbia University, where he earned his doctorate. His publications include *Traditions Unbound: Groundbreaking Painters of Eighteenth Century Kyoto*; *Silver Wind: The Arts of Sakai Hōitsu* (1761–1828); and numerous articles on Japanese painting.

Melissa M. Rinne is Associate Curator of Japanese Art at the Asian Art Museum, San Francisco. Educated at Brown University, Kyoto University of Arts, and Kyoto University, she has been the recipient of fellowships from the Japanese government's Ministry of Education and Agency for Cultural Affairs. Her publications include *Masters of Bamboo: Artistic Lineages in the Lloyd Cotsen Japanese Basket Collection* and other exhibition catalogues and articles on Japanese art.

Emily J. Sano, Director Emerita of the Asian Art Museum, works as a private curator and as art consultant to the Larry Ellison Collection of Japanese art. Her PhD is from the department of art history at Columbia University, New York. Her museum career began in Texas at the Kimbell Art Museum in Fort Worth, and the Dallas Museum of Art before joining the Asian Art Museum in San Francisco, where she led the museum's move from Golden Gate Park to the Civic Center of San Francisco. She is a recipient of the Order of the Rising Sun from the Japanese Government for promoting Japanese art and culture.

Index

ISBN: 978-0-939117-61-1 (cloth) / 978-0-939117-62-8 (paper)

Published to accompany the exhibition

In the Moment: Japanese Art from the Larry Ellison Collection

presented at the Asian Art Museum, San Francisco, from June 28 through September 22, 2013.

The exhibition was organized by the Asian Art Museum in collaboration with Lawrence J. Ellison. It was curated by Laura W. Allen and Melissa M. Rinne in consultation with Emily J. Sano. This catalogue was produced under the direction of Thomas Christensen, who also prepared the index. It was designed and typeset in Adobe Garamond and Gill Sans by Ron Shore of Shore Design (www.ronshoredesign.com). It was printed on Gardamatt Art 170 gsm paper and sewnbound in Italy by Elcograf S.p.A.

The Asian Art Museum–Chong-Moon Lee Center for Asian Art and Culture is a public institution whose mission is to lead a diverse global audience in discovering the unique material, aesthetic, and intellectual achievements of Asian art and culture.

Front cover: cat. no. 22
Back cover: cat. no. 3

Photography credits
T-land Studio: pp. 1, 6, 14, 34, 35, 36 left, 36 right, 37 bottom, 40, 43, 44, 45, 47, 48, 49, 53, 55, 59, 63, 64, 65, 68, 69, 72, 73, 78, 79, 80, 81, 82, 83, 85, 86, 87, 88, 89, 94, 95, 96, 97, 98, 99, 100, 101, 103, 104, 105, 107, 109, 113, 114, 115, 116, 117, 119, 121, 125, 126, 127, 128, 130, 131, 134, 135, 138, 139, 141, 144, 145, 146. 147, 149, 155, 162, 163, 164, 165
Courtesy Octopus Holdings: pp. 2, 20, 26, 29, 32, 37 top, 38 left, 38 right, 43, 51, 52, 56, 58, 60, 61, 66, 67, 70, 71, 74, 75, 76, 77, 87, 90, 91, 92, 93, 100, 110, 108, 111, 118, 122, 123, 124, 132, 133, 136, 143, 148, 151, 153, 154, 157, 158, 159, 160, 161, 166, 167
Mark Schwartz: pp. 4, 8, 11, 12, 172, 176

987654321
FIRST PRINTING